GARDEN

PHOTOGRAPHER OF THE YEAR

COLLECTION 01

Managing Editor: Paul Mitchell
Senior Art Editor: Nick Otway
Image retouching and colour repro: Sarah Montgomery
Production: Lyn Kirby
Indexer: Hilary Bird

Produced by AA Publishing
© Automobile Association Developments Limited 2008

Published by AA Publishing (a trading name of Automobile Association
Developments Limited, whose registered office is Fanum House, Basing View,
Basingstoke RG21 4EA; registered number 1878835).

A3690

ISBN-13: 978-0-7495-5711-9

A CIP catalogue record for this book is available from the British Library.

The contents of this book are believed correct at the time of printing. Nevertheless,
the publishers cannot be held responsible for any errors or omissions or for
changes in the details given in this book or for the consequences of any reliance on
the information provided by the same. This does not affect your statutory rights.

Printed and bound in Italy by Printer Trento S.r.l.

www.theAA.com/travel

The contents of this book are believed correct at the time of printing. Whilst every
effort has been made to correctly identify the subject matter in each photograph,
all captions and descriptions are written in the photographer's own words.
The publishers cannot be held responsible for any errors or omissions or for
changes in the details given in this book or for the consequences of any reliance
on the information provided by the same. This does not affect your statutory rights.

NICOLA STOCKEN TOMKINS ⋯⟩ COMMENDED

Wayford Manor in spring.
(Variegated pond iris, *Iris pseudacorus* 'Variegata'; *Lysimachia ciliata*
'Firecracker'). Crewkerne, Somerset, England.

The misty softness of the light revealed great textural depth, enabling me to include
everything from the plants at my feet through the pool to the cows in the adjacent field and
hills a mile away, with great clarity. The result emphasises Peto's structure and vision in
conceiving a design that has so well stood the test of time.

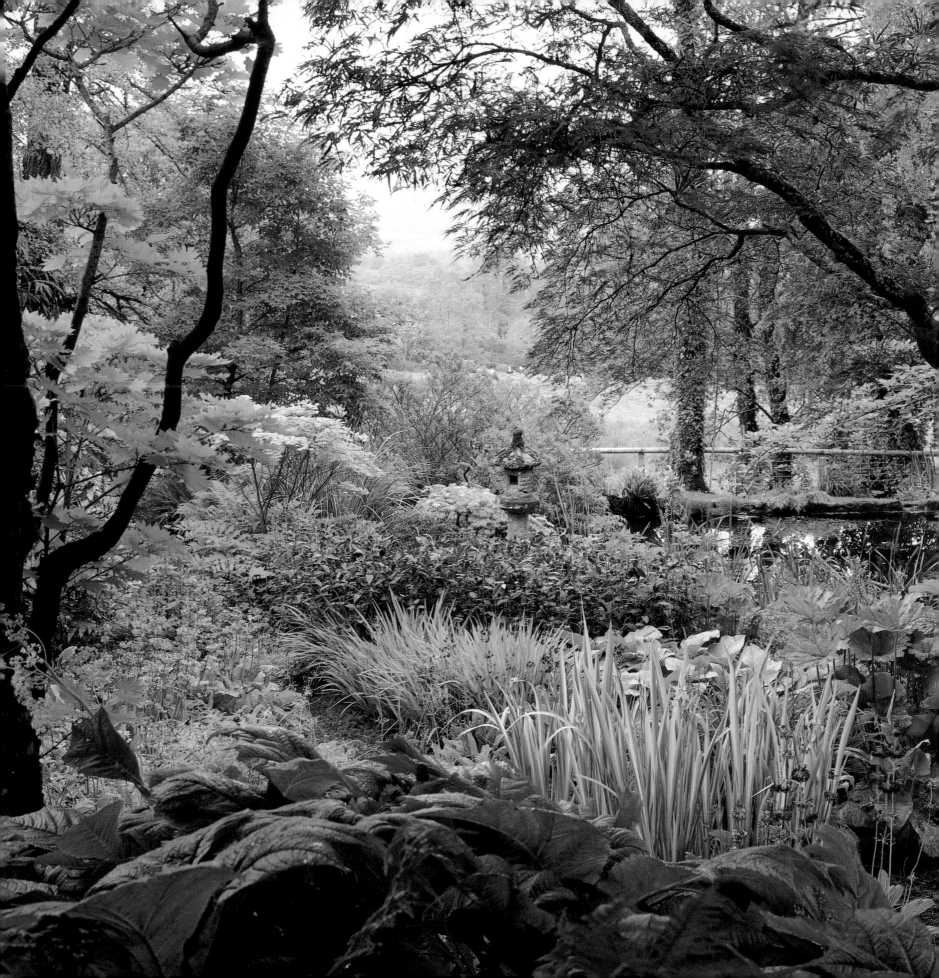

CONTENTS

CAROL SHARP ⋯⟩ FINALIST

Tulip 'Queen of Night'.
Photographer's garden in Norfolk, England.

A single bloom of the darkest of any tulip, 'Queen of Night', showing the subtle variations within its deep maroon petals. I aimed to capture the richness of the colour and texture.

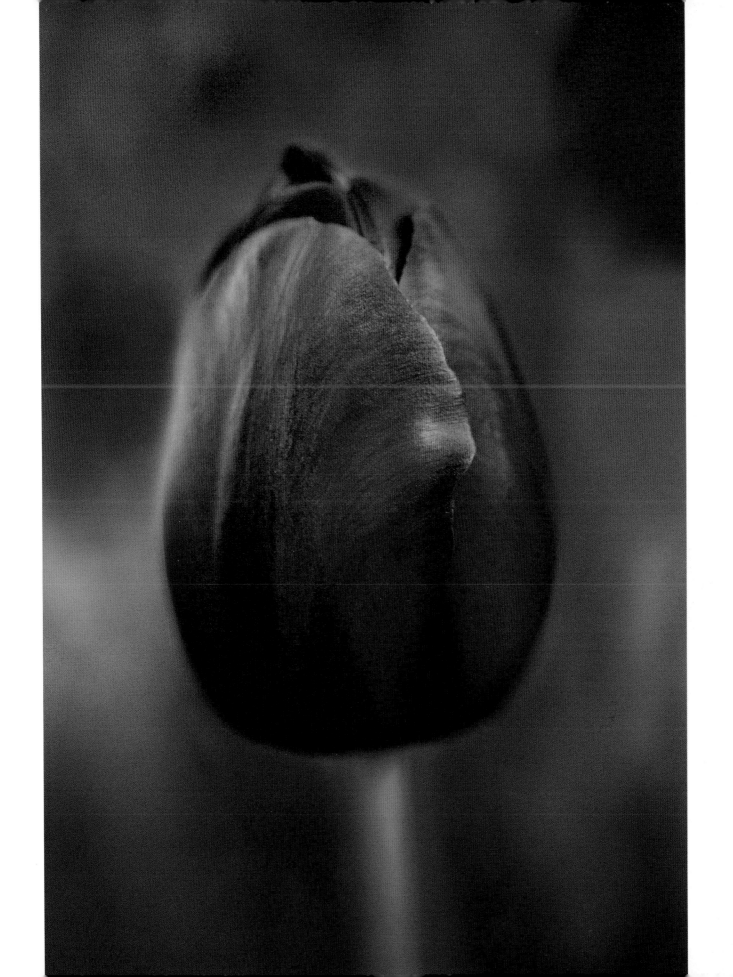

FOREWORD

Professor Stephen Hopper FLS,
Director of the Royal Botanic Gardens,
Kew

This book presents a wonderful range of images from over 100 finalists of the Garden Photographer of the Year Competition, open to professional and amateur photographers of all ages.

The Royal Botanic Gardens, Kew takes great pleasure in providing the venue for the exhibition associated with the competition, and in its continuing quest to encourage excellence in plant and garden photography. It is particularly pleasing to see the introduction of a category and award for the under 16s; young people are a special focus for Kew, at the heart of one of its priorities to encourage engagement and learning.

We are also delighted to see that a competition category has been devoted to trees, the theme of our 2008 summer festival, celebrating in particular the opening of Kew's Rhizotron and Xstrata Treetop Walkway.

The images themselves are stunning in their variety. There is much to delight, surprise, amuse and to appreciate in terms of their aesthetics and elegance. They link natural beauty to personal perspectives and significance in our lives. They also depict our rapidly changing world and, yet, at the same time show how we still connect and engage with wildlife and, in particular, with plants.

The story behind these images is thought-provoking and very much at the heart of Kew's mission and its work, to inspire and deliver science-based plant conservation worldwide, enhancing the quality of life.

We live in exceptional times of rapid environmental change, arguably bringing for many a declining quality of life. We need to nurture plant life as never before if society is to combat this and achieve sustainable ways of living. We must reduce and try to stop the destruction of wild vegetation, which currently contributes to about one-fifth of the carbon emissions that cause global warming.

This will only happen if people engage with and appreciate biodiversity. For many of us this begins with an association with our immediate surroundings; our gardens, parks and the richness of the countryside. The original artistic creativity, skill and inspiration that are portrayed in this wonderful collection of photographs highlight the delights, value and importance of plants in our natural world.

Professor Stephen Hopper
Director
Royal Botanic Gardens, Kew

7

ABOUT THE COMPETITION

The Garden Photographer of the Year competition and exhibition has developed from the 'members only' exhibitions run by the Garden Photographers' Association (GPA). The GPA was first formed in 1999 by leading garden photographers, including Andrew Lawson, Derek Harris and Jerry Harpur. Established initially as a forum for the exchange of ideas, experience and contacts, the Association also staged exhibitions of members' work, the most recent of which was 'Imagine, Yesterday Today' which was shown at the Royal Botanic Gardens, Kew, in 2006. With a vision to inspire a wider audience to appreciate the subject of flower and garden photography and to place it firmly on a par with landscape and wildlife, several members of the GPA established the company, Garden and Landscape Photographic Art (GALPA Ltd), to run an annual competition and exhibition. Still actively supported by the professional roots of the GPA, Garden Photographer of the Year is now a competition open to all.

The vision to inspire everyone to appreciate the beauty of plants and gardens is shared by botanic gardens around the world and so, as one of the longest established and best loved of all the botanic gardens, the Royal Botanic Gardens, Kew, is a wonderful home for the Garden Photographer of the Year competition. As the competition develops, it is hoped that other major venues will join with Kew in what is set to become the world's premier garden photography event. For more information on our future plans visit www.igpoty.com

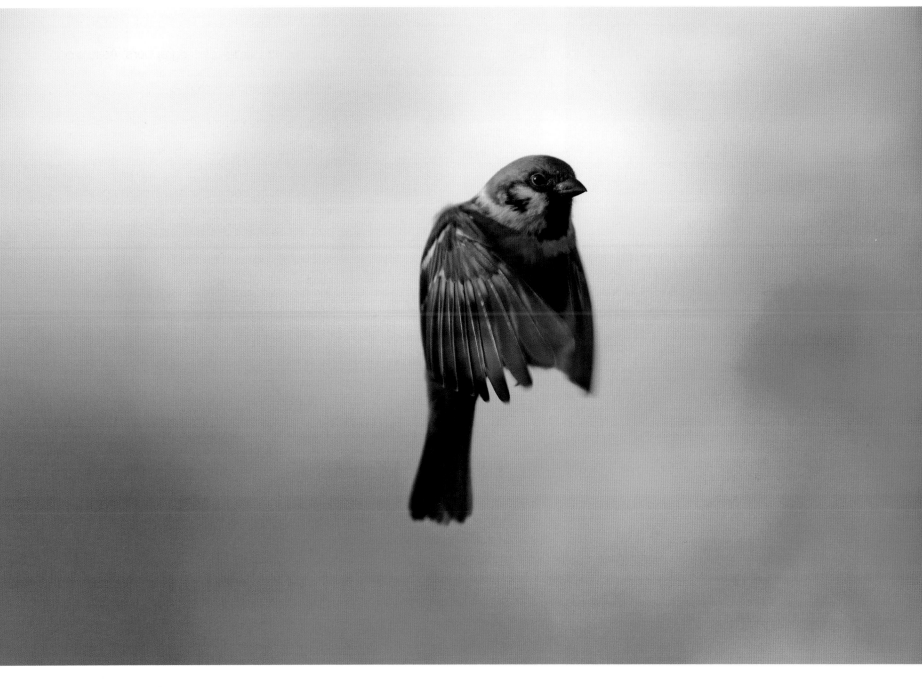

FERGUS GILL (age 15) FINALIST

Hovering tree sparrow.
Perthshire, Scotland.

I am lucky enough to have a flock of 30 or so tree sparrows living in my garden and, on a summer's night, I will fill up the bird feeders after school and try to photograph the sparrows in flight in the beautiful light.

ABOUT US

THE ORGANISERS

Garden Photographer of the Year is run by Garden and Landscape Photographic Arts Ltd, (GALPA Ltd). Philip Smith and Jane Nichols have organised the competition and exhibition, supported by Andrew Lawson and Clive Nichols in non-executive capacities.

PHILIP SMITH

Philip Smith is Managing Director and co-founder of the Garden Photographer of the Year competition and exhibition. Philip trained as a photographer in the late 70s in Nottingham and Bournemouth, but went directly from college into the fast-developing computer software business. During the 80s and 90s he worked as creative director in a pioneering IT company. He later co-founded a company to produce CD ROM based educational products for clients such as Dorling Kindersley and Ordnance Survey. In recent years Philip has returned to his photography roots and created a new career as a professional photographer specialising in plants and gardens. He is passionate about the part that gardens play in the lives of both people and wildlife. He feels that our gardens – big or small – need to be celebrated and that establishing Garden Photographer of the Year as a major public event has helped in that celebration.

JANE NICHOLS

Jane Nichols is Marketing Director and co-founder of Garden Photographer of the Year. Jane trained as a food scientist and spent her early career with the Mars Group of companies, firstly in research and production and then in marketing and business development. As a mother of a young family, she then worked with her husband, Clive Nichols, to establish his career as a flower and garden photographer and to set up his photo library. Always a keen supporter of the photographers in this field, Jane was the founding Chairman of The Garden Photographers' Association. She worked with the many volunteers from the group to create several highly regarded photography exhibitions. Jane believes that the digital revolution in photography has served to make it even more accessible and that flower and garden photography is the perfect tool to inspire everyone to appreciate plants and their place in our lives.

Thanks

The Directors of GALPA Ltd would like to thank the following individuals for their help with the 2008 Garden Photographer of the Year competition: Emma Peios, Derek Harris, Susie Pickering, Jane O'Brien, Glyn Heald, Mary Denton, Gary Rogers, Janine Wookey, Nigel Bellwood, Hagar Lee, Ben Waterson and our wonderful judges and friends at Kew Gardens. They would also like to thank the publishing team at AA Publishing and editorial support team, Eddie Ephraums, Ailsa McWhinnie and Val Bourne and to acknowledge the wealth of support from members of the GPA who laid down the foundations for the annual competitions. Jane would specifically like to thank her long-suffering children, Hazel and Rob, but also Graham Nichols for his unstinting belief and support. Philip thanks his family Eileen, Hannah and Elsie for their constant encouragement and help.

Above all, the whole Garden Photographer of the Year team thanks all the photographers who have entered the competition. Whether selected or not, their photographs have been a joy to review, a privilege to share and an inspiration to all.

The Garden Photographer of the Year team also extends it warmest thanks to all its sponsors, supporters and partners.

In particular, they thank Garpa Garden and Park Furniture for support and inspiration. With an endless passion for the garden, GARPA has supported the Garden Photographers' Association (GPA) photographic exhibition for three years. Now, in 2008, GARPA continues its association with the professionals with the GPA best portfolio award. To find our more about GARPA visit www.garpa.co.uk.

Our sponsors

Our supporters

Our media partners

Prizes

Photographers from all over the world were invited to enter single images or themed portfolios in any of the categories shown on page 12.

When there was unanimous agreement among the panel of eleven judges that the photographs were of superb photographic merit, photographs were classed as **Finalists**.

The Finalists' photographs form the first Garden Photographer of the Year exhibition, shown at the Royal Botanic Gardens, Kew, during the summer of 2008.

As well as selecting an overall winner, the judges selected a first, second and third placed single image from the finalists in each category.

They also selected a first, second and third placed portfolio from any category.

Photographs classed as **Commended** are those, which, the judges agreed, were worthy of high merit, even though some judges may have expressed minor reservations.

The prize fund for Garden Photographer of the Year 2008 exceeded £30,000 worth of cash and vouchers.

Special prizes

Garden Photographers' Association, Best Portfolio:
A separate prize for the best portfolios submitted by its members.
For more information about the Garden Photographers' Association please visit www.gpauk.org.

Young Garden Photographer of the Year:
Open to under 16s only. The judges awarded three prizes: Young Garden Photographer of the Year, Second Place, and Third Place.

THE CATEGORIES

Garden views

Visiting a garden is a great day out for many of us. We can stand and admire the work of gardeners who have dedicated themselves to creating a personal paradise for the enjoyment of themselves and others. Images could be submitted from gardens in any part of the world, from Tokyo to Cape Town, from Glasgow to Melbourne, showing what is special about a particular garden, whether large or small, a chic design statement or a plantsman's paradise.

Life in the garden

Gardens are for enjoyment – even if that enjoyment sometimes means hard work! Kids love to run around, while many of us will enjoy the round of the seasons – sowing, planting, clipping and harvesting. And then of course there's always that day when the garden is just for family and friends – good conversation or just plain relaxation. Our gardens are very much alive even without people. This category is about all the creatures that enjoy the garden, from beetles and butterflies to birds and badgers – as well as the humans!

My garden

We all have our favourite piece of garden heaven, whether it's a window box or a wildflower meadow. This category provided the chance to express what entrants felt about their own garden or local environment. Entrants were encouraged to go out in early morning light, or at the end of the day, to see what magical images they could conjure up. Their space through their eyes.

Plant portraits

Achieving great images of plants and flowers requires skill, passion and commitment. This category celebrates the ephemeral beauty of the plant – from seed to compost. Plant portraiture is all about capturing the very essence, or character, of a plant. This could be a rambling rose or a humble bluebell, an exotic tree peony or the delicate flowerhead of a grass. A single bloom in isolation can be admired for its uniqueness.

Trees

This category celebrates the tree in all its diverse forms. From the gnarled old oak to the mighty redwood, entrants were invited to show how important trees are in our lives and in the health of our planet. Winning images will reveal the treasures of our great world forests as well as the beauty of a solitary tree. How do people and trees live side by side in one world? How does a tree create a sense of well-being?

Young Garden Photographer of the Year

Under 16s were invited to enter single images into any of the above categories.

THE JUDGES

Chris Beardshaw
Award winning garden designer

Andrew Lawson
Garden photographer

Clive Nichols
Garden photographer

With four RHS Gold Medals to his name and with his ever increasing popularity, he has now received the 'People's Choice' Award at the Chelsea Flower Show for two years running.

As an accomplished author, Chris has written two books – *The Natural Gardener* and *How Does Your Garden Grow?*, and he is a regular columnist for the *Daily Mail* and *Period House* magazine. Central to much of his work is his desire to extend his knowledge to a wider audience with his lectures and talks around the country. Plus with a unique ability to capture the imagination of today's children and keen to promote horticulture to all, Chris strives to develop school projects and continues to devote time to a number of charities such as The Woodland Trust, RSPB, RNLI, the Salvation Army and the Environment Agency. With continued success, Chris's TV shows are going from strength to strength with the captivating and informative series *The Great Garden Detectives*.

Andrew is a well-known and highly respected garden photographer whose pictures have been reproduced extensively in books and magazines worldwide. Andrew is a keen gardener himself and his pictures are informed by a deep knowledge of the subject. He wrote and illustrated *The Gardener's Book of Colour* published by Frances Lincoln, and he has provided pictures for numerous books including those written by Rosemary Verey, Penelope Hobhouse, Sir Roy Strong and HRH The Prince of Wales.

Clive is one of the world's most successful flower and garden photographers. He has won many awards for his work, which appears in countless magazines, books and calendars throughout the world. He is in constant demand as a lecturer and teacher, running workshops for many clients, including the Royal Botanic Gardens, Kew and the Royal Horticultural Society. He has appeared on British and Japanese TV and sits on the RHS Photographic Committee. His most recent book is *The Art of Flower & Garden Photography*, which was published in association with the Royal Horticultural Society, by Argentum.

THE JUDGES

Eddie Ephraums
Publishing consultant and commissioning editor of photography books

Eddie is a well-known black and white landscape photographer, author and independent publisher of limited edition photography books. He is also Argentum's consultant commissioning editor, helping to conceive such books as Joe Cornish's *First Light* and a wide variety of other inspirational titles. Through his own publishing consultancy, Envisage Books, he works with photographers and visual artists, to help them translate their ideas into outstanding published works. Pursuing his belief that everyone can make a book, he recently devised the *What's Your Book?* competition.

Laura Giuffrida
Exhibitions and Galleries Leader, the Royal Botanic Gardens, Kew

With a background in art and design including photography, Laura has spent much of her career working at Kew Gardens where her main responsibility has been the management of Kew's exhibition programme. Examples include the development of the *Plants+People* exhibition, and the Orange Room at the Millennium Seed Bank, Wakehurst Place. She is also responsible for delivering temporary exhibitions at both sites, these include *Gardens of Glass – Chihuly at Kew*, and the co-curation of *Moore at Kew*.

Janine Wookey
Editor The English Garden magazine

Janine has worked for *The English Garden* magazine for the past ten years and became editor in 2004. Her knowledge of gardening has been learnt on the job, benefiting from the writing and photography of some of the best people about in the business. It was just ten years ago that she discovered the joys of gardening in that classic mid-life now-for-something-different way.
Her previous journalistic experiences were based in the UK and Asia on regional newspapers and in the travel industry.
Her first serious attempt with photography was in Tibet in 1980, as one of the first few journalists to be invited in after the thaw following the Chinese takeover, and she has been enthusiastic about it ever since.

As Janine is constantly reviewing features for *The English Garden*, she is Guest Judge for the Portfolios entered into the competition.

Gordon Rae
Chairman of the RHS Photographic Committee

Gordon is a temperate and tropical agriculturalist by training. He became interested in plant photography whilst travelling extensively during his 28-year career with ICI. On leaving ICI, he became Director General of the Royal Horticultural Society (RHS) and there encouraged, developed and judged the RHS Photographic Competition. He has a particular interest in macro photography, especially the alpines of the European Alps. As a keen and active gardener with extensive photographic experience, Gordon is perfectly placed to be Guest Judge for both the Plant Portrait and Portfolio sections of the competition.

Tony Kirkham

Head of Arboretum and Horticultural Services at the Royal Botanic Gardens, Kew

With his roots firmly in the world of trees, Tony is now Head of Arboretum and Horticultural Services at the Royal Botanic Gardens, Kew, where he looks after an amazing 14,000 specimens.

Author and editor of countless publications on the subject of trees, Tony is also the presenter of the acclaimed BBC series, *The Trees that Made Britain*. He has just finished filming the second series, which will be screened in 2008. With this wealth of experience, he is ideally placed to be our Guest Judge for the Trees category.

Iben Lund Gladman

GAP Photos Ltd

Iben has worked in the specialist stock industry for 15 years, editing and promoting garden and plant photography worldwide. Her agency, GAP Photos Ltd, represents many of the world's best-known garden photographers.

Known for her great love of the subject matter and her eye for quality, Iben is ideally placed to judge Young Garden Photographer of the Year.

Chris Collins

Blue Peter gardener and leading horticulturist

Chris's in-depth knowledge and enthusiasm has always set him apart from the crowd, whilst his cheeky persona simply exudes the passion, that has shaped his life. Chris says "The beauty of gardening is that it's a game of continual discovery. You could live ten life times and still keep coming across new plants."

Chris is a unique character. Not only does he have green fingers but green blood too. He has a deep love of the outdoors and is hugely passionate about environmental issues, which make listening to and watching him compelling. He is the perfect personality to take gardening into the future. As the BBC's '*Blue Peter* gardener' he is perfect for the role of Guest Judge for the Young Garden Photographer of the Year.

David Watchus

AA Publishing Publisher

David took over as Publisher at the AA at the beginning of 2006 having worked in a variety of roles within the business. His vision is to build on AA Publishing's strong base in travel, lifestyle and map and atlas publishing, in which areas the AA has many market-leading titles, while increasing the presence of the AA in the wider illustrated reference market.

David's involvement in *Garden Photographer of the Year* is core to this vision and is also indicative of the quality of both production ideals and editorial integrity that is the cornerstone of what we are setting out to do at AA Publishing.

THREE PERSPECTIVES

JUDGE'S PERSPECTIVE

As a Garden Photographer of the Year judge you look at several thousand shortlisted images. All the time you're on the look-out for that special picture – that extra bit different. Certain photographs stand out and you put them on the short-list for the group judging. This is when the judges meet, compare notes and the wrangling begins. Each of us promotes his or her favourites and we are all prepared to be convinced. It is reassuring how this process distils into the final picture choice – the best pictures consistently come out of it.

The standard of entries was incredibly high, and sometimes there was only a whisker between a picture that was shortlisted and one that was not. We tried to take account of the fact that a simple graphic image, like a plant close-up, may look striking as a judge's small preview image on a monitor, but a complex garden picture has a slower fuse and may only reveal its depth when enlarged to full screen size. It is a fact of life that when you enter this competition – and I hope you will – your picture first has to attract the judge's eye and then it must pack a bigger punch when enlarged. I would say that all our winners have this quality.

Andrew Lawson

Judge's favourite: *New play* (page 69) by Suna Aktas
I admire this picture enormously because I know how difficult it is to achieve. There's so much going on and so much mystery. The children's expressions of surprise are convincing and so is the snowy garden reflected in the window. But why was the photographer in exactly the right position – at the key moment – and how about those cracks in the glass?

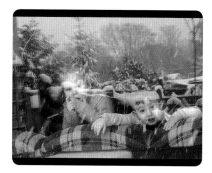

PHOTOGRAPHER'S PERSPECTIVE

The desire to capture the transient beauty and character of flowers and gardens, with a film or digital camera, is a challenge which has eluded many people over the years. I have spent the last 15 years as a professional trying to do just that. What I have learnt is that to get a great flower or garden photograph requires planning, commitment and considerable technical skill. And, quite simply, you have to learn to be in the right place at the right time. I have lost count of the number of occasions I have woken up at 3am, to get to a garden for dawn, only to be disappointed when a large cloud that wasn't meant to be there was obscuring the rising sun!

Looking through the images in this book, it is pleasing for me to see the huge effort, technique and passion that has gone into the shots, whether they be of people, animals, insects, flowers, trees or borders. Most pleasing of all is the quality of work being produced by young photographers around the world. In their hands, garden and flower imagery will continue to improve and the Garden Photographer of The Year competition is a great way to share this wonderful imagery.

Clive Nichols

EDITORIAL PERSPECTIVE

What do we see when we look at this book or the associated exhibition – a collection of beautiful pictures, or is there more to discover?

Like a good photograph, for a book or exhibition to succeed it must possess a quality that exceeds the sum of its component parts. It must communicate something else, but what and how? Something *else* can be hard to define; art is open to interpretation, but works best – and our appreciation of it grows – when it is accessible and we can figure it out for ourselves. For example, at the Henry Moore at Kew exhibition in 2007–2008, maquettes and tools gave tantalising insights into his craft, but it was through looking at the artist's box of very sculptural-looking flint stones that something else could be discovered: Moore's art was to be a conduit for nature, too.

I like to think that this book and the associated exhibition are conduits, also. But, how do they convey that vital something else? One way is through picture layout. As the book's designer happened to say (almost without thought, like an artist might pick up flints), "I work with what I am given and simply respond to it". I wonder what your response will be to the images, to the way they are laid out, and what else you might see looking at the image combinations? And if this inspires you to discover something 'Moore', how about picking up a camera and taking part in the next competition? Who knows what else the judges might discover looking at your pictures?

Eddie Ephraums

Judge's favourite: *Marguerites in rain* (pages 108–109) by Chinch Gryniewicz Photographing plants in sunshine is hard enough, but to photograph them in heavy rain is something else. This shot works so well because the photographer has chosen the perfect shutter speed, to freeze the movement of the raindrops, at the same time taking advantage of the brilliant light that often comes with a heavy rainstorm.

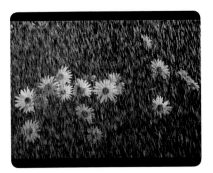

Judge's favourite: *Yuyuan gardens, Shanghai, China* (pages 62–63) by Victor Korchenko Working in visual-based books, I am always attracted to narrative images, or sets of images, and ones that don't try to tell a complete story. I liken books and pictures to the start of a conversation that invites the viewer to join in and help complete the picture. The Yuyuan portfolio does this for me. It's an invitation to be there, in China, with the photographer, to look through his lens and to discover for myself the pictures therein.

GARDEN
PHOTOGRAPHER OF THE YEAR

GARDEN VIEWS

JUDGE'S CHOICE

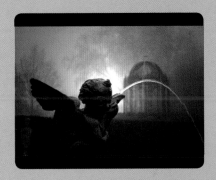

JAKUB GWALBERT FIGURA

SECRET

This is a beautifully executed photograph, with an unusual but very effective composition that shows real depth. It's a deceptive photograph in that it looks quite simple, but would have been very difficult to achieve – and it has a sense of humour!

Chris Beardshaw

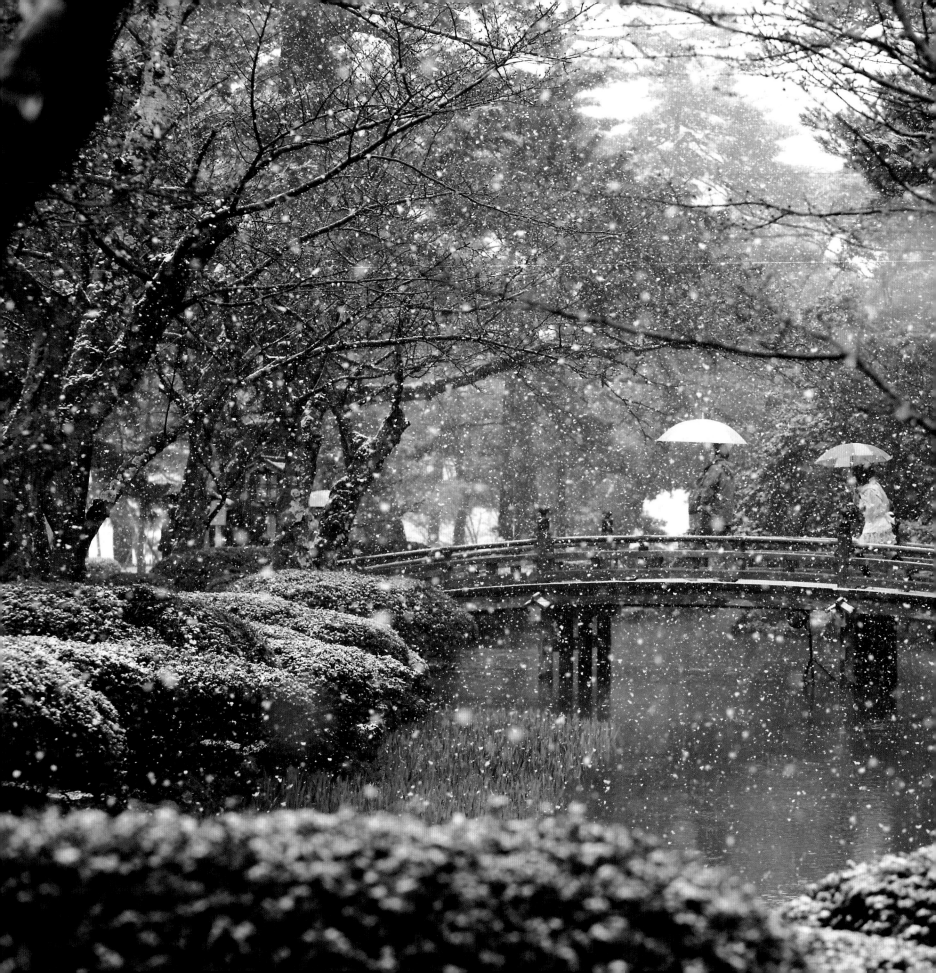

GARDEN PHOTOGRAPHER OF THE YEAR

OVERALL WINNER

CLAIRE TAKACS FIRST

Kenrokuen.
Kanazawa, Japan.

I went to Japan specifically to photograph the gardens during cherry blossom season. Visiting Kenrokuen while it was snowing was like being in a painting, but the visitors weren't deterred by it. It was such a sight to see the colourful umbrellas passing through the gardens and over the bridges, and definitely added a whole new dimension to the visit.

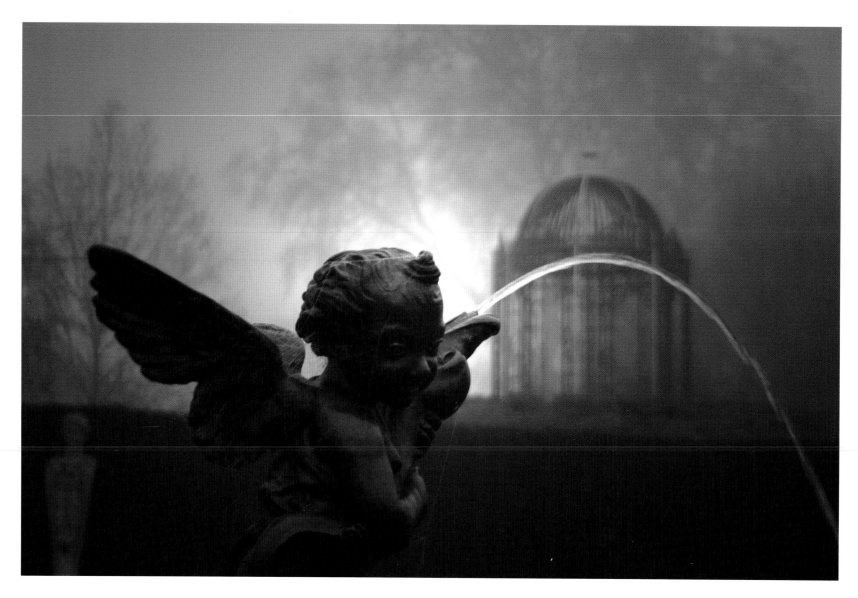

✝ JAKUB GWALBERT FIGURA SECOND

Secret.
The Queen's Garden, the Royal Botanic Gardens, Kew, England.

The unique character of this photograph was created by the extraordinary weather
conditions of fog, light and cloud – there's a sense of mystery emerging from the
morning mist.

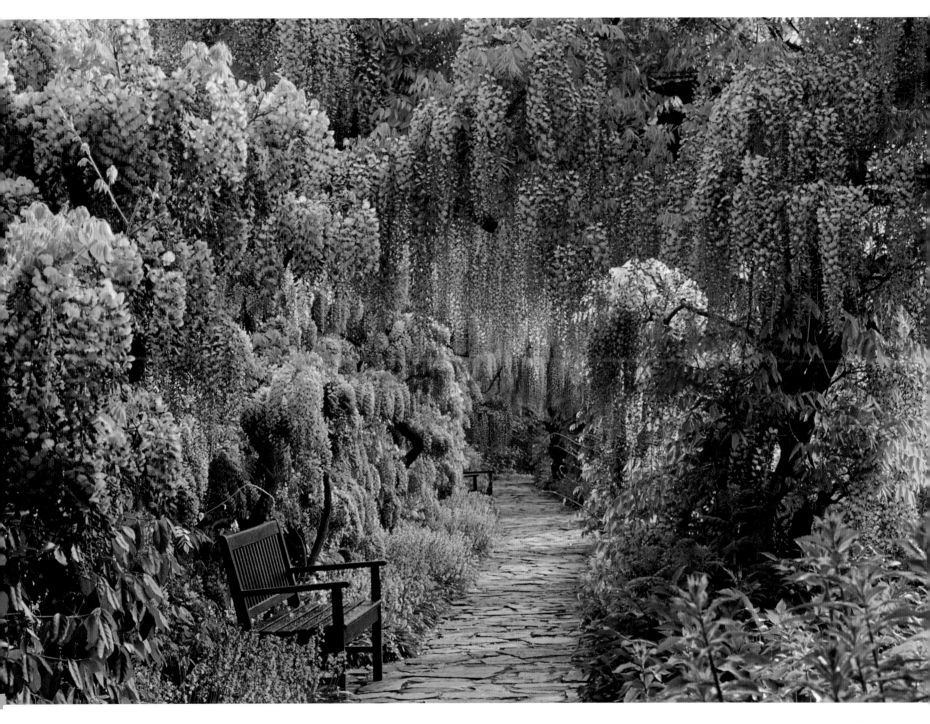

JERRY HARPUR <small>THIRD</small>

Wisteria walk.
(*Wisteria floribunda* 'Macrobotrys'). Hermannshof, Germany.

It was a softly sunny May afternoon – one of those magical times that occur only two or
three times a year – and the blossom was 'au point'. The light and shade provided so many
different tones, so much depth, all that was needed was to find the best views.

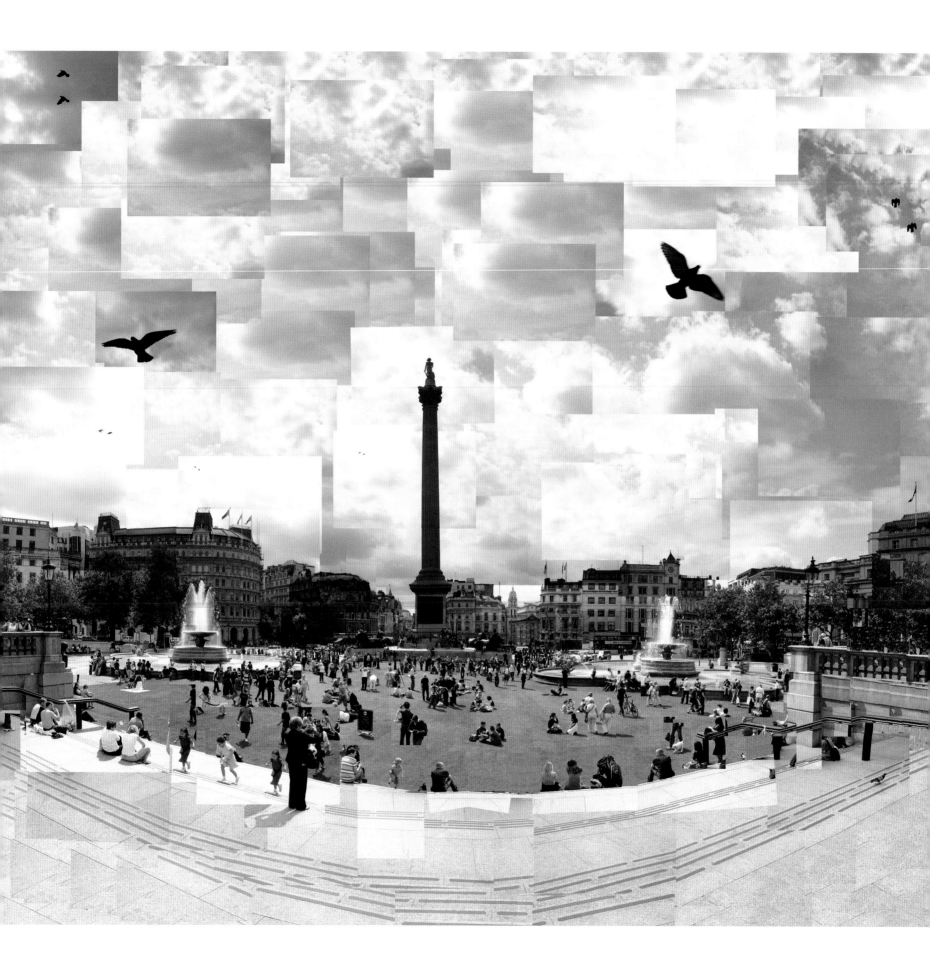

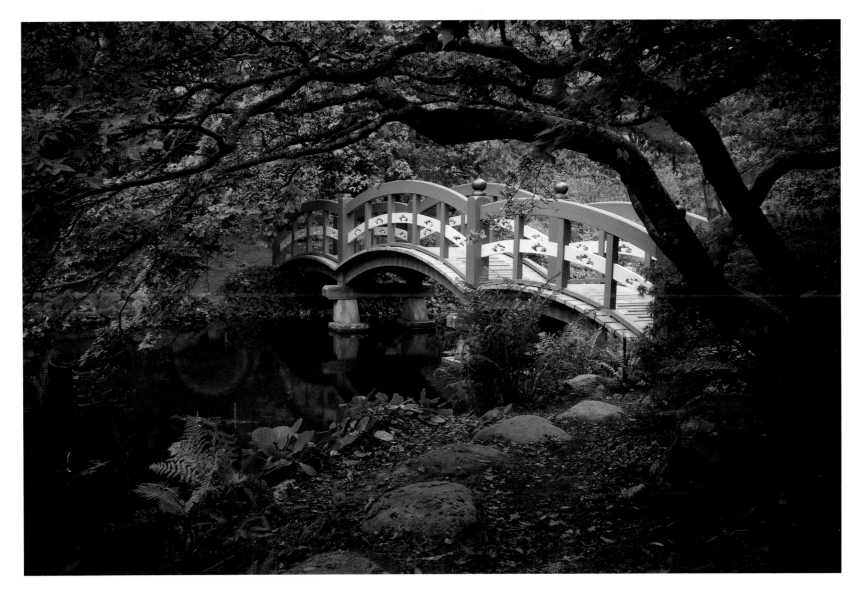

PAUL DEBOIS

City garden.
Trafalgar Square, London, England.

This montage, consisting of 291 photographs, shows Trafalgar Square while it was covered in lawn to promote green spaces in the city. The square was so crowded that the only way of capturing the atmosphere was to photograph individual elements to assemble later. I felt it couldn't be done with one single image, and I wanted to create an impression of what it was like to be there, rather than a clinical representation of the subject.

DAVID BALLANTYNE

Japanese bridge and maple.
Hatley Park, British Columbia, Canada.

I live in a very short growing-season area at a high elevation and this was my first visit to the west coast in the autumn. I was astounded by the colours on this damp and misty day.

ROB WHITWORTH

Broughton Grange, Oxfordshire, England.
Designer: Tom Stuart-Smith

This series was taken one magical autumn morning, during a
hard frost. As dawn broke, the sun filtered through the trees,
accentuating the form and stature of the seed heads and grasses.
The mist rising across the valley below completed the scene.

Hasselblad XPan II, 45mm lens, f/22, Velvia 50
Panoramic is my favourite format for garden photography. I can
achieve a great sweep of drama that enables each element of the
garden to be set in context.

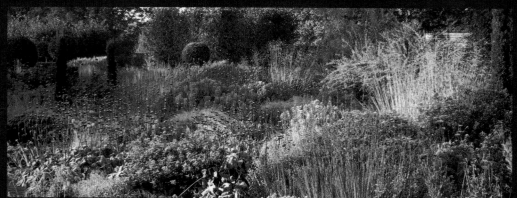

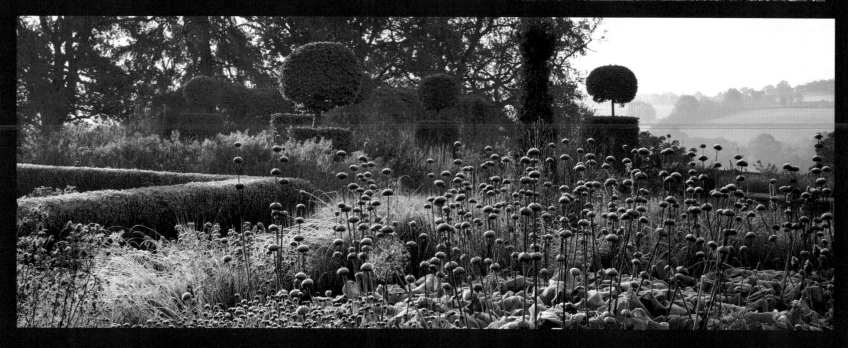

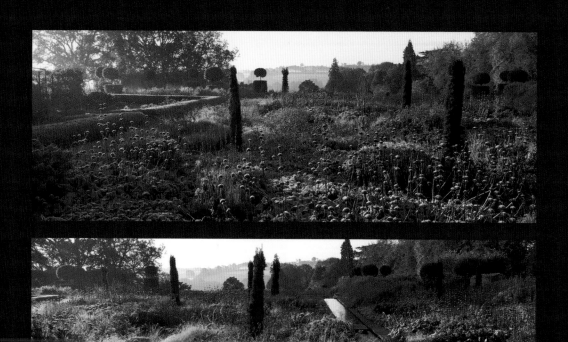

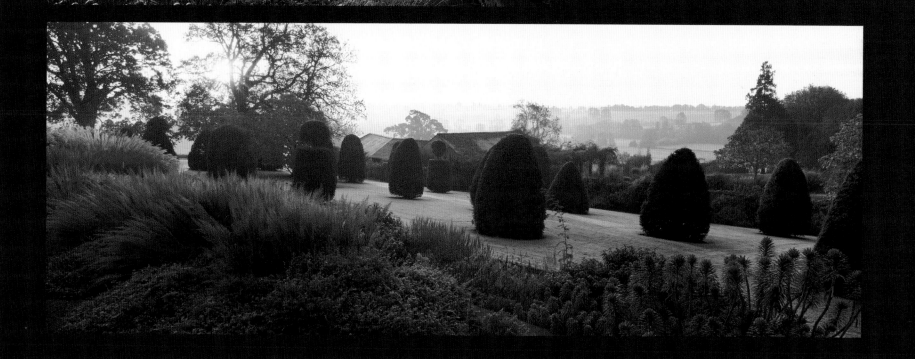

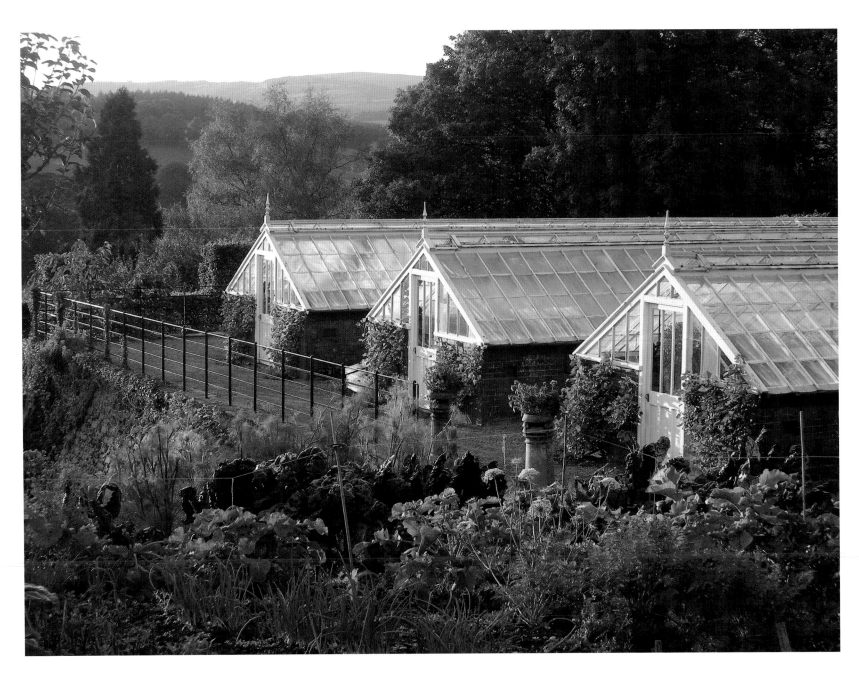

⚘ MATTHEW BULLEN ⤳ COMMENDED

Kitchen garden glasshouses.
Chatsworth, Derbyshire, England.

I noticed that the warm evening light on the freshly painted glasshouses in the kitchen
garden at Chatsworth complemented the array of different vegetables outside, in the raised
bed. The glasshouses are used to grow melons and tomatoes, as well as winter vegetables
and flowers.

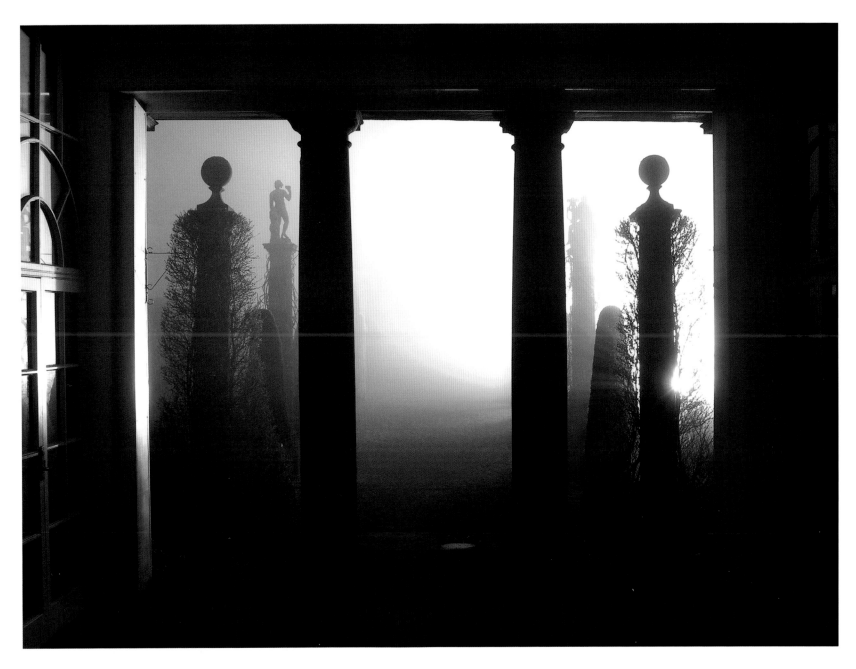

The Orangery.
Chatsworth, Derbyshire, England.

This is the view out onto the Rose Garden from the centre of the first Duke of Devonshire's greenhouse. Built in the 1760s, it now houses a large collection of camellias. I wanted to capture the light from behind the pillar, the fog and the way in which the building framed the composition.

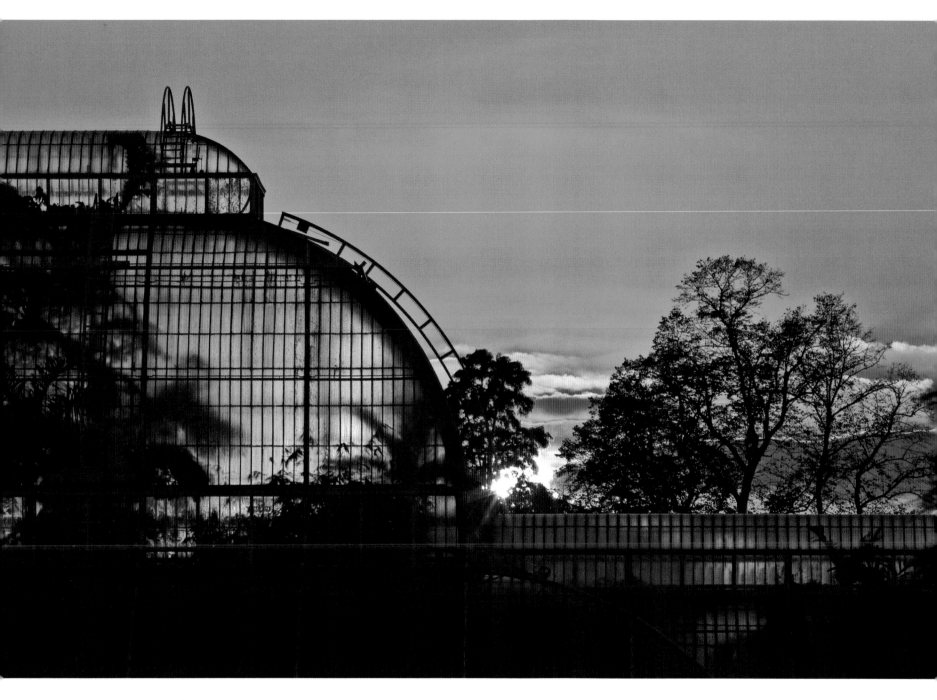

🌿 JOHN SWITHINBANK Commended

Palm House sunset.
The Royal Botanic Gardens, Kew, England.

It was a wonderfully still autumnal day at Kew. I've known the Palm House since I was a student in 1975 but had never captured a decent sunset shot of it. I had a feeling that this could be the day – and also the shot of the day – so I just went for it.

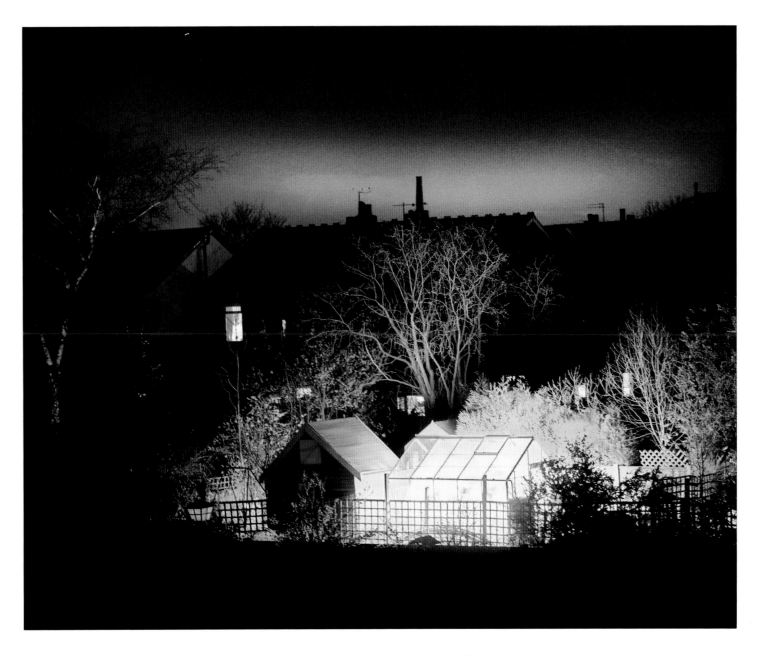

JILL JENNINGS

The night gardener.
The Heatons, Stockport, England.

I was curious when I observed the greenhouse that glowed from dawn to dusk in the garden
at the end of my road; I could see it from my bathroom window and it puzzled me for ages.
It turns out that during winter my neighbour, Martin, force grows onions under a 600-watt
daylight bulb. I like photographs that reveal unusual moments in everyday life, and there is
an element of intrigue in this one.

JONATHAN BUCKLEY COMMENDED

Sissinghurst at dawn.
Sissinghurst Castle, Kent, England.
By kind permission of the National Trust.
www.nationaltrust.org.uk

For me, the most exciting photography is that which captures the
essence of one moment in one place. There is no more exciting
time than dawn, and no more magical place to be than Sissinghurst
in spring. The light changes very quickly at dawn so, although the
pictures look tranquil, there was actually a lot of running going on in
order to be at the right place at the right moment – including racing
up the stairs to the top of the tower!

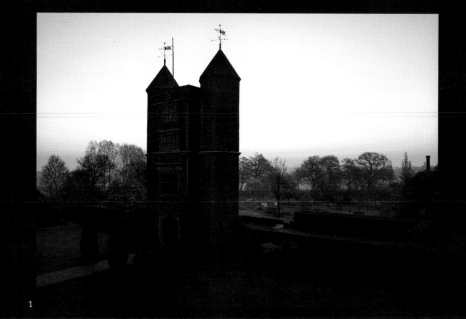

1

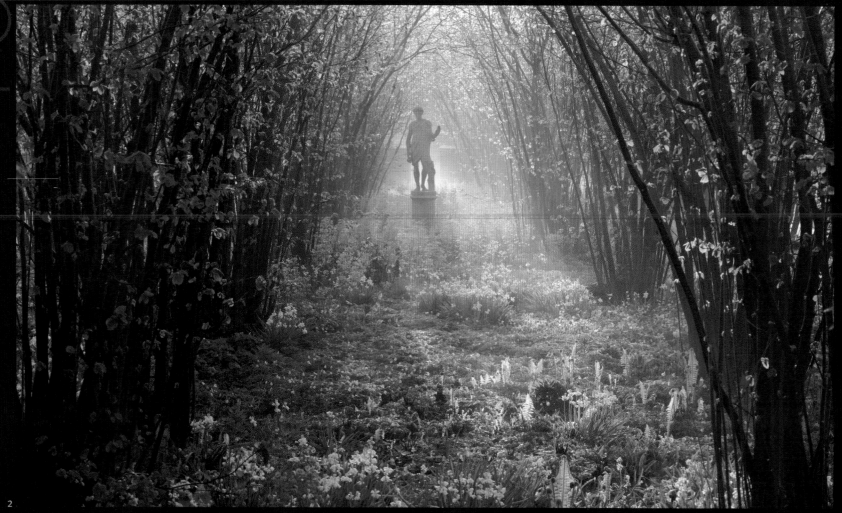

2

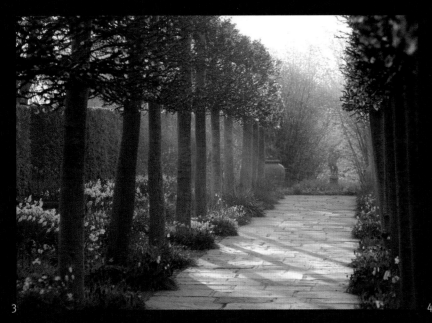

3

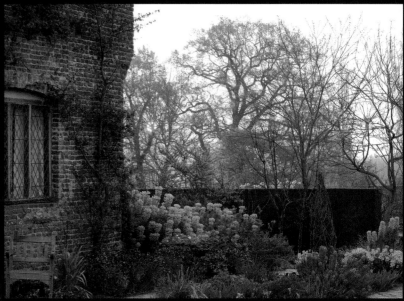

4

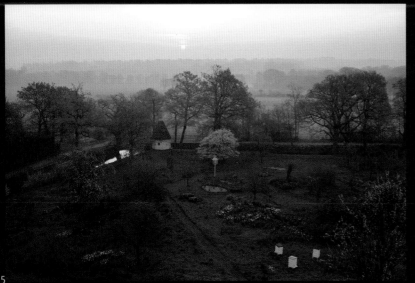

5

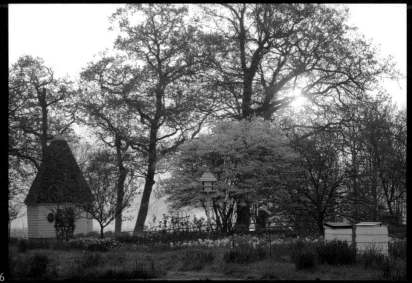

6

Canon EOS 5D

Several decisions were made at the digital-processing stage, such as deliberately letting the tower go very dark to enhance the sense of noble mystery and the feeling of expectancy of the new day.

1–The Tower
2–Statue of Dionysus in the Nuttery
3–The Spring Walk
4–Wallflowers and euphorbia in the Cottage Garden
5–View from the Tower across the Orchard
6–The Orchard

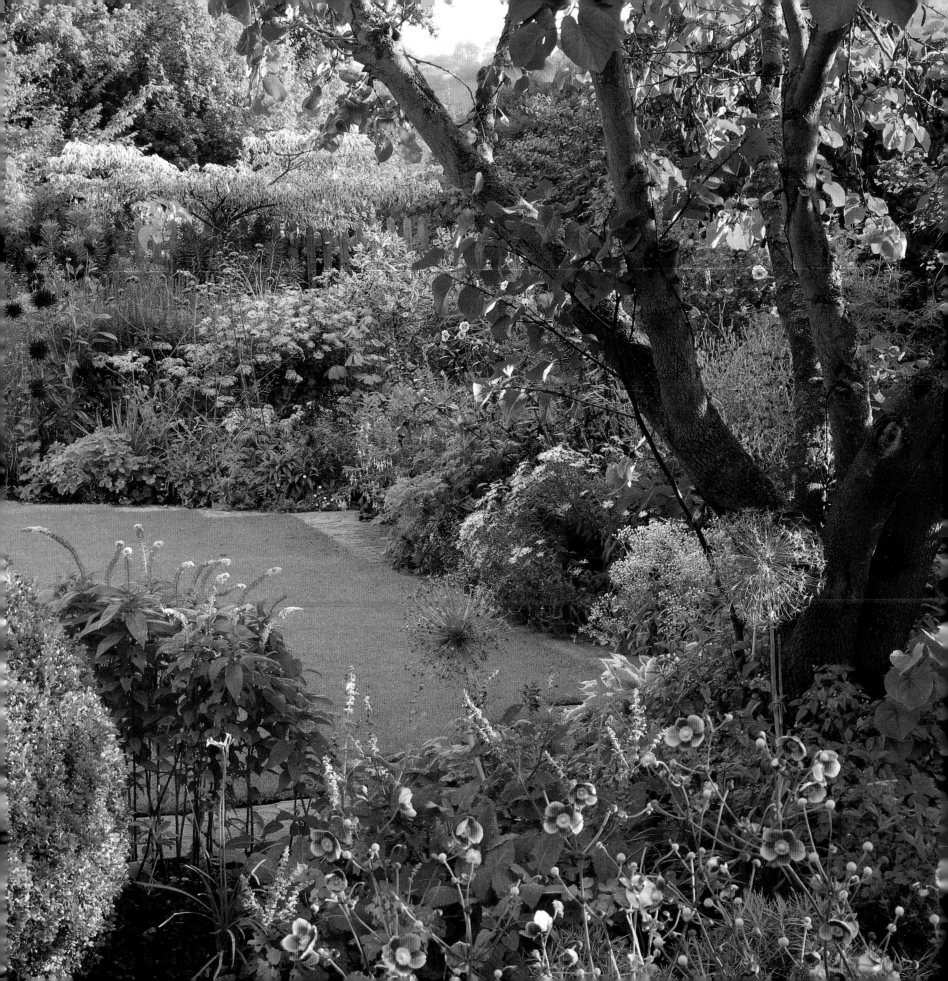

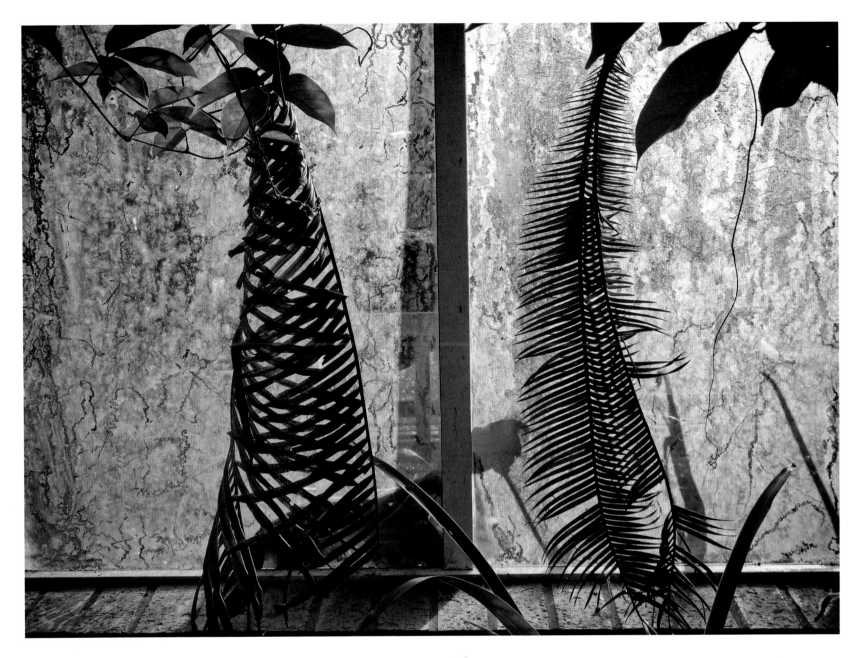

⚘ NICOLA STOCKEN TOMKINS FINALIST

Autumn profusion.
(Mixed borders with *Anemone hupehensis* 'Hadspen Abundance'.)
Woodbury Cottage, Reigate, Surrey, England.

As the shadow from Colley Hill recedes, an ascending sun softly brushes the Japanese
anemones and dogwood without detracting from the brimming borders in between.
My inspiration came from a combination of the South Downs backdrop, masterful planting
and the garden's owner, Shirley Stoneley, for the joy she derives from the garden she has
created over the past 20 years. If ever a garden was a reflection of its owner, this is it.

⚜ DAMIAN GILLIE FINALIST

Dried cycad leaves.
Cambridge University Botanic Garden, Cambridge, England.

While exploring the wet tropical house at the Botanic Garden in Cambridge I came across
these extraordinary withered cycads, hanging in front of the steamed-up windowpane.
Like two very different personalities, one appears to be closing in on itself while the other
reaches out to touch the surrounding foliage. Cycads are believed to be the most primitive
living seed plants, dating back more than 300 million years.

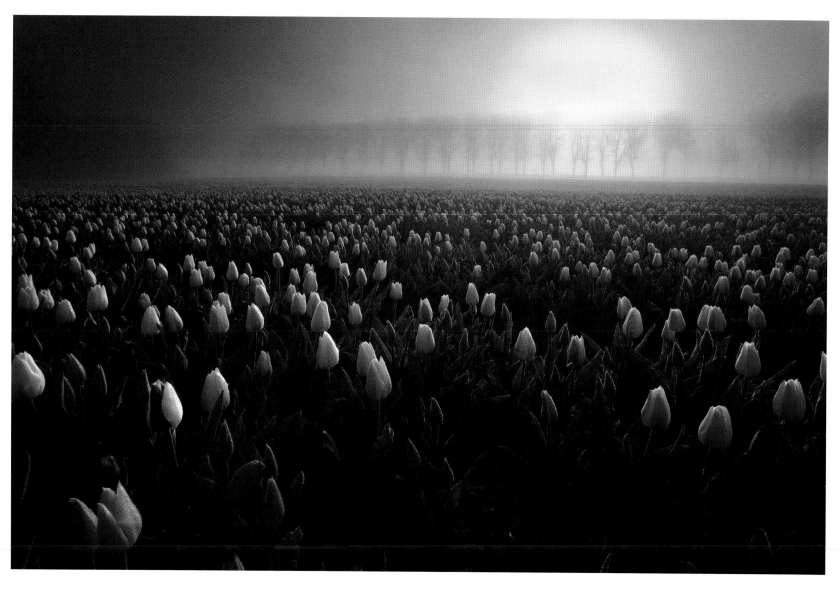

MACIEJ DUCZYNSKI FINALIST

ALLAN POLLOK-MORRIS ···⟩ FINALIST

The One.
Amsterdam, The Netherlands.

Searchlight 2.
Little Sparta, Dunsyre, Scotland.

Tulip fields are the first thing you notice on arrival in The Netherlands during spring.
I had tried to photograph this subject many times, but only this picture came together in
the way I wanted. The low, early morning light enhanced the atmosphere.

The artist Ian Hamilton Finlay had invited me to photograph his garden at night, so, as
a small tribute after his death in 2006, I made a set of night images at his garden, Little
Sparta. This sculpture is symbolic of the garden, and already well photographed, but I
wanted to bring my own angle to the subject.

JERRY HARPUR COMMENDED

Aspects of Design.

Garden design is, surely, the most varied of all the arts: the work of British landscape architects is among the most inspirational, and is frequently illustrated in books and magazines. Here is an eclectic selection of the work of six international designers whose work I enjoy photographing – interpreting their philosophy according to the brief and the surrounding atmosphere.

Nikon F3, Nikkor 28mm and 35mm lenses, f/22, polariser and neutral density filters for some images, Velvia film.
I like to try several different angles, in different lights, to describe the use of different materials and plants. Often this means working as fast as possible to catch the best of the light.

Photographs reproduced by kind permission of Mitchell Beazley, the publishers of Jerry Harpur's book *Gardens in Perspective*

1–A castle garden in Belgium by Jacques Wirtz
2–The stone garden at Chaumont-sur-Loire, France, by Peter Latz
3–Daniels garden in Tucson, Arizona, USA, designed by Steve Martino
4–The Red Garden, Sydney, NSW, Australia, by Vladimir Sitta
5–Gilberto Strunck's garden in Brazil by Roberto Burle Marx
6–Wij Gardens, Ockelbo, Sweden, Ulf Nordfjell

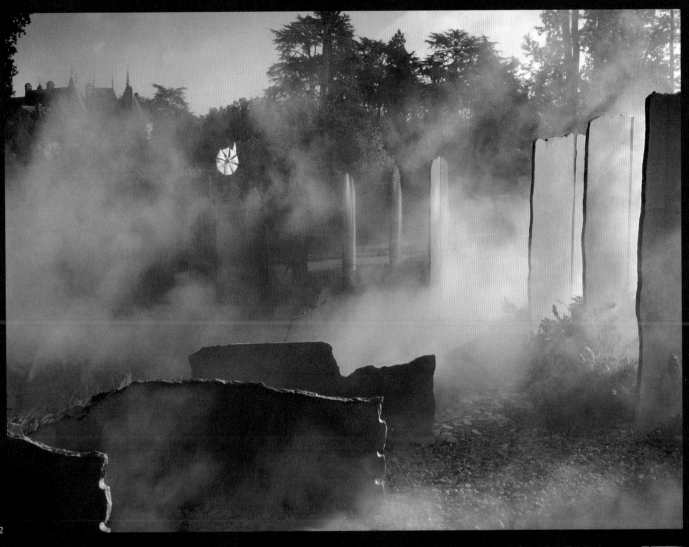

2

3 4 5 6

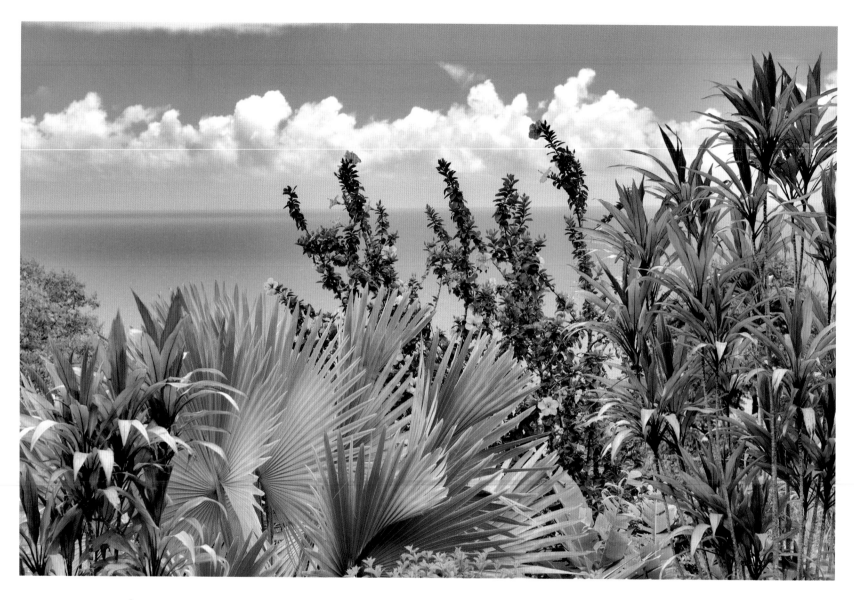

🌴 DENNIS FRATES 🌴 COMMENDED

Ocean view garden.
(*Trachycarpus fortunei*). Garden of Eden Botanical Gardens, Hawaii,
USA.

I love the textures of tropical plants. In this picture, the hibiscus flowers are the focal
point, and I was also attracted by the full spectrum of red, green and blue – a powerful
compositional element.

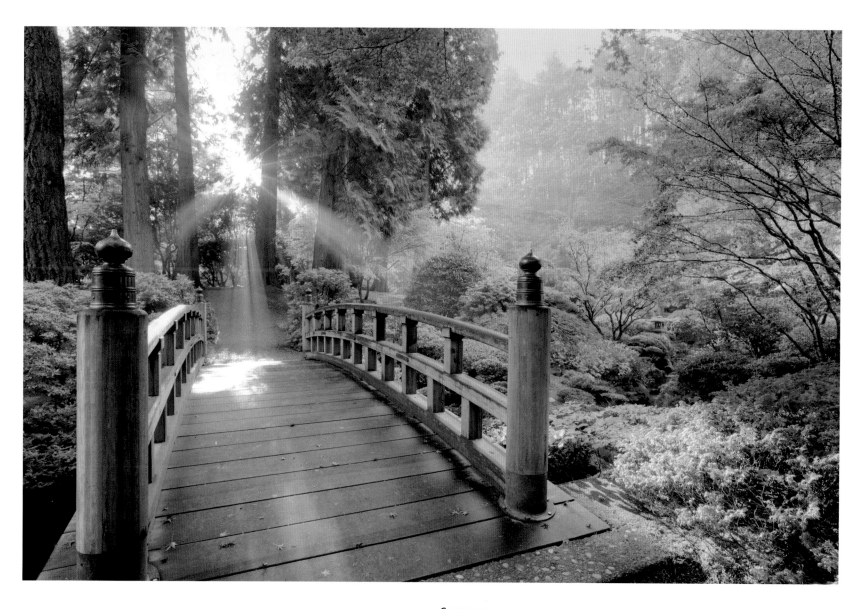

Garden bridge.
Portland Japanese Garden, Oregon, USA.

I have photographed this composition many times, but the combination of autumn colour,
fog and sunrays made it unique.

COLIN HOSKINS ⋯⋰⁞ COMMENDED

An English Country Garden.
Montacute House near Yeovil, Somerset, England.
By kind permission of the National Trust. www.nationaltrust.org.uk

I have spent several years experimenting with infrared film, and in this case knew that the topiary and leaves would appear as if covered with snow, despite it being summer. The shapes created by the topiary, the weather conditions and the position of the sun were all favourable for the technique I used.

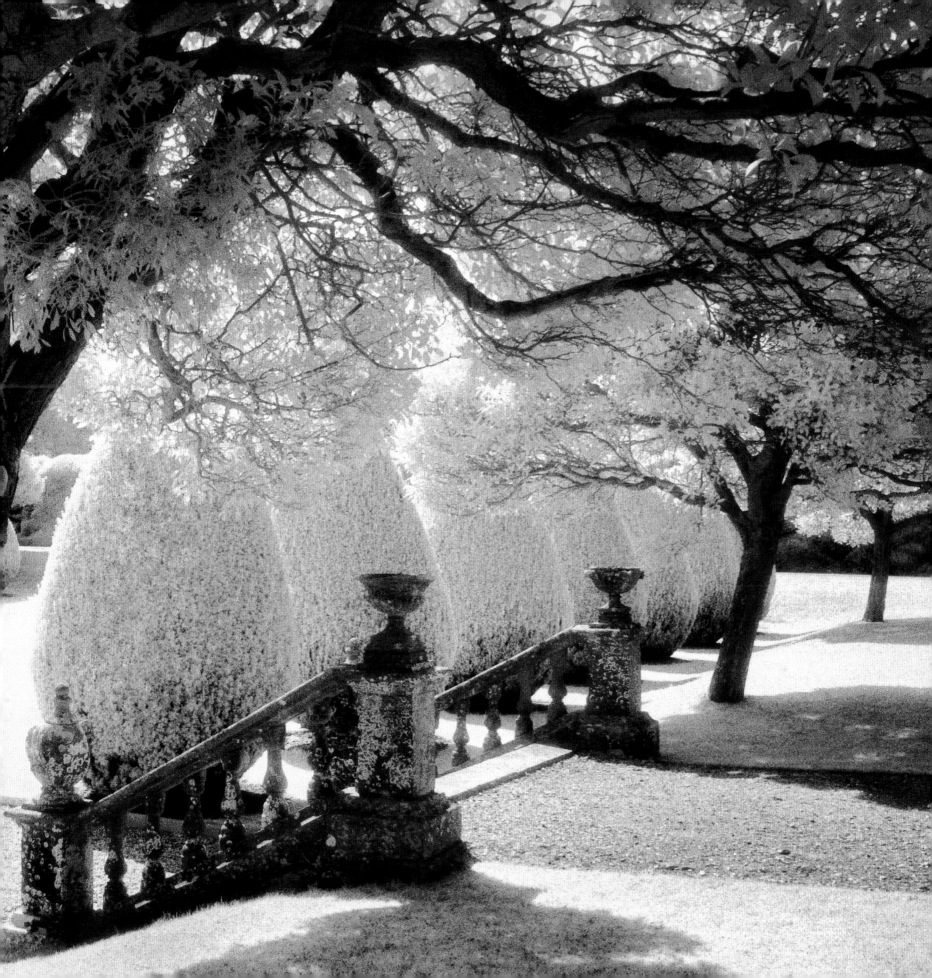

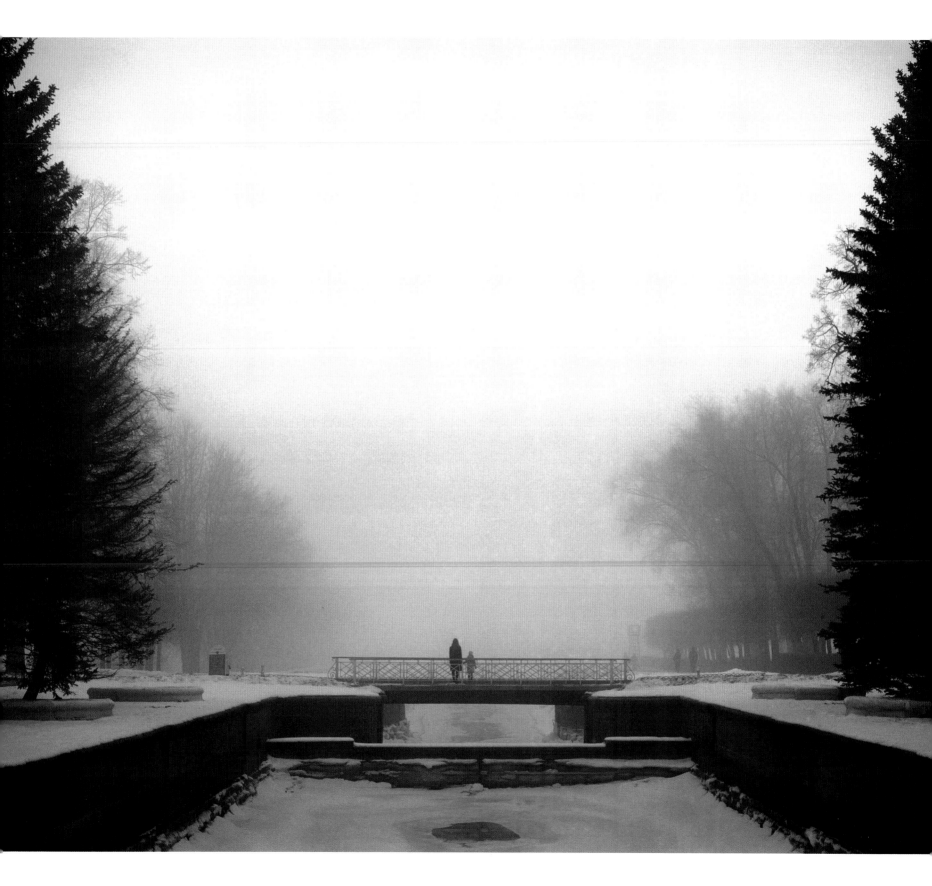

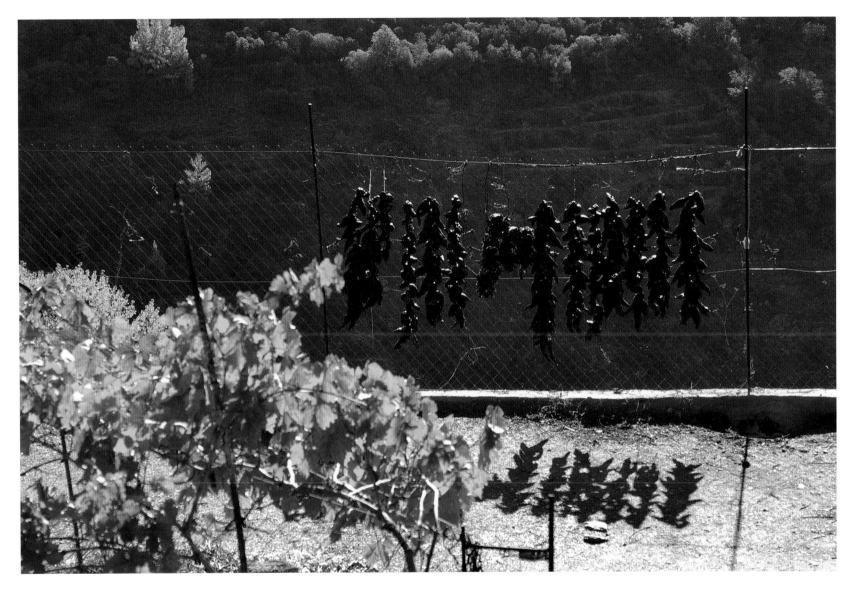

KATYA EVDOKIMOVA COMMENDED

Fog in Peterhof.
Public gardens, Peterhof, Russia.

I knew the gardens in Peterhof to be beautiful in summer, but was intrigued to see what they would look like in winter, so I went along despite the dire conditions. There was fog, and very few visitors, so the mother and child on the bridge added that little extra special something.

PAUL HORRELL COMMENDED

Chillies.
Trevelez, Sierra Nevada, Spain.

The light streaming through the chillies, which I spotted drying in a small garden in rural Andalucia, created the vivid colours in this scene. The yellowing vine leaves in the foreground were set off by the dark wooded shadowed background.

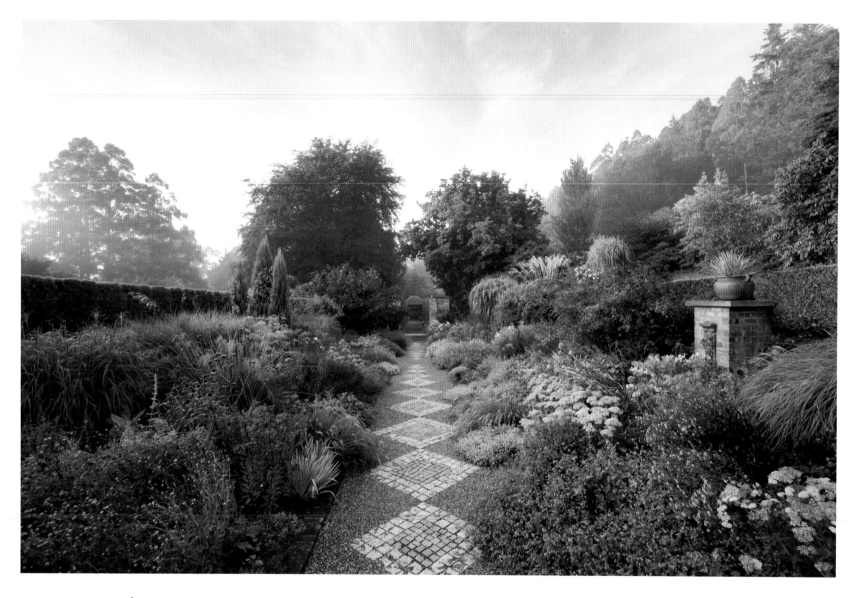

FINALIST

Sunrise at Cloudehill 1.
Cloudehill Gardens, Olinda, Victoria, Australia.

Thanks to being allowed access by the owner, Jeremy Francis, I have visited and
photographed Cloudehill Gardens many times in the past three years. Early morning light is
always the most beautiful, when you also have the gardens to yourself. I am always hoping
for fleeting moments, as caught in this photograph, when the garden truly shines.

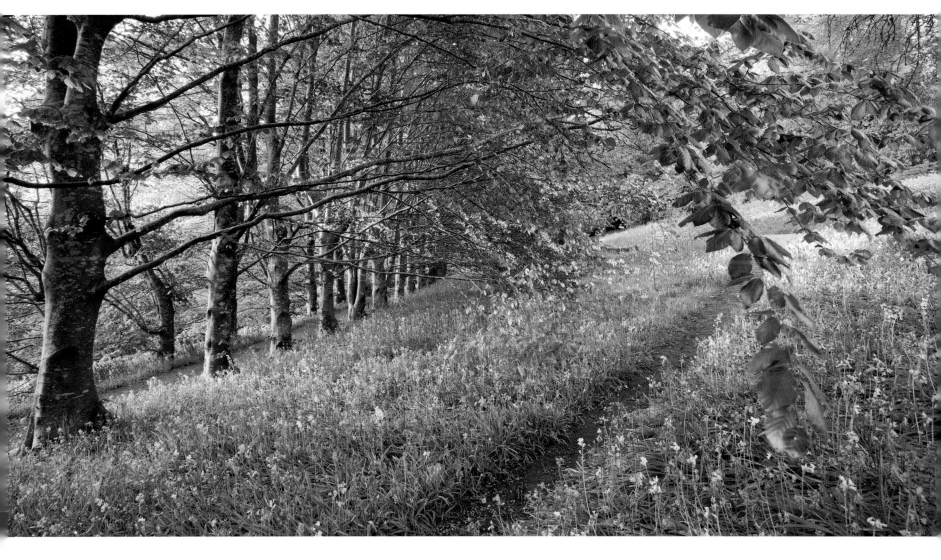

Sunrise at Cloudehill 2.
Copper beech (*Fagus sylvatica* 'Atropurpurea') and bluebells.

MARIANNE MAJERUS

Frosty garden. Private garden, Luxembourg.

It was a magical frosty morning in a garden designed by Piet Oudolf,
with the temperature hovering at around -10°C. The hoarfrost
that resulted transformed a dead garden in the grip of winter into
something out of this world.

Leica R9, 50-100mm lens, Velvia 50

It was necessary to proceed strategically so as to avoid leaving
footprints in the snow or damaging the delicate crystals clinging
to the stems. Speed was of the essence if I was to catch the
ephemeral moment.

1 –View towards house with *Thalictrum rochebruneanum* and
Echinops exaltatus seed heads
2 –Frosted seed heads of *Echinacea purpurea* 'Rubinglow'
3 –Mixed, frosted border including *Thalictrum rochebruneanum*
4 –Frosted *Thalictrum rochebruneanum*
5 –Path surrounded by frosted sedums, phlomis and grasses
6 –Mixed, frosted border including *Thalictrum rochebruneanum*

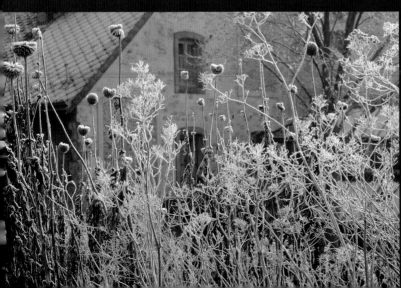

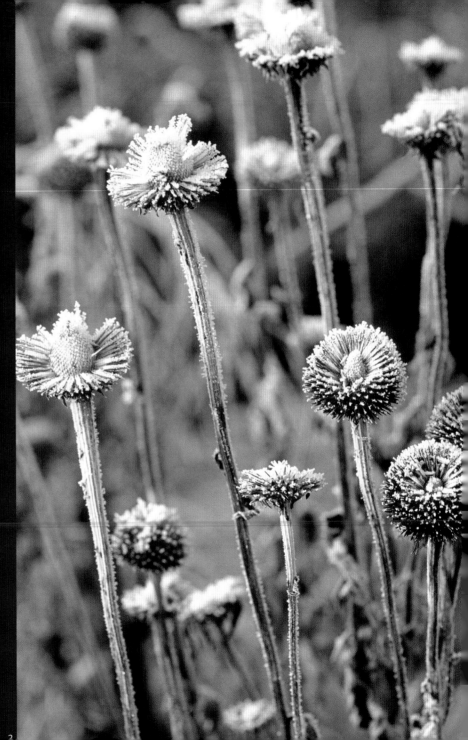

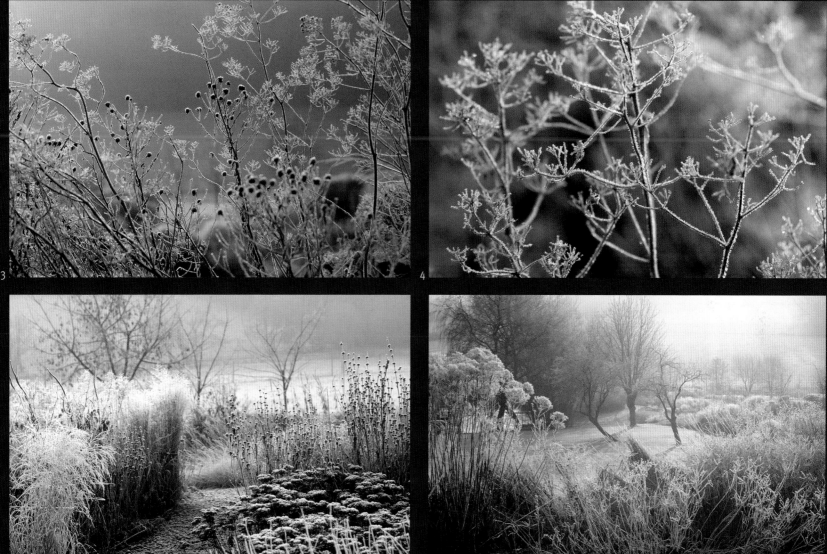

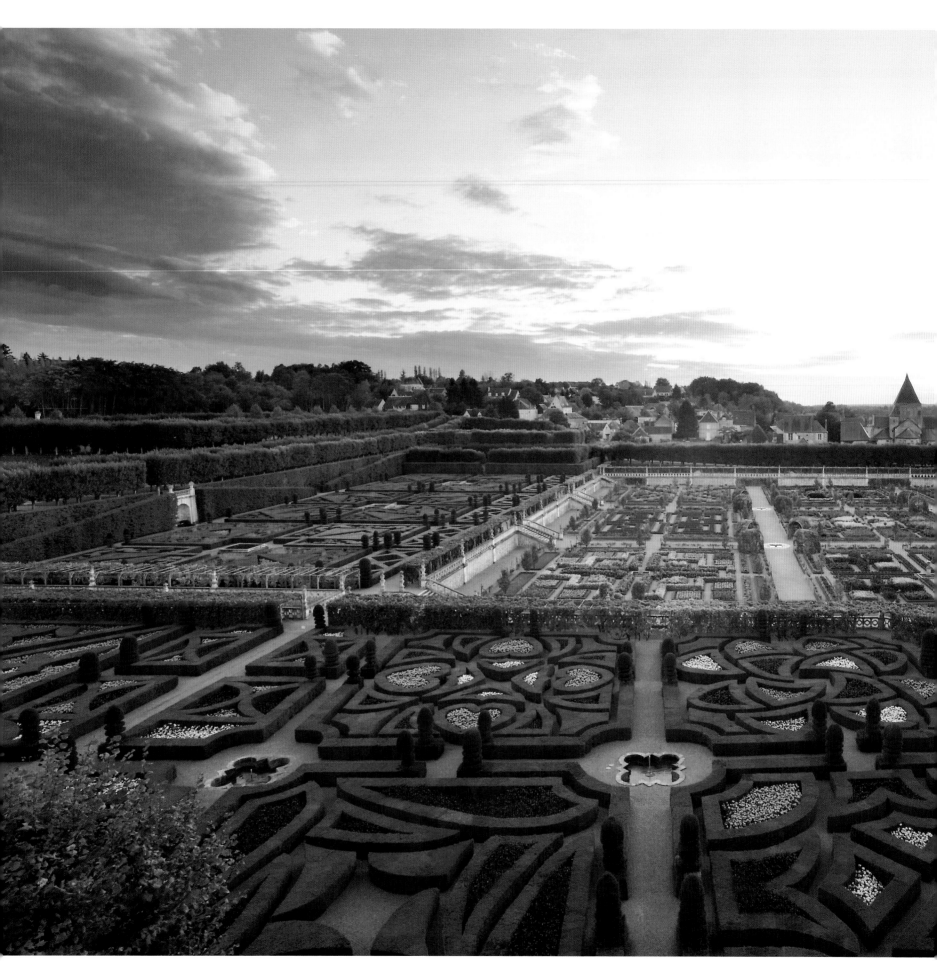

⋮ CLAIRE TAKACS COMMENDED

Sunset at Château de Villandry.
Indre-et-Loire, France.

I photographed this scene from an upper storey of the château. I had the gardens pretty much to myself, letting myself out through a back gate when darkness came. I appreciated the opportunity to see the gardens in such beautiful light, and it gave me a totally different perspective from the busier daytime. It was a wonderful sight to behold and capture.

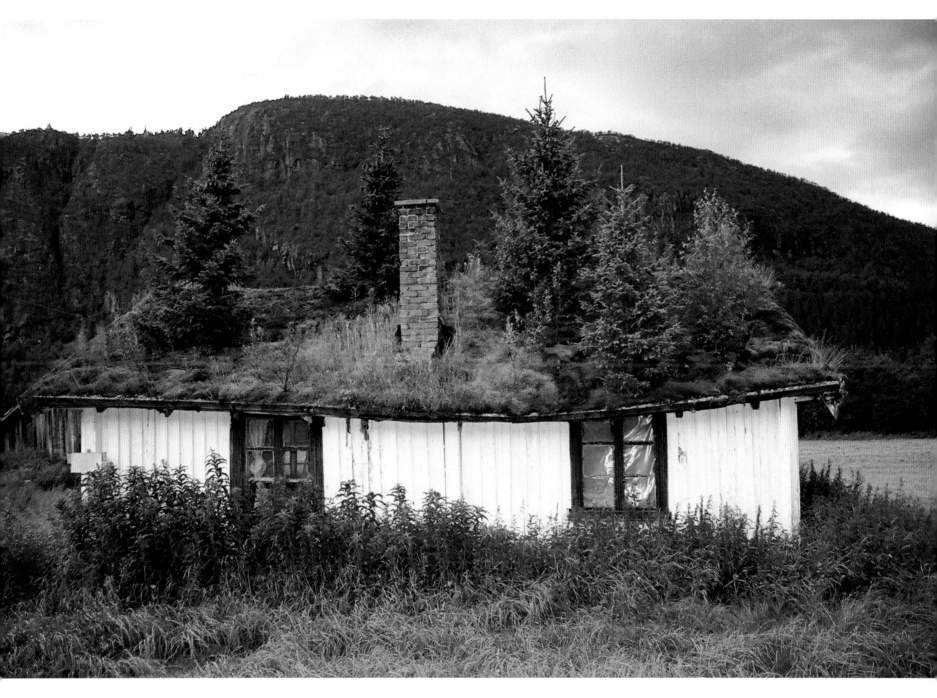

· NIKKI DE GRUCHY FINALIST

† RENATA GIERLACH COMMENDED

Fiery Seville.
Historic Gardens, Royal Alcázar, Sevilla, Spain.

In the Alcázar Gardens, Sevilla, the shadows were dancing like flames. The hint of reality in the right hand side of the photograph and the symmetrical arrangement of the three potted plants allude to the stately garden of the Royal Alcázar beyond the frame. It was a momentary opportunity where the angle of the strong Andalucian sun created a dynamic light sculpture upon an aged wall.

Roof garden.
Gol, Buskerud, Norway.

Before this moment, I had never seen real trees growing on a building. It was as if someone had started a wild garden on the roof of their house, and then abandoned it. Despite heavy rain, I decided to stop the car and take a few pictures.

CAROLE DRAKE COMMENDED

Three great gardens in autumn.

I'm inspired by these gardens in two ways. The academic in me
is fascinated by them as historical texts that can be read and
deciphered, telling us about fashions in garden design. The artist in
me is excited by their visual and tactile properties – a combination
of formality and exuberance.

All these photographs were shot soon after first light, my favourite
time for taking photographs of gardens as it's quiet, the light is
soft and even, and the air tends to be still – though not always,
of course.

1–Tulip tree, *Liriodendron tulipifera* behind the Tunnel Garden,
Heale House, Wiltshire, England
2–Fallen leaves of *Liquidambar styraciflua* in the Japanese Garden,
Heale House, Wiltshire, England
3–The Herb Garden, Cranborne Manor, Dorset, England
4–View over Mapperton, Dorset, England
5–The Green Garden, Cranborne Manor, Dorset, England
6–Clipped yew and fading perennials at Mapperton, Dorset,
England

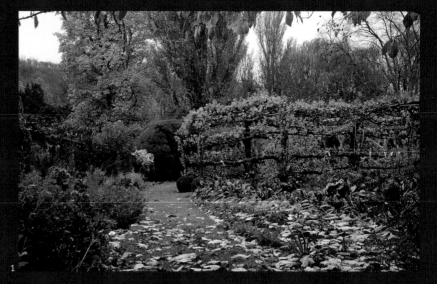

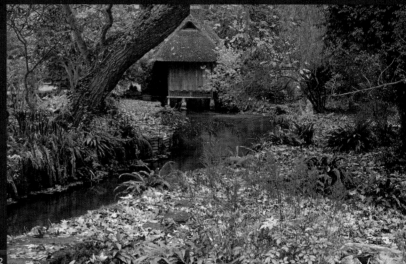

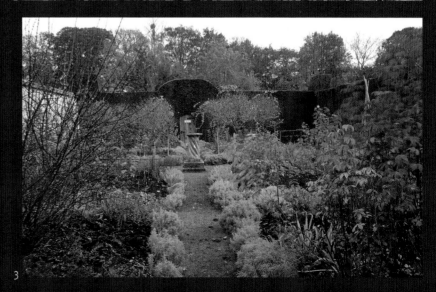

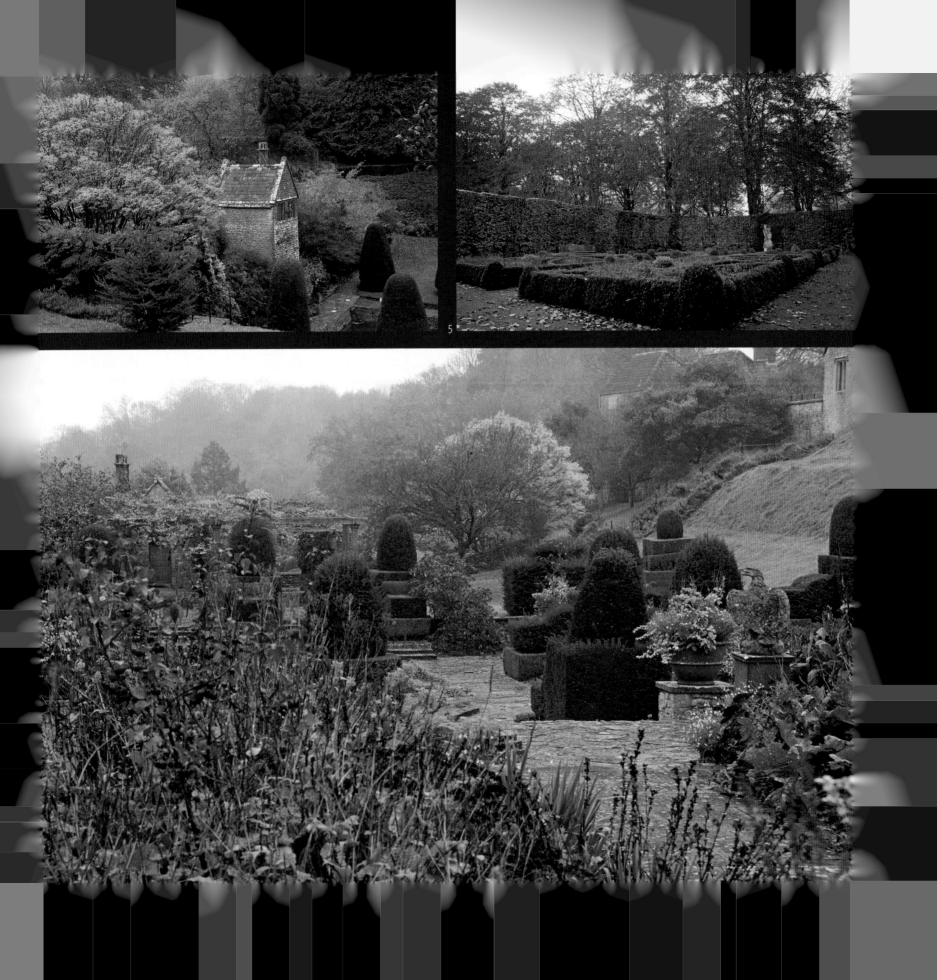

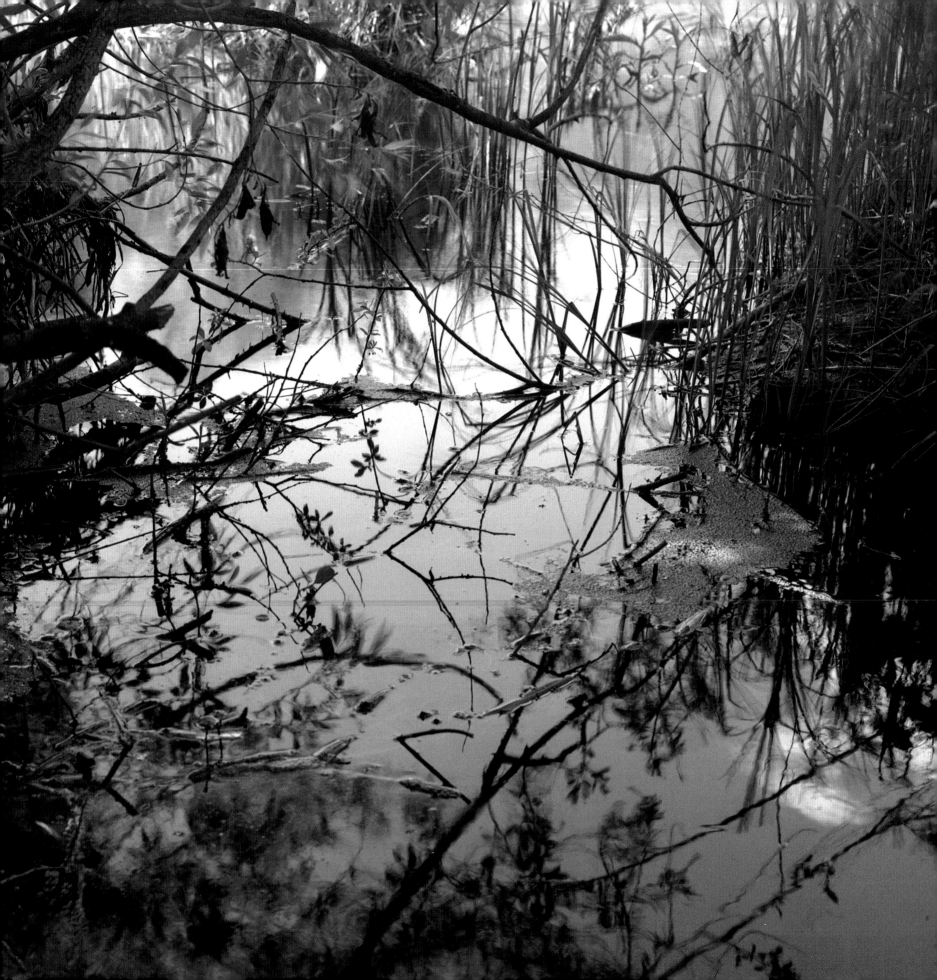

◦••• VADIM KUSHCH COMMENDED

Garden pond.
Vorontsov Garden, Alupka, Ukraine.

This photograph is from a series called 'Abandoned Paradise', where I photograph neglected gardens and parks where nature has been left to its own devices. Places like these – which, at first glance, seem unkempt and wild – have a kind of balance, harmony, and particular beauty all their own. The pond fragment drew me in with its sense of spatial depth and atmosphere.

⚕ RAY SANTELLA COMMENDED

Valley spring.
Flowering crab apple (*Malus*). Carmel Valley Inn, Carmel Valley, California, USA.

I took this photograph in early spring 1980. It shows a flowering crab apple behind an old mossy grape stake fence. The red and green colours on a dreary day just shouted out to me. I was inspired simply by the fact that I was doing what I loved to do most: taking pictures. I was 28 years old, and had my first Nikon and lots of great images in my head.

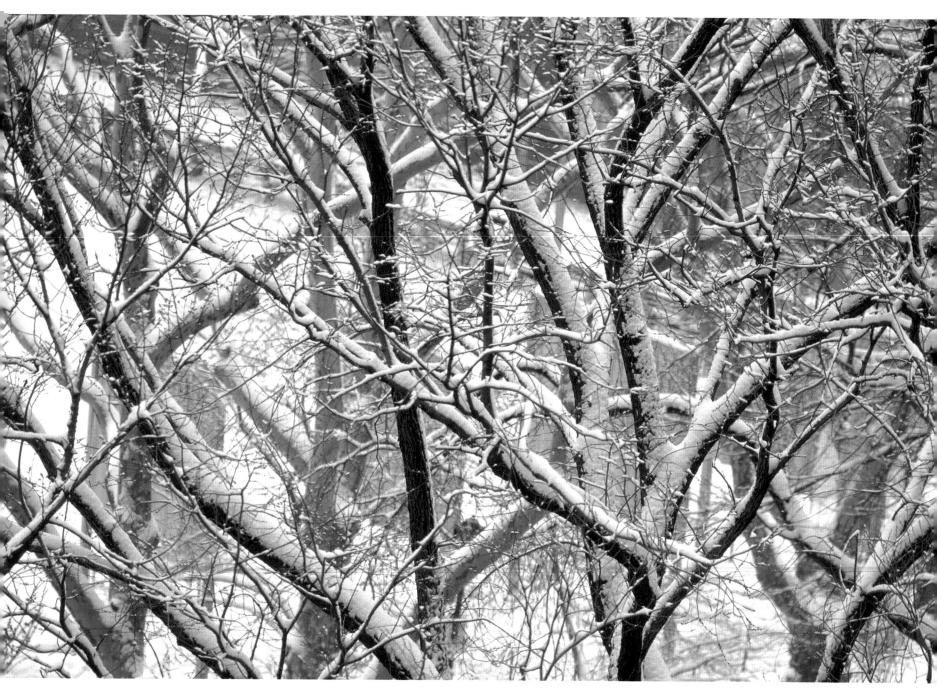

☦ BARBARA MACKLOWE ⚜ COMMENDED

Christo's Gates.
Central Park, New York, USA.

When the artist, Christo, installed his sculpture, 'The Gates', in Central Park, I – along with thousands of others – photographed the experience. When I heard of an impending snowfall I stayed up the entire night envisioning this very image of the black and white bare trees in the snow, and the brilliant orange sculpture. I photographed for hours from my window on Fifth Avenue until the snow melted in the ensuing rain.

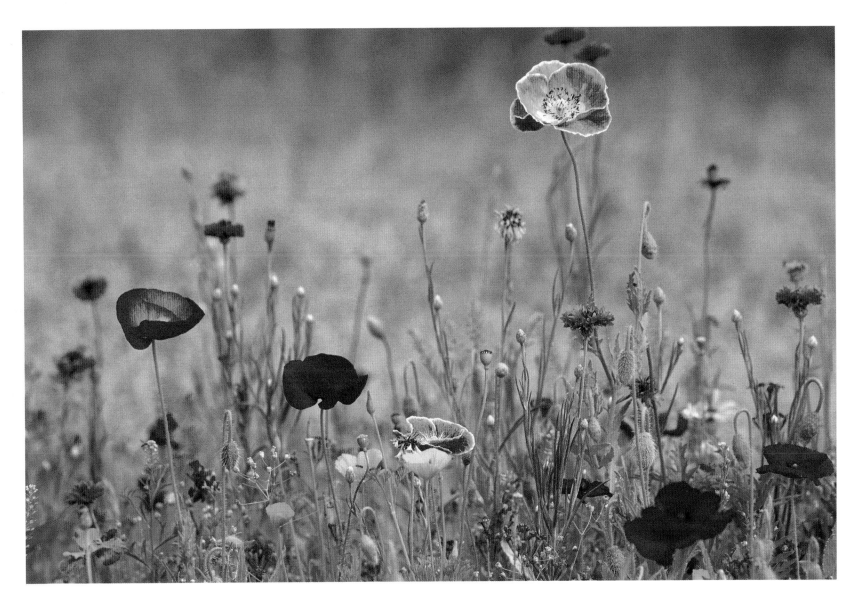

Wild flower field.
(*Papaver rhoeas* and *Centaurea cyanus*). Bridgehampton, New York, USA.

This planted field at the Atlantic Golf Club begins at the road and greets both members and passers-by with a planted and seeded mixture of annual, biennial and perennial wildflowers. This image is a vignette within that field, with brilliantly coloured flowers swaying gently in the breeze, and set against a golden background.

VICTOR KORCHENKO THIRD

Yuyuan gardens, Shanghai, China.

Yuyuan gardens, finished in 1577, is a famous Chinese classical garden in Shanghai. This series is a meditation on the components of classical Chinese garden design. I was fascinated by the juxtaposition between the natural elements – such as trees, fish and rain – and the man-made environment.

Nikon D80, 80-300mm zoom lens
Before taking the pictures I studied Chinese garden design and read ancient Chinese authors' advice on how to admire the classical garden scenery.

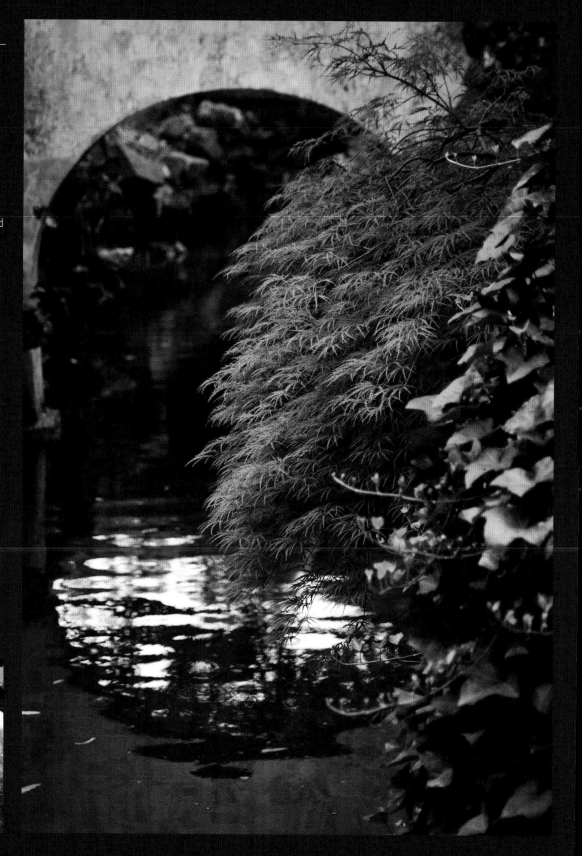

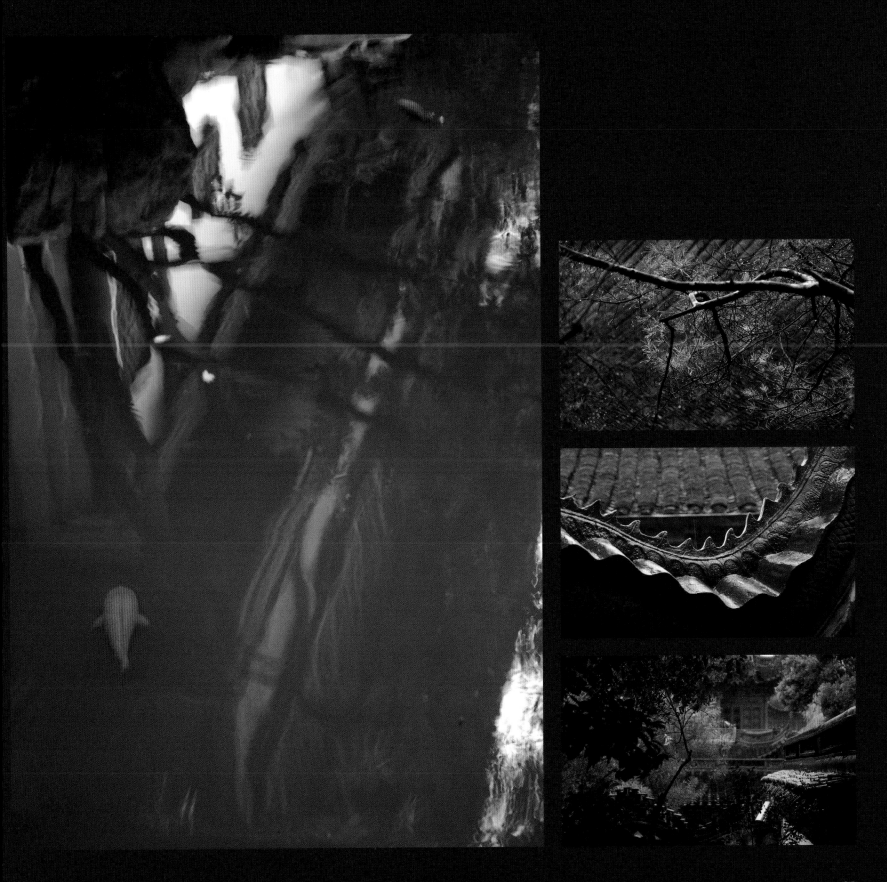

LIFE IN THE GARDEN

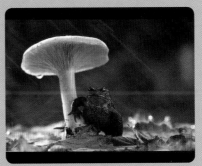

DAVID CHAPMAN

TOAD IN THE RAIN

I particularly like this picture for the wonderful tones and the arrogant, almost posed, stance of the majestic toad. Neither toads nor toadstools are rare, so it is an approachable, almost everyday subject – yet brilliantly executed. The composition is truly inspired. This is just the type of photograph that will encourage people to get creative in their gardens, and that can only be a good thing.

David Watchus

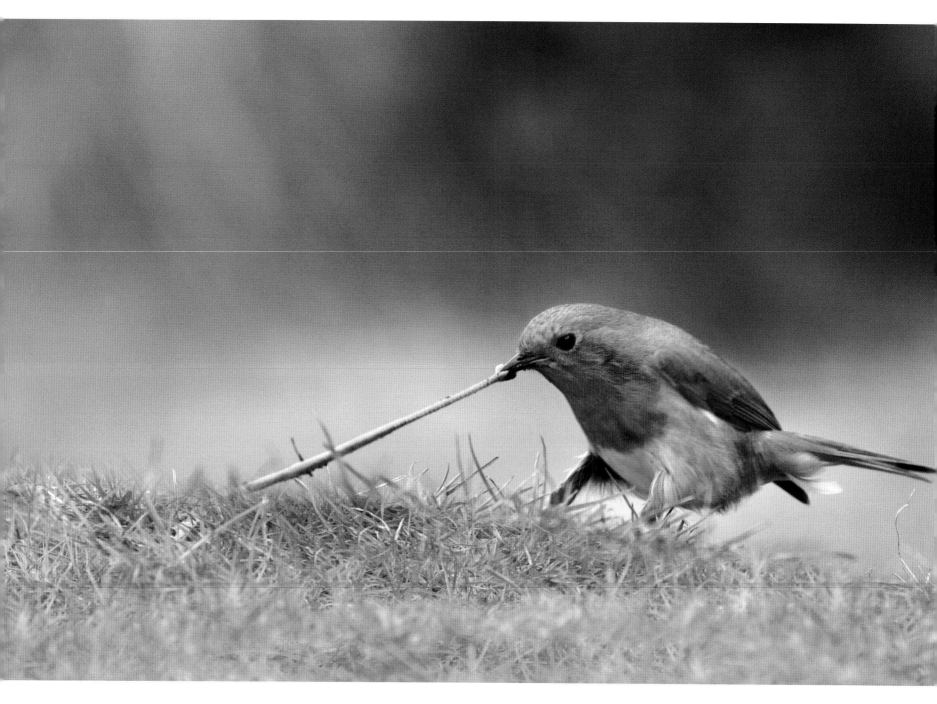

ANDREW BAILEY FIRST

Tug of war.
Bentley, Suffolk, England.

As I dug out a new pond in the wild part of my garden, I put out worms and cockchafer larvae
to see whether any birds would be attracted to the easy pickings. This photograph is one of
a sequence taken of the resultant tug of war caused by the worms digging into the lawn to
seek safety.

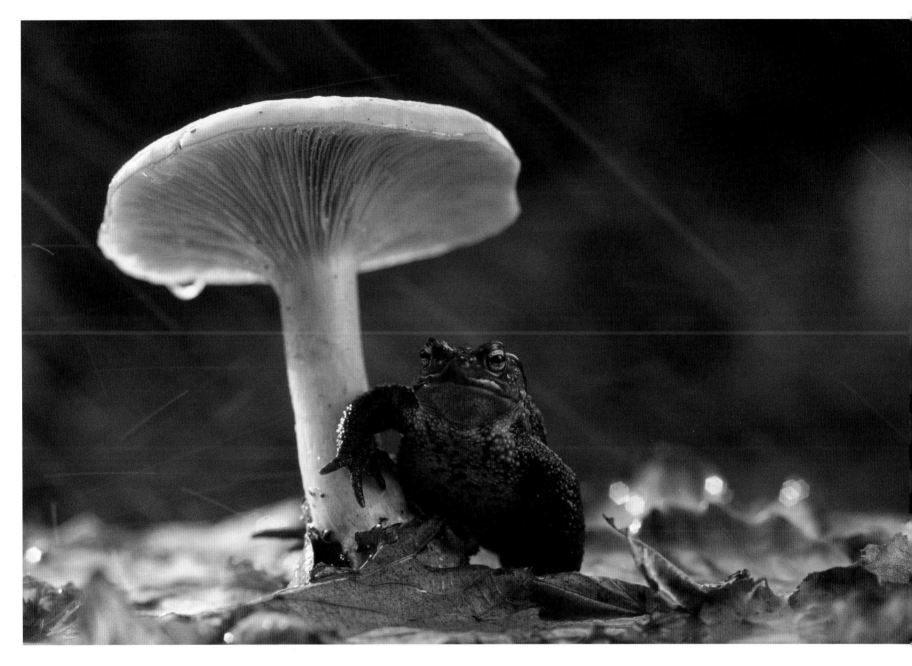

✝ DAVID CHAPMAN SECOND

Toad in the rain.
Townshend, Cornwall, England.

I really wanted to show a subject that is often regarded as unappealing, in an attractive way.
I had seen a toad underneath a toadstool beside our garden pond and wanted to capture
the scene in a photograph, so I created an arrangement of leaves around a toadstool,
introduced a toad to it, and it moved itself into the position seen.

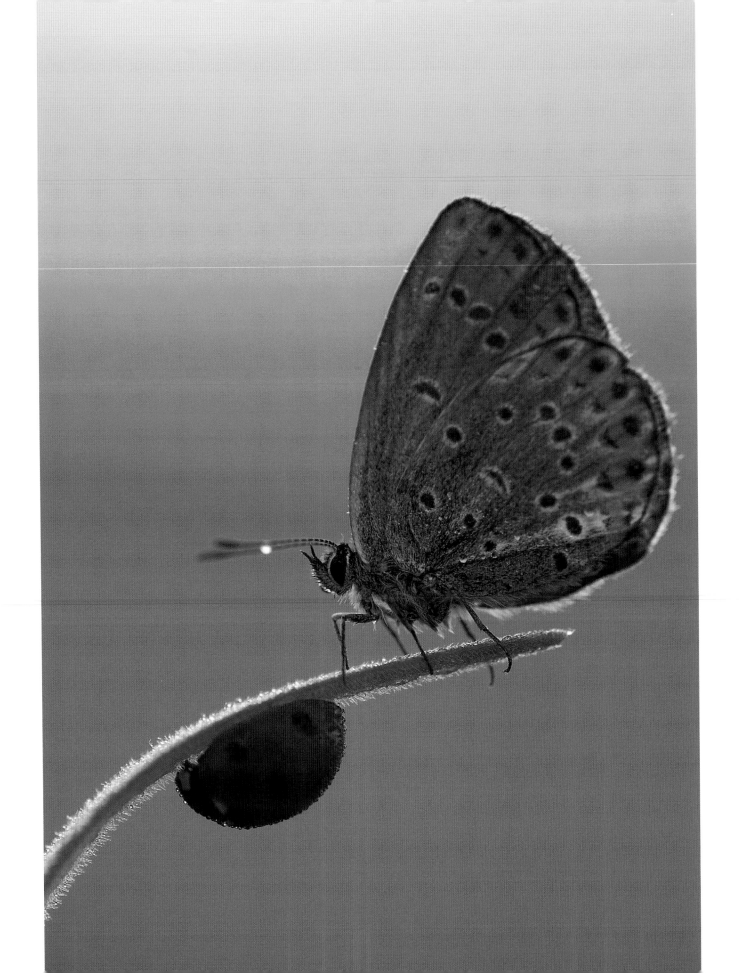

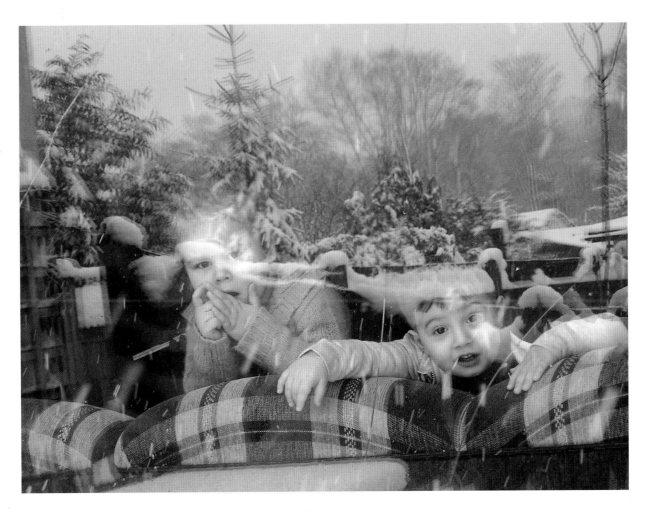

ANDRAS MESZAROS THIRD

Friends.
Agard, Hungary.

One morning I found this Common Blue butterfly and Ladybird who, interestingly, chose the same blade of grass as night shelter. After being heated by the sun's rays, they started their day from there. Photographically, I wanted to present the colours of dawn, an aim that was helped by such a lovely subject.

SUNA AKTAS FINALIST

New play.
Mill Hill East, London, England.

Ibrahim and his friend Dicara were watching snow in our back garden – which has been a project of mine for almost two years now. I've made a point of taking many pictures throughout all four seasons.

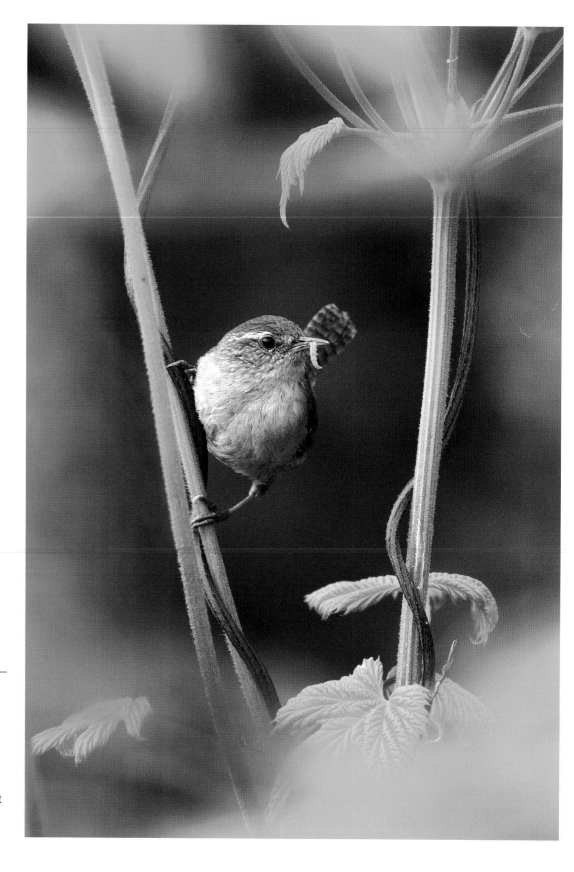

DAVID CHAPMAN ⋯⟩ Commended

Wren.
St Mary's, Isles of Scilly.

I was watching this Wren feeding its young. Having left the nest,
they were mobile but had rested in a patch of rough ground in this
garden. I wanted to try to capture an image of the bird with food in
its mouth on the way down to the young. I particularly liked the fact
that the wild hops stem matches the colour of the Wren and the
caterpillar matches the colour of the surrounding vegetation.

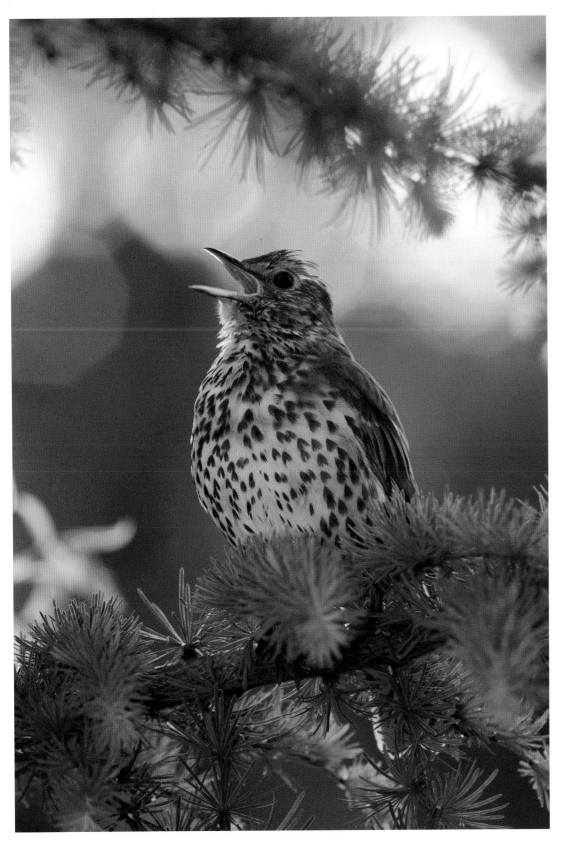

The Song Thrush.
Ayr, Scotland.

For me, the Song Thrush's song is the epitome of a healthy garden.
I heard this bird singing for several days and wanted to capture
something of its spirit by showing it in full spate. I was actually able
to park our camper van next to the tree in which it sang.

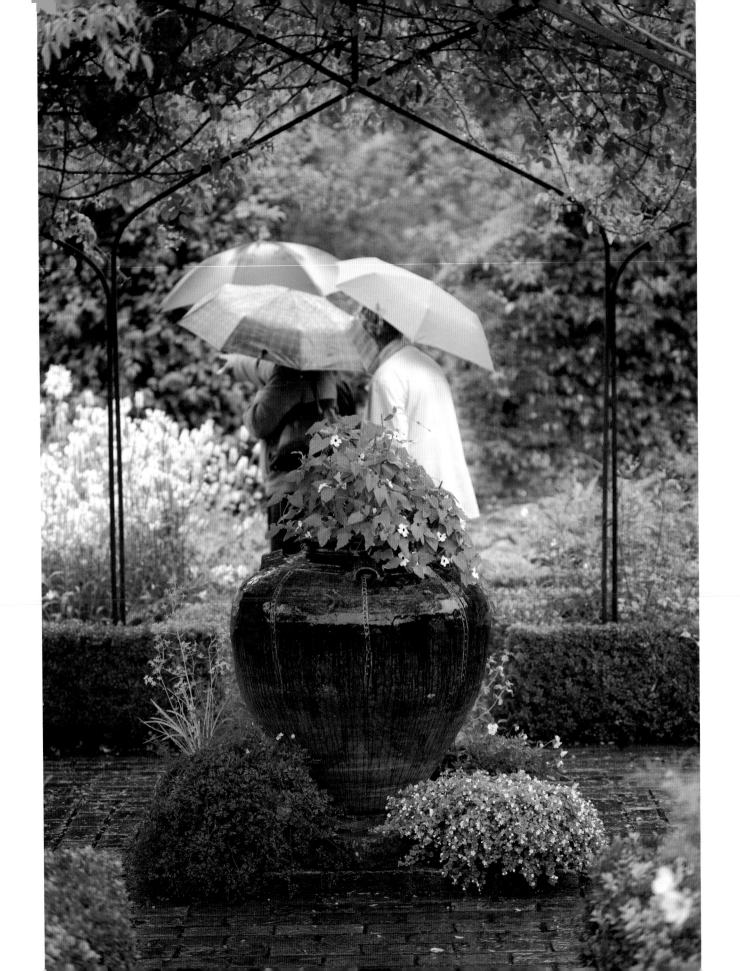

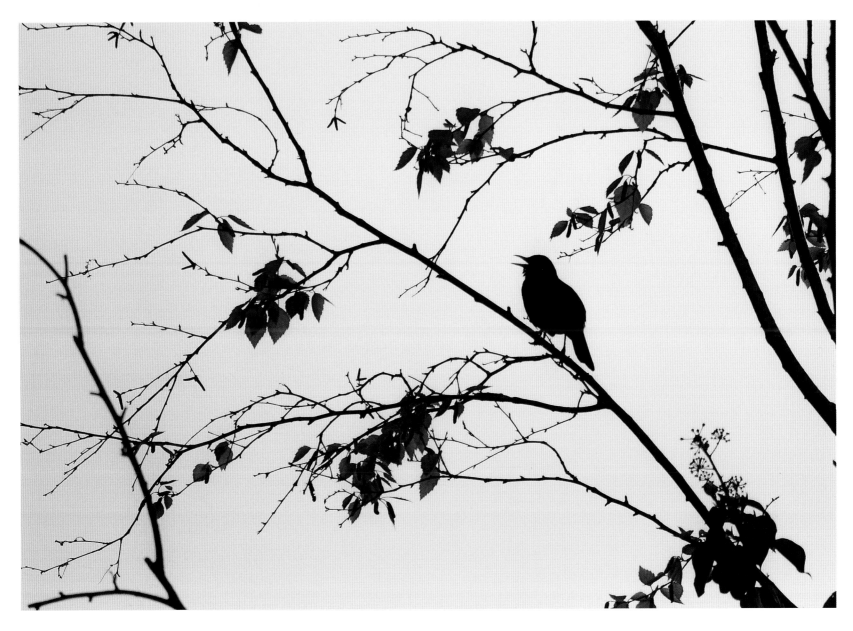

⟵··· JOHN MACPHERSON FINALIST

⸙ MICHAEL WALKER FINALIST

Rainy day at Sissinghurst.
The White Garden, Sissinghurst, Kent, England.
By kind permission of the National Trust. www.nationaltrust.org.uk

My partner and I visited Sissinghurst on a day of epic rainfall during the flooding of 2007. We were two of only a few people, so had the gardens virtually to ourselves. I loved the soft colours and the incessant hiss of the falling rain, and when I saw this composition I knew it was a lovely evocative scene of garden enjoyment.

Blackbird singing.
Ferndown, Dorset, England.

The beauty of the blackbird's song made me look up. I stopped to listen, then remembered I had my camera with me. It was one of the first outings with my new camera – and one of the first photos I took with it.

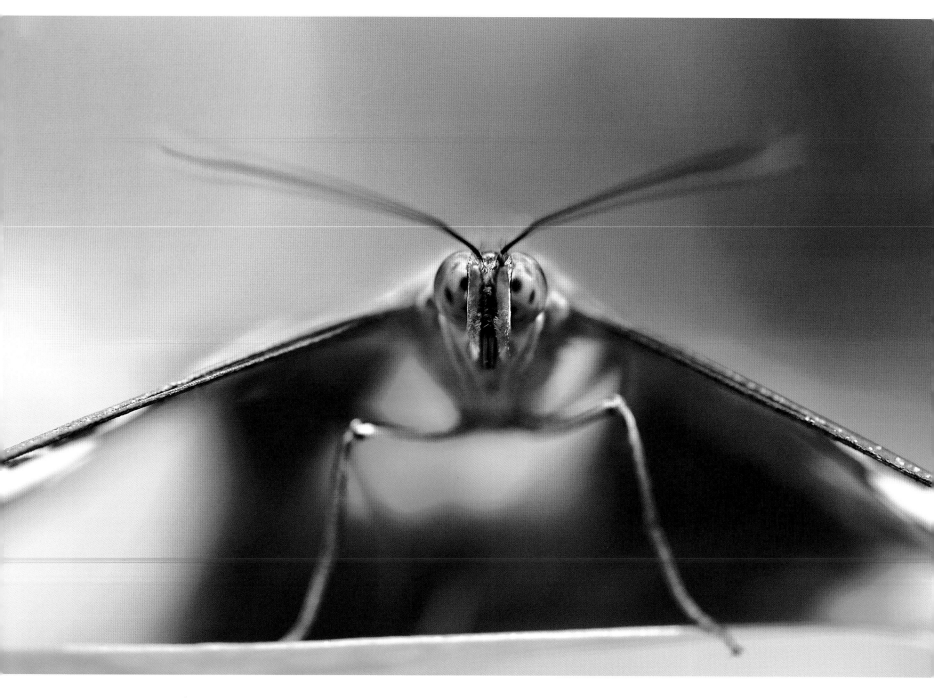

✝ SHARKAWI CHE DIN | FINALIST

Looking at you.
Segamat, Johore, Malaysia.

I saw this moth and approached it immediately. It was early in the morning and the light was subtle enough for me to use a wide aperture. This shot was captured handheld simply because I didn't have much time to set it up. I tried to experiment with various points of view and camera angles. This one was a lucky capture, simply because the subject landed in a spot where I could hold the camera steadily.

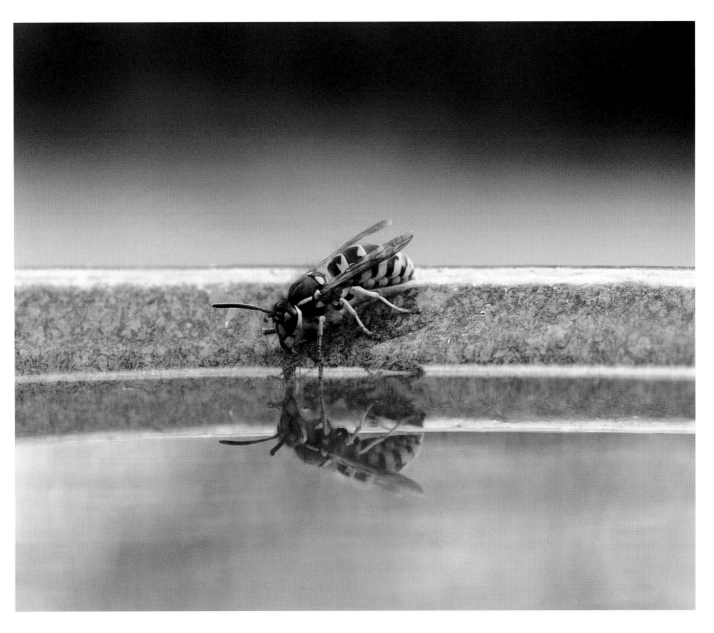

MARY SUTTON COMMENDED

Thirsty work.
Photographer's garden, Herefordshire, England.

I spend a lot of time photographing the wildlife in my small urban garden and I noticed that several wasps were using the birdbath to drink. After many days of waiting, the conditions were right and I was able to capture this reflection. I had never before spent time close to a wasp but, as I observed it, I found the way it utilised the garden's facilities fascinating and the insect itself very beautiful.

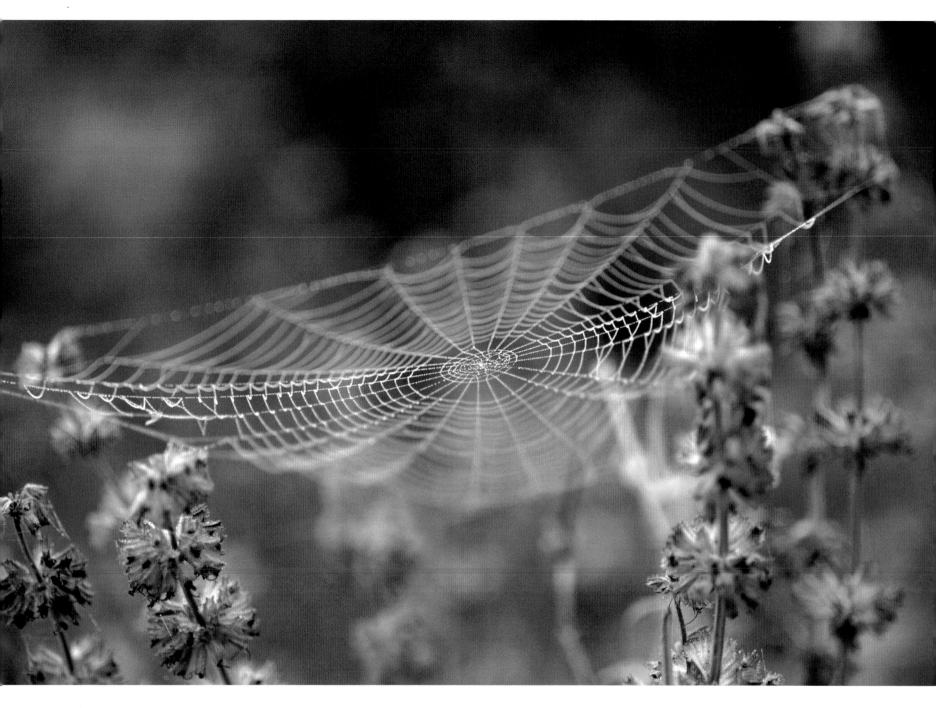

⚶ TORIE CHUGG FINALIST

Dew-covered spider's web.
Pensthorpe Nature Reserve and Gardens, Norfolk, England.

The soft morning light was making the dew on the spider's web sparkle, and it caught my eye. The short depth of field draws the viewer's eye to the web and the soft tones of the flowers behind help to invoke a relaxed, warm feel.

JONATHAN BUCKLEY ⋯⋗ FINALIST

Ladybird on lupin foliage.
Helen Yemm's garden, East Sussex, England.

Immediately before taking this picture I had taken a shot of an infestation of Greenfly on the same plant. Out of the corner of my eye I noticed the Ladybird who had obviously enjoyed a good meal and was now resting on the leaf – a much more attractive subject. The tripod was already set up so I recomposed quickly to capture it before it flew off.

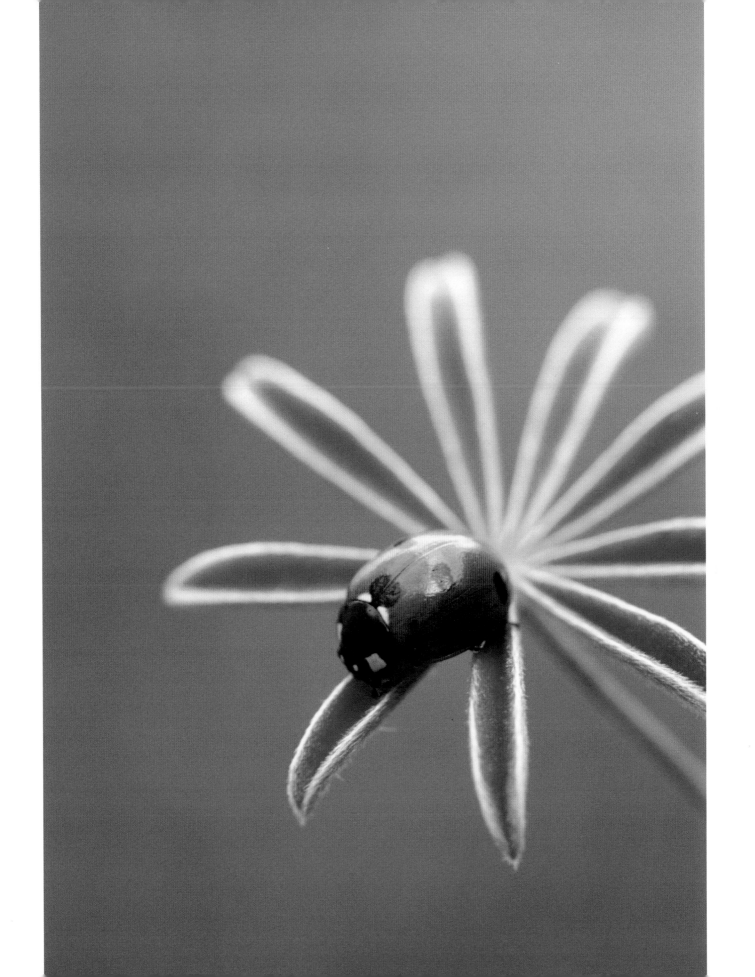

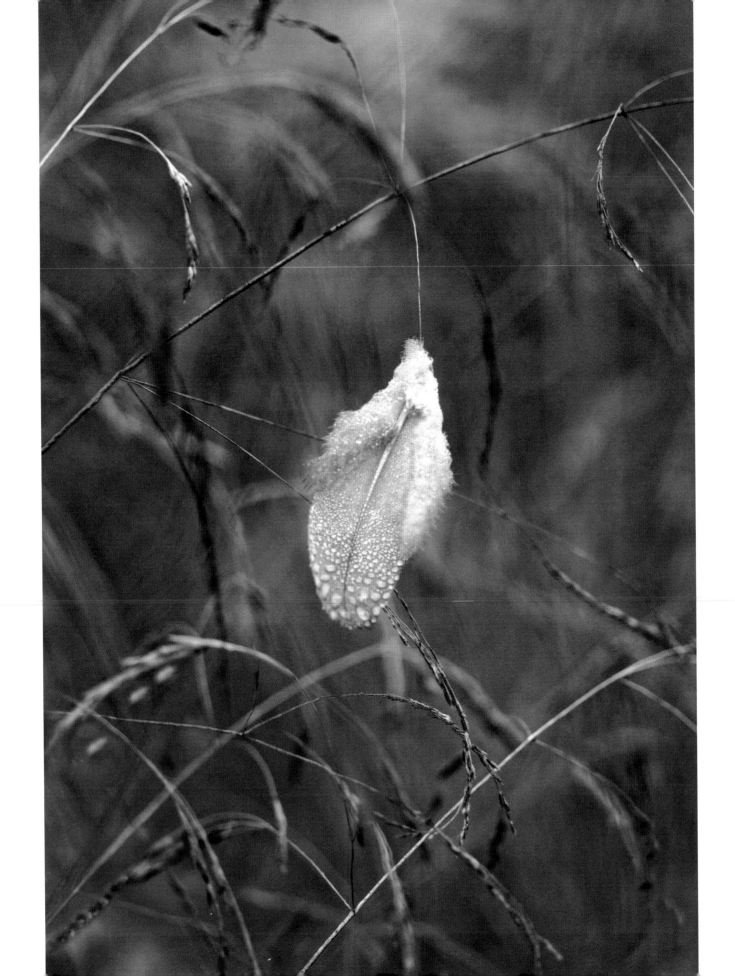

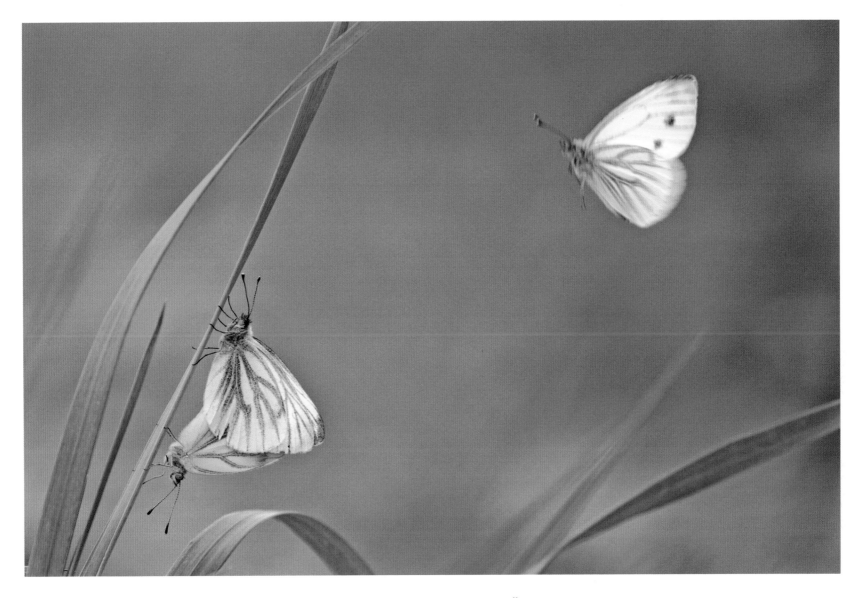

⟵ SALLY SMITH FINALIST

Calling card.
Purple Moor Grass (*Molinia caerulea* ssp. *arundinacea* 'Strahlenquelle').
Ashprington, Devon, England.

The simplicity and poignancy of this white feather snagged on a slender, curving stem of purple moor grass was all the inspiration I needed for this photograph.

SVEN GRÄFNINGS FINALIST

Green-veined white butterflies.
(*Pieris napi*). Siljansnäs, Sweden.

During a peaceful summer's day in my garden, I noticed two butterflies resting on long grass straw. A third butterfly arrived to join them.

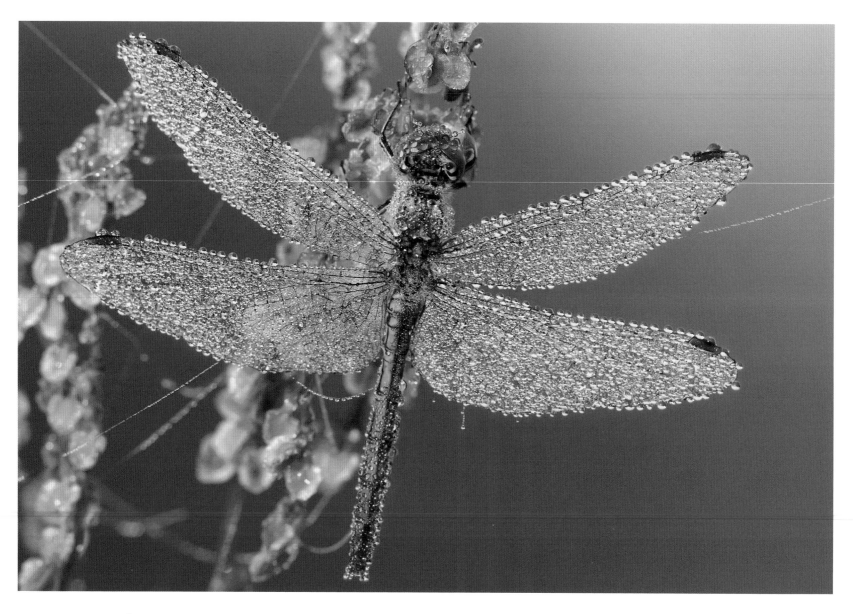

🌿 **OLEGAS KURASOVAS** FINALIST

Waiting for the sun.
Vilnius, Lithuania.

Such a beautiful subject, laden with dew in the misty morning light, called out
to be photographed. As my tripod is short and the dragonfly was high up, I had to
shoot handheld.

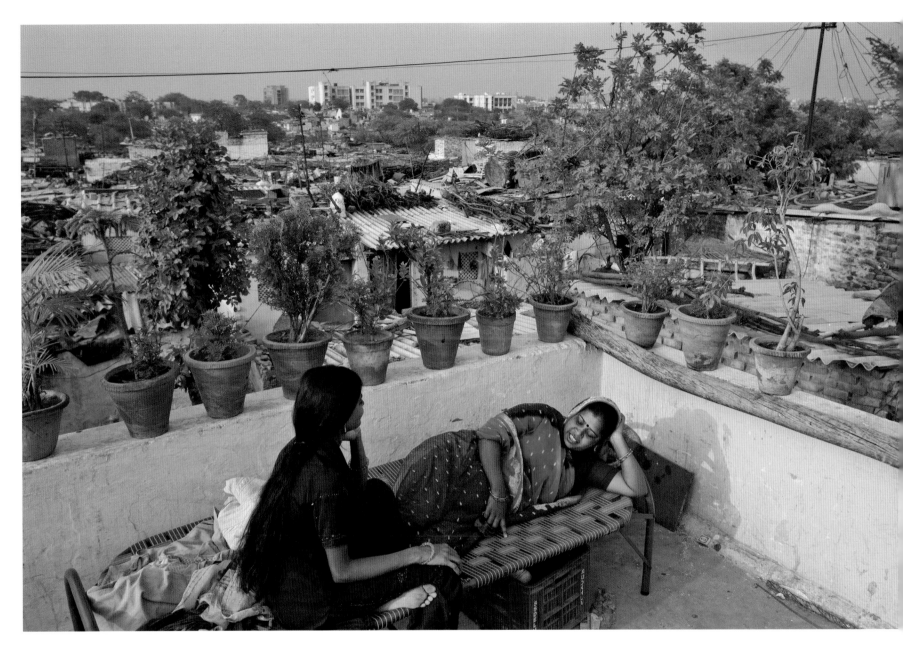

STUART FREEDMAN FINALIST

Radhika and her neighbour, Saroj.
Delhi, India.

Radhika and her neighbour, Saroj, on her roof garden in one of Delhi's largest slums –
Kesumpur Pahari. The slum, built more than 30 years ago, has no running water or sewage
facilities but, despite the residents' poverty, many have beautified their homes with plants
and flowers. Radhika told me she was very proud of her plants.

DAVID MAITLAND ⋯⟩ FINALIST

Grass snake.
(*Natrix natrix*). Calne, Wiltshire, England.

This grass snake was basking in the afternoon sun after awaking from hibernation in spring.
I like the disembodied nature of the snake – the ambiguity – its beautiful face and piercing
eyes seem to disguise the fact that there is a metre-long snake attached! There's also a
contrast between the textures of the brick and the snake.

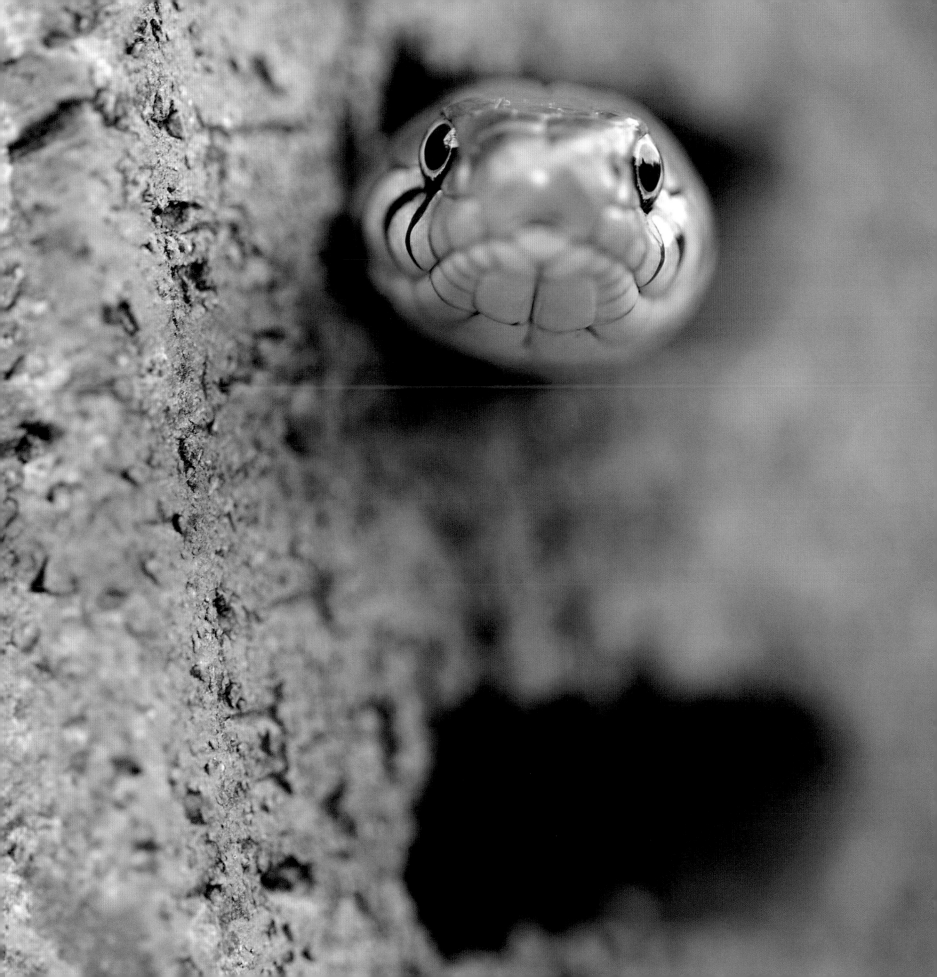

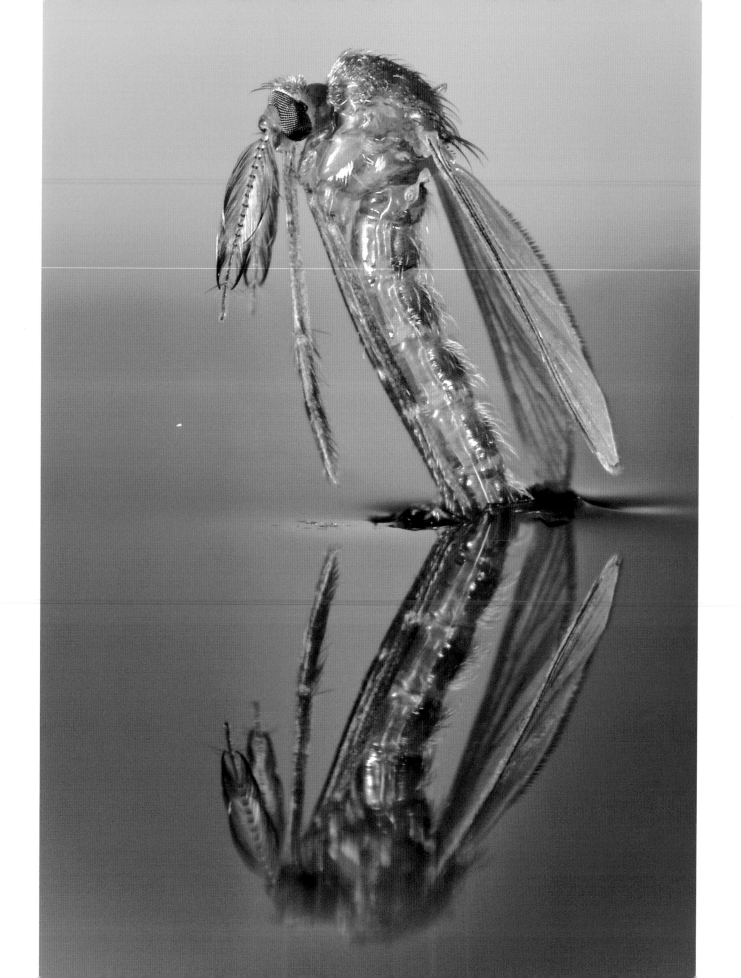

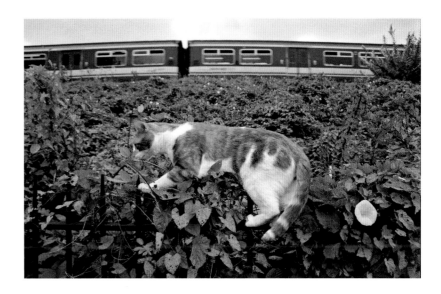

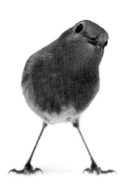

 TIM GAINEY COMMENDED

SILVIA DEMETILLA FINALIST

Robin.
(*Erithacus rubecula*). Adderbury, Banbury, Oxfordshire, England.

Months of patience and plenty of mealworms led to this little Robin becoming a firm favourite in our garden. This moment occurred when I placed a piece of white card on my garden bench, whereupon he flew down to land. His whole stance highlights his inquisitive nature towards me, the cameraman. A long time spent feeding him – and enjoying magical moments – resulted in him trusting me enough to land on the card.

Acrobatics in my garden.
Raynes Park, London, England.

I used to see this ginger cat every day. He lived next door and was always following me. On this day I took my camera and waited for the train to pass behind him in order to give more power to the photograph. I knew that a moving subject in the background would emphasise the fearlessness of the cat.

 MATTHEW BURRARD-LUCAS COMMENDED

Mosquito emerging.
(*Culex pipiens*). Photographer's garden, Kent, England.

After the wet summer of last year, there was a lot of news about stagnant water offering breeding grounds for mosquitoes. I noticed some larvae in my garden, so decided it would be a fascinating challenge to photograph them as they emerged. This one is only 5mm long so a 4x magnification was used to frame the mosquito and its reflection. It took a couple of minutes for the insect to emerge, after which it rested on the surface of the water before flying away.

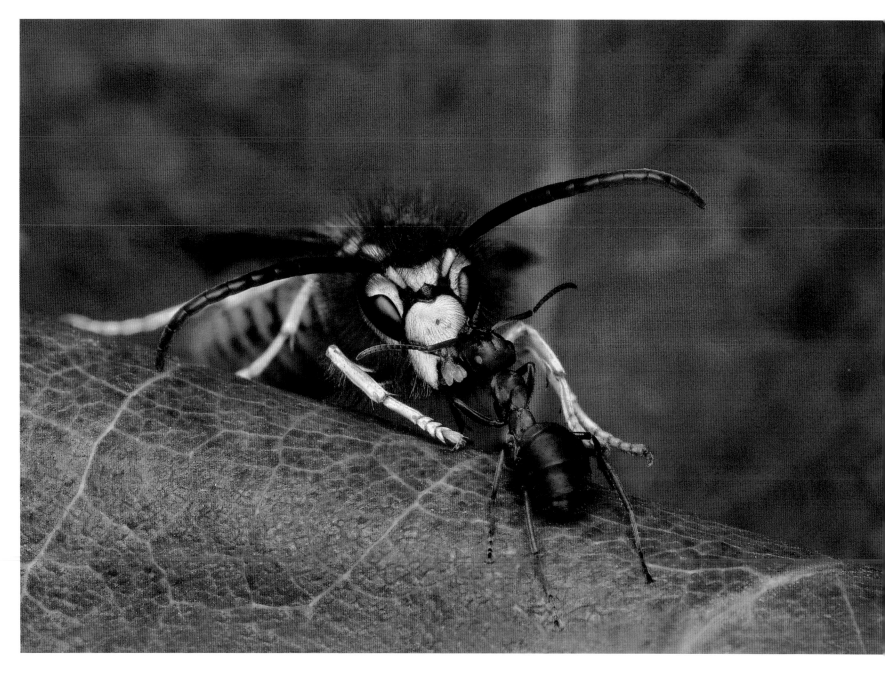

PAWEL BIENIEWSKI FINALIST

ZARA NAPIER ⋯⋗ COMMENDED

The Kiss.
Jablonna, Poland.

I spotted this red wood ant and common wasp engaged in a deadly struggle on this
beautiful autumnal oak leaf. It was an incredible sight, with the red of the leaf underlining
the drama of the situation. What makes it more extraordinary is that an ant won the fight –
perhaps the wasp was weakened or sick.

Jumping the rill.
Alnwick Garden, Northumberland, England.

I love water rills and these, combined with my son's enjoyment and energy, made for a
perfect composition. Alnwick Garden was created with children in mind, and the designers
have succeeded in creating a fascinating environment for all ages – enlivened by the many
fountains and water features.

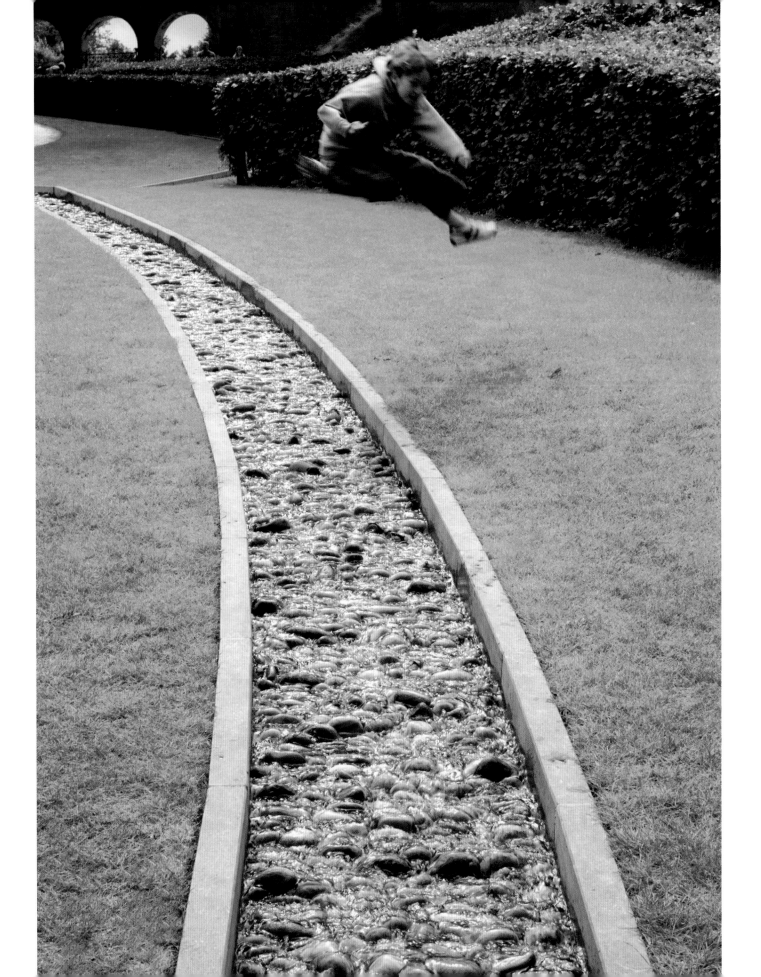

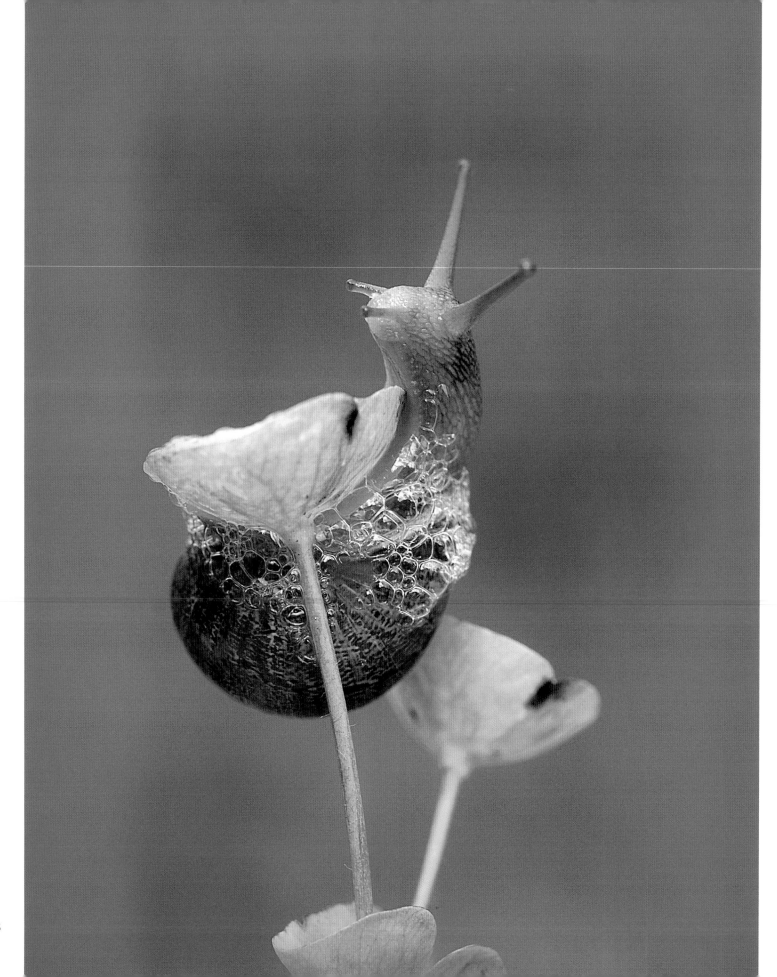

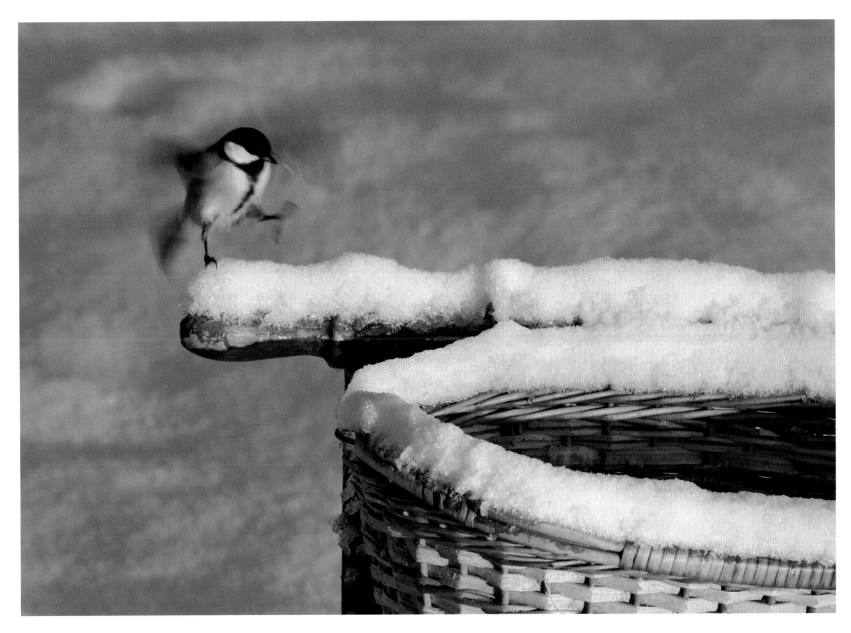

JACKY PARKER COMMENDED

Forever blowing bubbles.
Garden snail (*Helix aspersa*). Photographer's garden, Buckinghamshire, England.

After a rain shower I noticed this common brown garden snail on a euphorbia plant in my herbaceous border. To assist its movement up the plant the snail was secreting copious amounts of slime and bubbles from a mucous gland in its feet. By the time I had grabbed my camera it had reached the top of the euphorbia bract.

SVEN GRÄFNINGS COMMENDED

Great tit.
(*Parus major*). Sweden.

This great tit landed on a kick-sled (a popular Swedish toboggan) to see if there was any food in the basket. There was – it was filled with sunflower seeds. It was beautifully sunny, which gave a sense of warmth to the cold winter day.

✝ DAVE CHARNLEY Commended

Come and see.
Stainton Village, Teesside, England.

I nearly ended up on my back shooting this picture of Charlie with his friends looking for bugs. I love the picture for many reasons – the various ages involved, and the excitement despite it being a common spider seen anywhere! The shot is from the spider's perspective.

MITCHELL KROG ⸱⸱⸱⸱⸱⸱ Commended

Hummingbird moth on salvia.
(*Salvia chamaedryoides*). Magaliesburg, South Africa.

The African hummingbird moth, as its name implies, resembles a hummingbird. This moth never seems to stop to rest, and is continually in flight. In this image I captured him in flight feeding from the nectar of *Salvia chamaedryoides*.

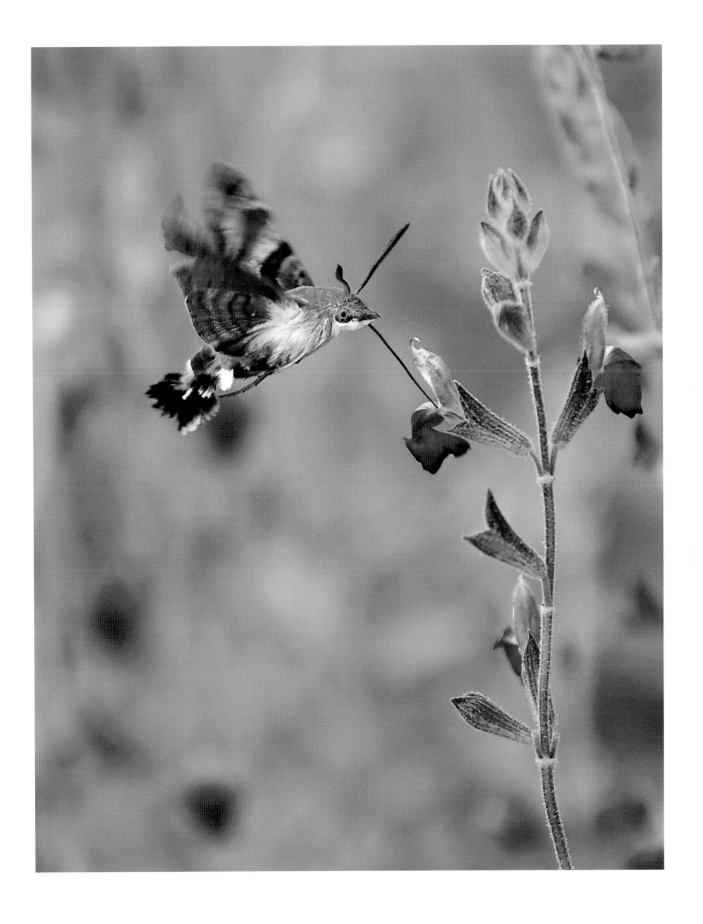

MY GARDEN

JUDGE'S CHOICE

SERGEY KAREPANOV
RED CURTAIN

The atmosphere of this rather quirky image appealed to me. Viewed through a fringe of leaves, we are offered an intimate glimpse of a secluded space in a rather charming garden. The ephemeral nature of the red curtain swept among the border, along with the distant sheet of luminous yellow, injects life into the picture – and hints at the exotic.

Laura Giuffrida

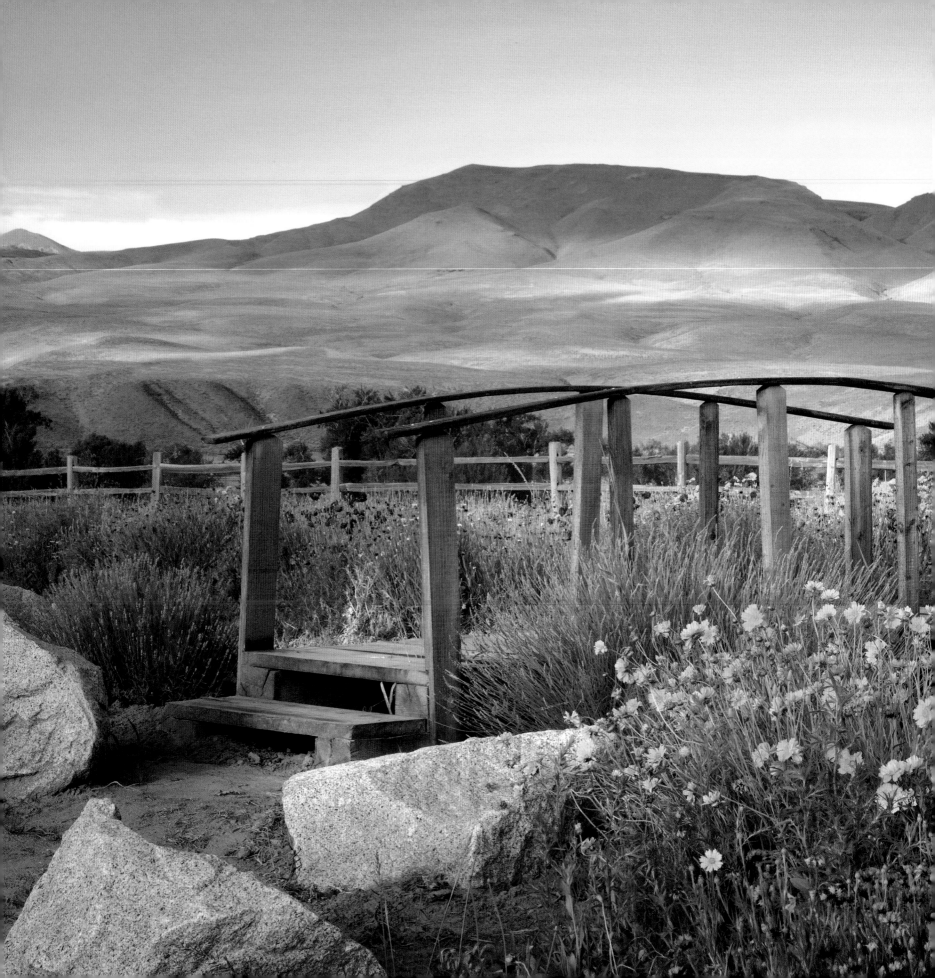

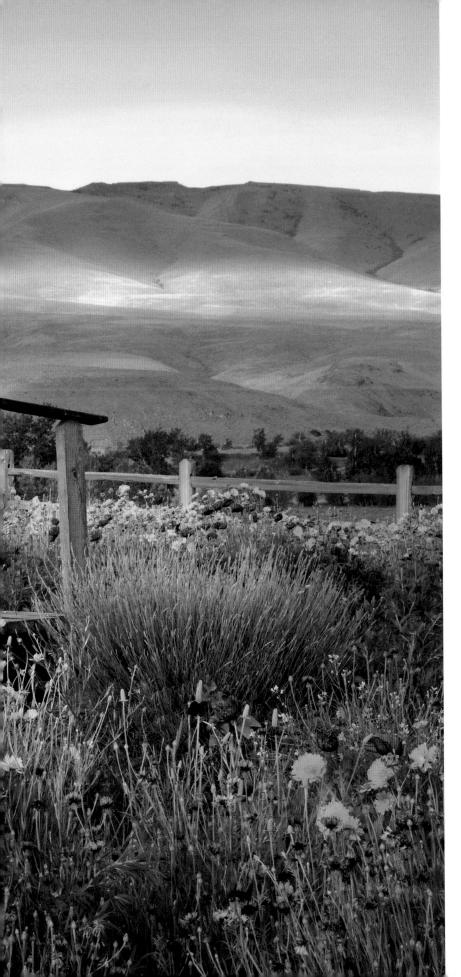

⟨··· DENNIS FRATES FIRST

Desert garden.
Richland Wildflower Project, Oregon, USA.

I wanted to show the stark contrast between this lush garden and the backdrop of the dry,
barren desert hills of eastern Oregon. It was partly cloudy and I waited until the light was
filtered and less direct on the flowers, otherwise it would have had too much contrast.

95

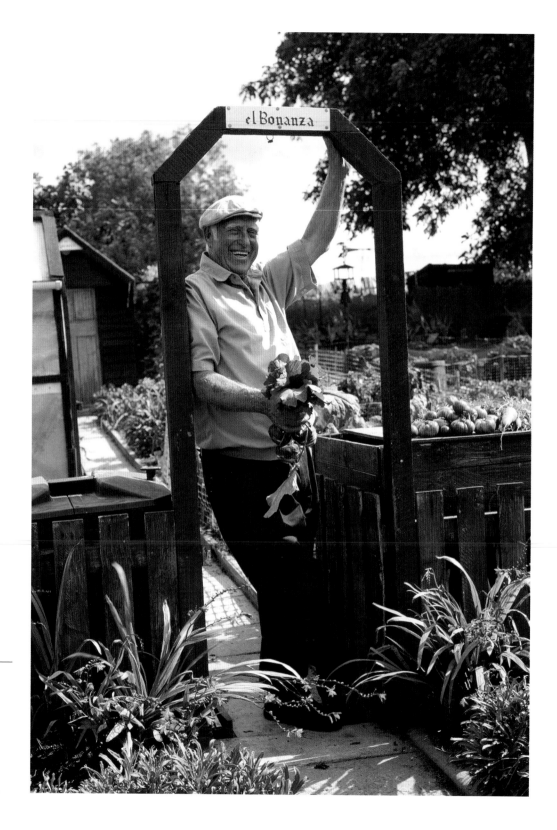

SUZIE GIBBONS ···⫶ SECOND

El Bonanza.
Eric's allotment, Kent, England.

Eric simply radiates with the joy of growing his own produce.
He comes here to relax, too, and enjoy the camaraderie of the
allotments. Eric's big personality inspired me – he was a natural
in front of the camera and we had great fun shooting this portrait.

SERGEY KAREPANOV Third

Red curtain.
Paradise Gardens, Cordes-sur-Ciel, France.

I dreamed of visiting this garden as I studied books and maps
one frosty winter. I left Moscow and drove for three days; then,
around a bend in the road, I saw a mountain and the medieval
town of Cordes-sur-Ciel. On entering the Paradise Gardens and
walking down the narrow path across the bamboo thicket I smelled
a pungent and exciting oriental aroma – and saw this red curtain
luring me on.

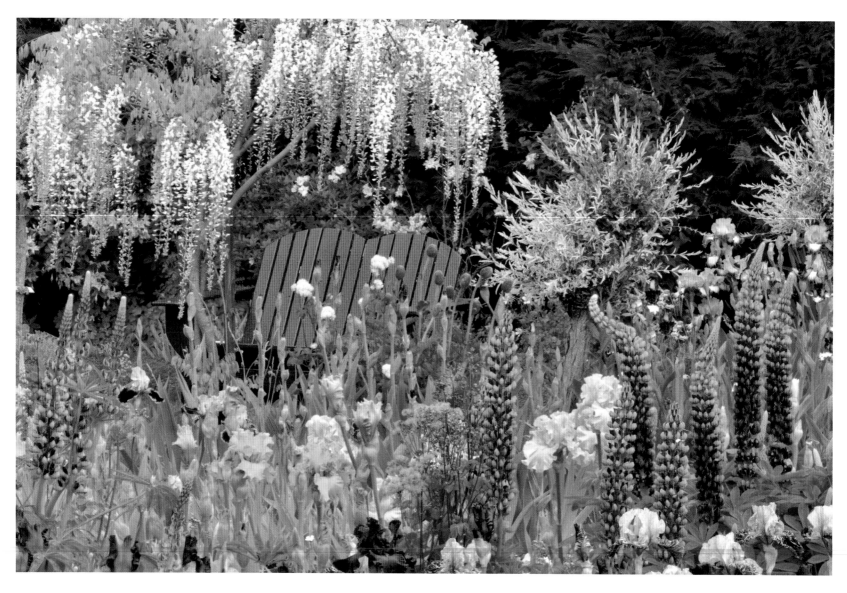

DENNIS FRATES COMMENDED

Cosy corner.
Schreiner's iris garden, Salem, Oregon, USA.

I was looking for a shot where the garden bench was completely surrounded by flowers. I especially like the way in which the lupins complement the bench colour, and how the bench is partially hidden.

SUZIE GIBBONS ⋯⟩ COMMENDED

Rita's bicycle garden.
Rita Armfield's garden, London, England.

Rita Armfield's London garden is full of recycled objects which have been put to ingenious use. In this case an old bicycle, casually leaning against the fence, has a new lease of life as a quirky plant holder.

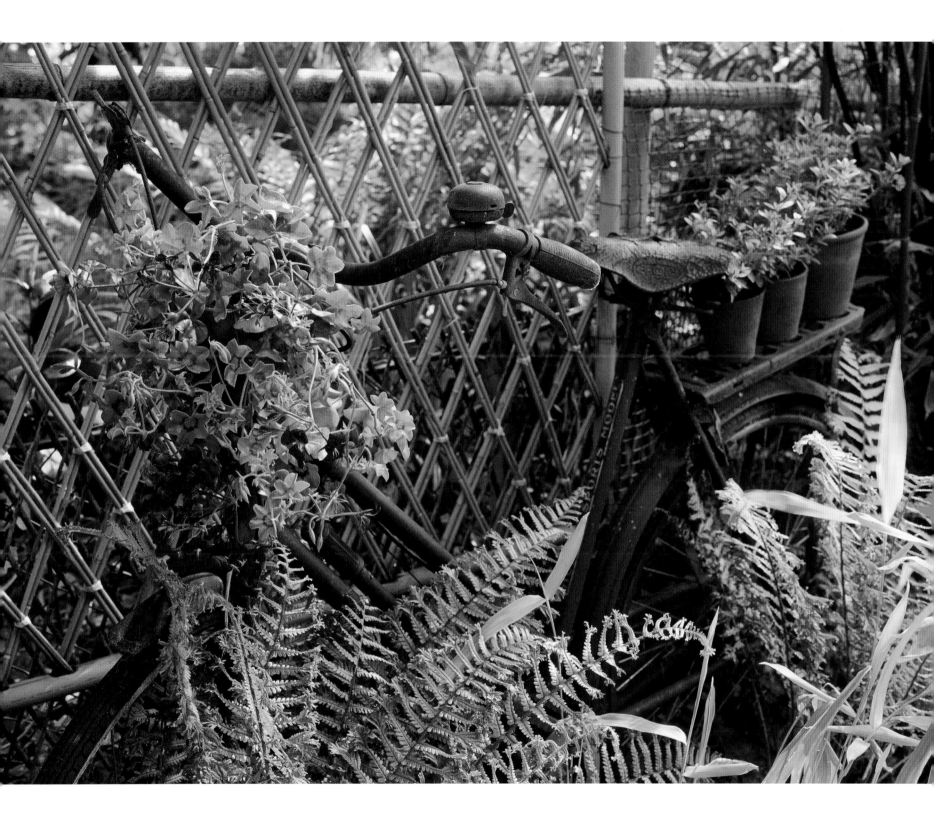

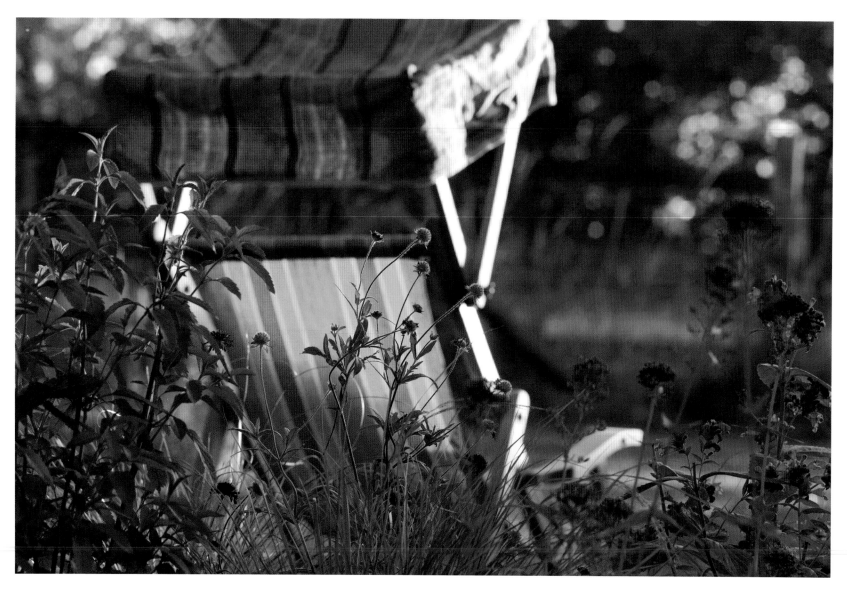

🌱 **ZARA NAPIER** ⋯⋰

COMMENDED

COMMENDED

Deckchair in the evening light.
Newmarket, Suffolk, England.

This shot was taken in our garden in Suffolk. The picture shows a stripy deckchair with a sun canopy that once belonged to my grandmother. It is seen here in the soft evening light through a group of grasses and salvias that I had recently planted.

Proudly mowing.
Newmarket, Suffolk, England.

My father loves using his old faithful cylinder mower to mow his lawn, keeping it weed free and perfectly striped. He has cared for the same lawn for more than 45 years.

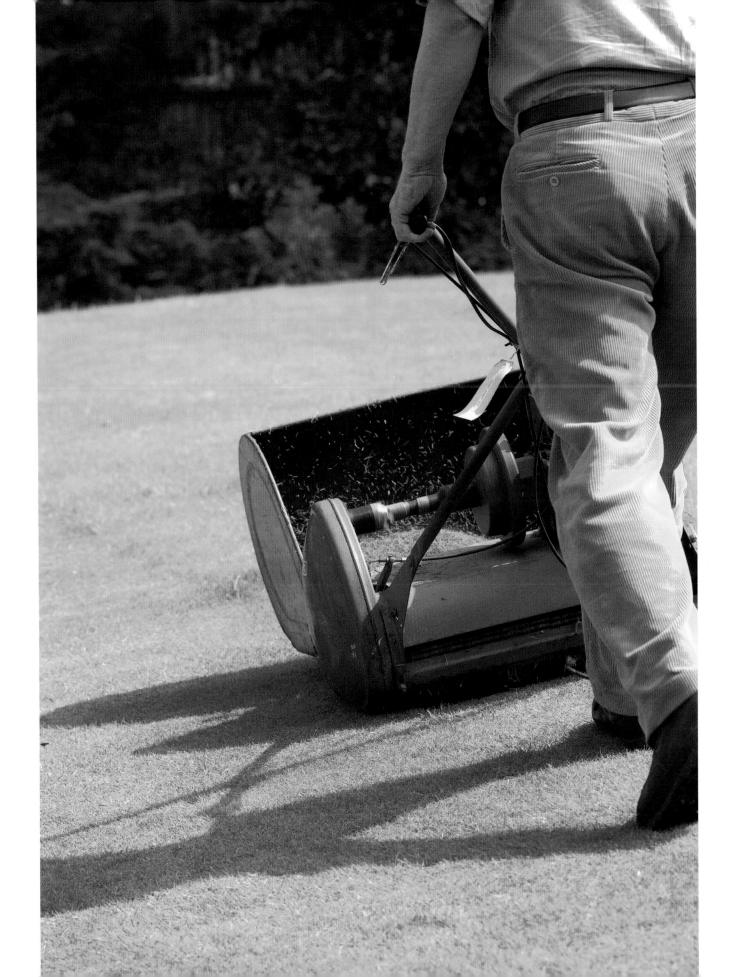

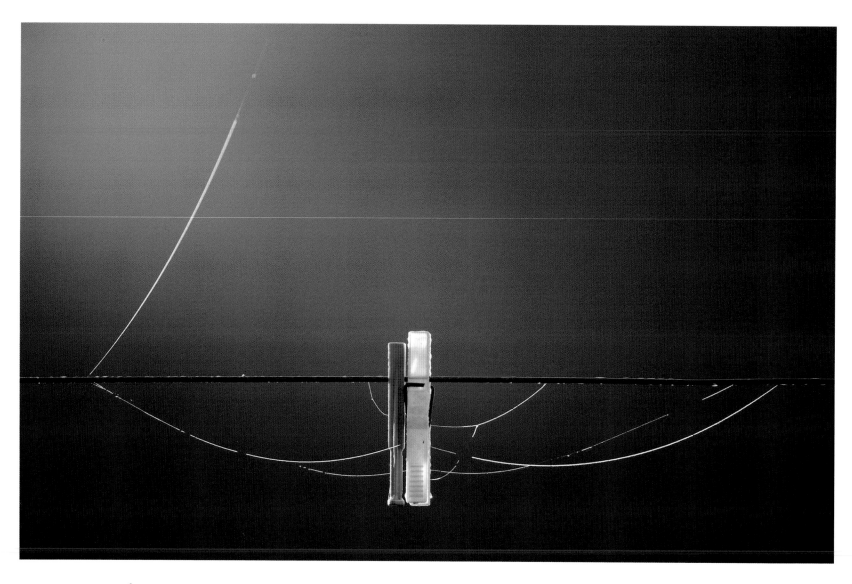

🌱 **JAKE EASTHAM**

FINALIST

Pegs on line.
Chilmark, Salisbury, Wiltshire, England.

I had been photographing partridges in a field next door and noticed the light on the cobwebs. It was a cold, misty morning and there was a beautiful diffuse line behind the pegs and cobwebs. I loved the symmetry of the cobweb and the way one strand seems to disappear into the top of the image.

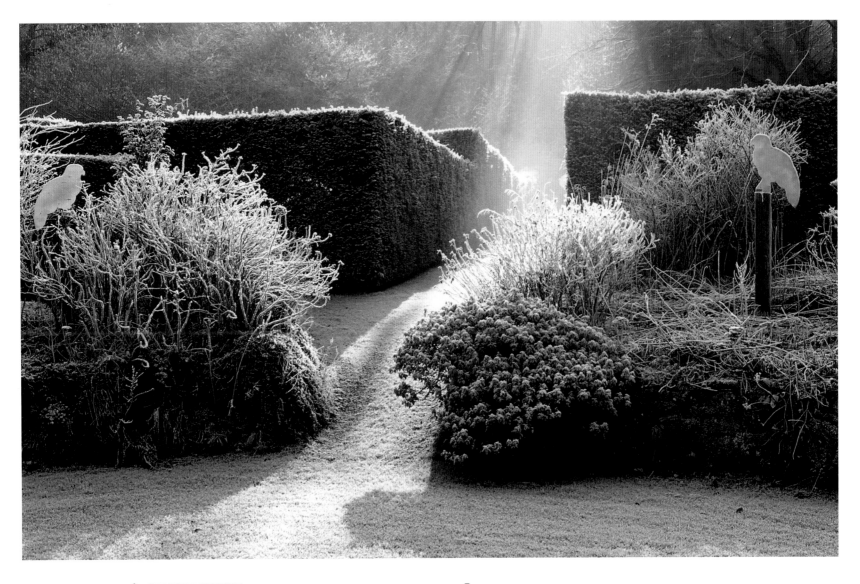

CHARLES HAWES

Breakthrough.
Veddw House Garden, Monmouthshire, Wales.

Our garden is situated on the side of a hill. During the shortest days of winter the sun doesn't get above the horizon but, by the end of January, it appears briefly around midday. The Yew Walk runs north to south, so when the sun shows itself it shines directly down the space between our tall yew hedges. If I'm lucky, it quickly evaporates any frost to create a mist that catches the sunbeams.

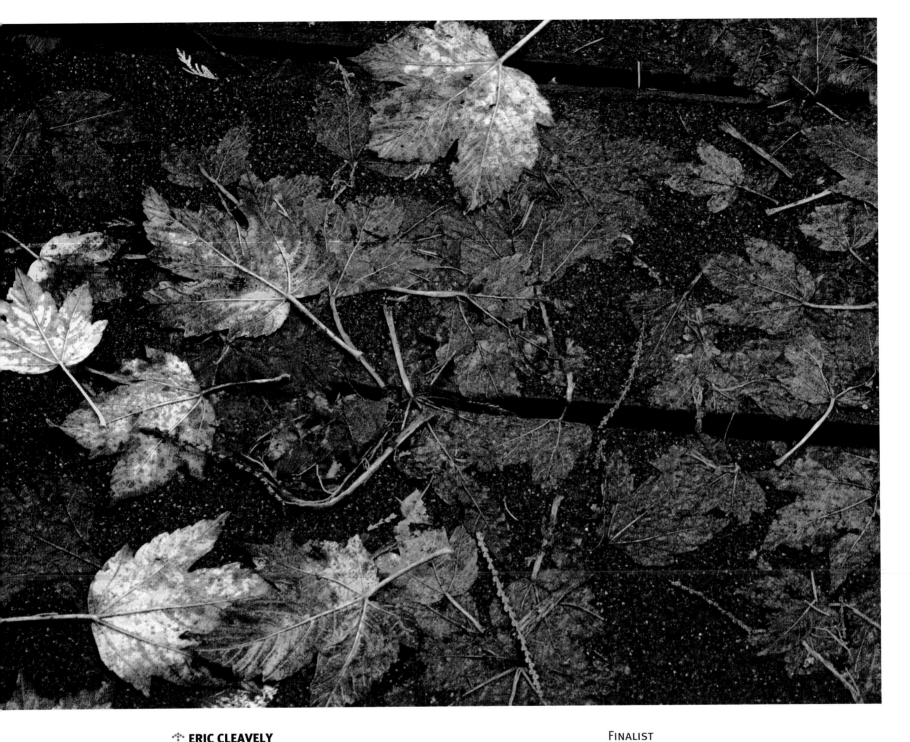

✝ **ERIC CLEAVELY** FINALIST

Autumn abstract.
Grasmere, Cumbria, England.

These sycamore leaves were lying on the boards of a small wooden bridge, and had been flattened by people walking over them. The image seemed to be symbolic of autumn, with the fallen leaves painted by nature, time and, unconsciously, by people treading over them – creating a palette of autumn colour.

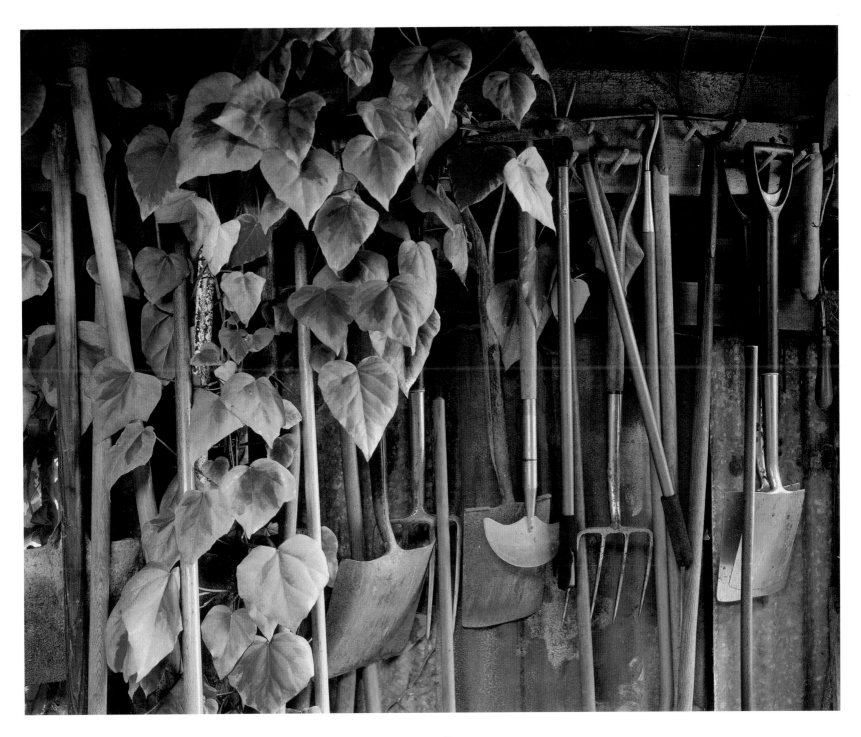

LIAM GRANT COMMENDED

Tools.
Cooksmill Green, Essex, England.

This picture is a behind-the-scenes representation of the hard work that makes my
grandfather's garden a riot of shape and colour, year after year. The ivy wrapping itself
around the tools really emphasises how much a part of the garden they are.

PLANT PORTRAITS

JUDGE'S CHOICE

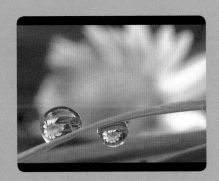

ALAN BRYANT

DAISIES ON DEWDROPS

Of the many images submitted for the Plant Portrait category, this photograph – which was taken after a rain shower – fulfilled the criteria for this class better than any other, in my opinion. However it was achieved, it demonstrated outstanding technique and a highly original treatment of the subject.

Gordon Rae

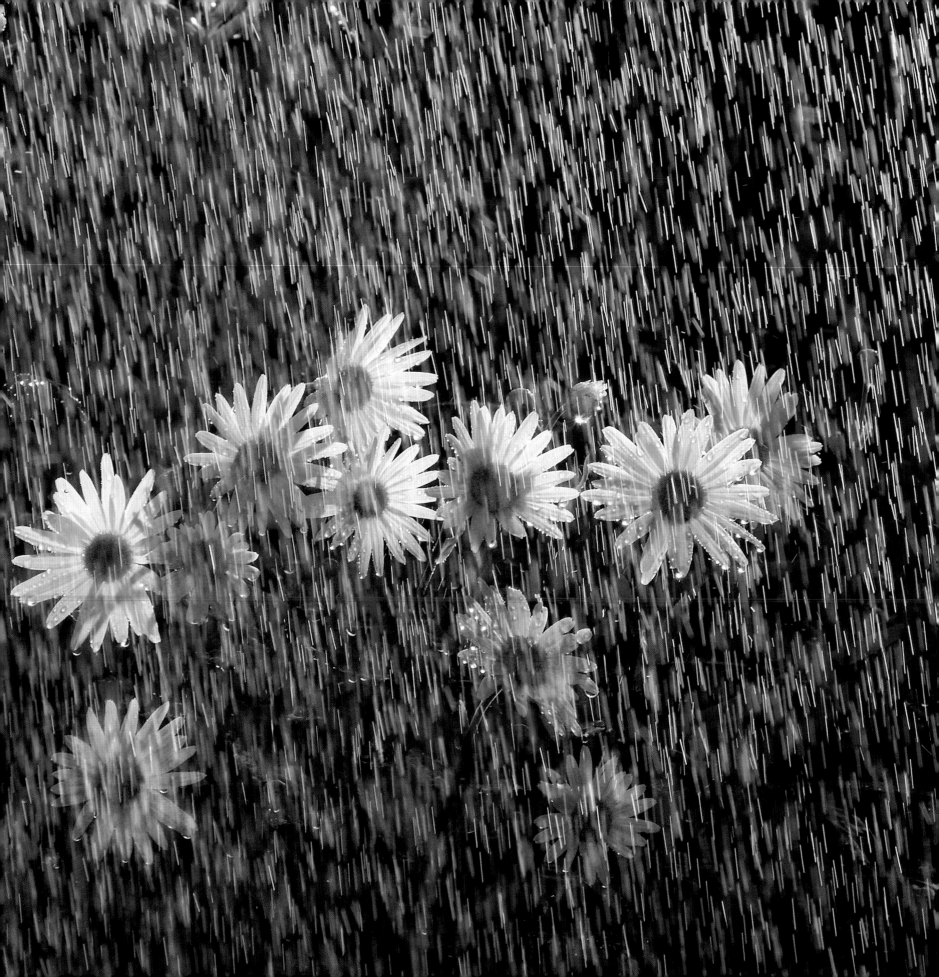

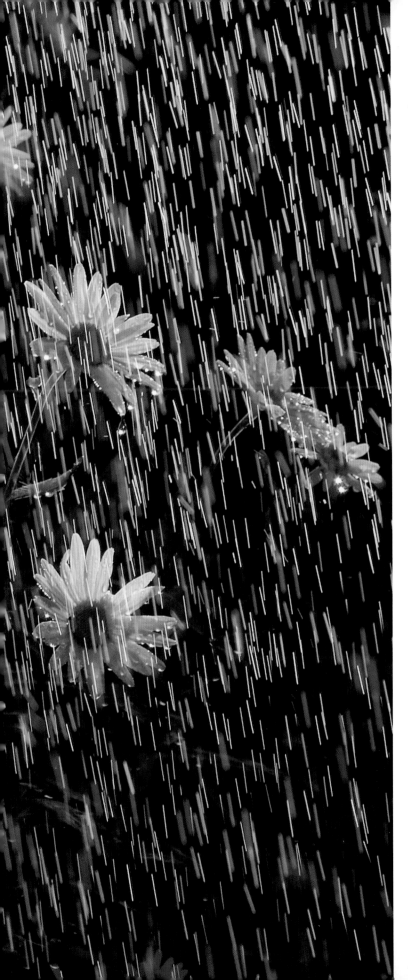

CHINCH GRYNIEWICZ

FIRST

Marguerites in rain.
(*Leucanthemum* x *superbum*). The Gower, South Wales.

The beautiful light is the reason for me taking this picture. I love the way the flower heads and raindrops are glowing backlit against the dark background. For me, the picture sums up the atmosphere of a sudden summer shower in a flower garden, with the flower heads stretching towards the life-giving water.

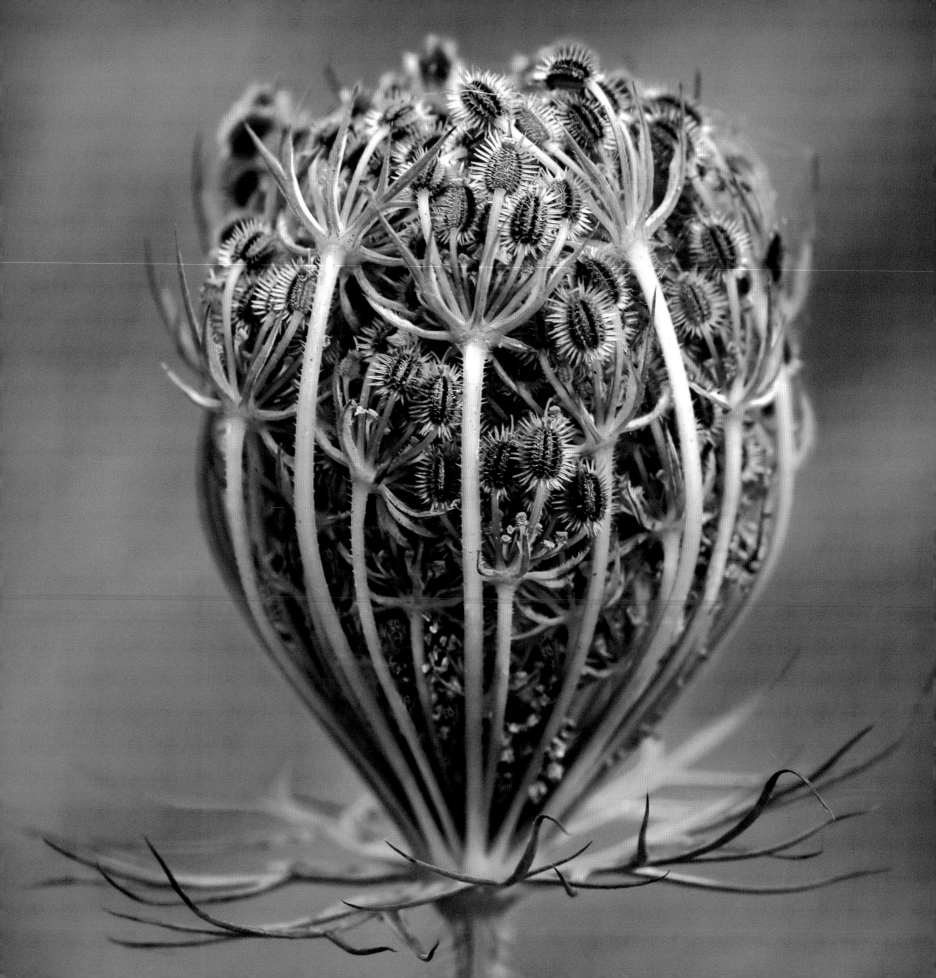

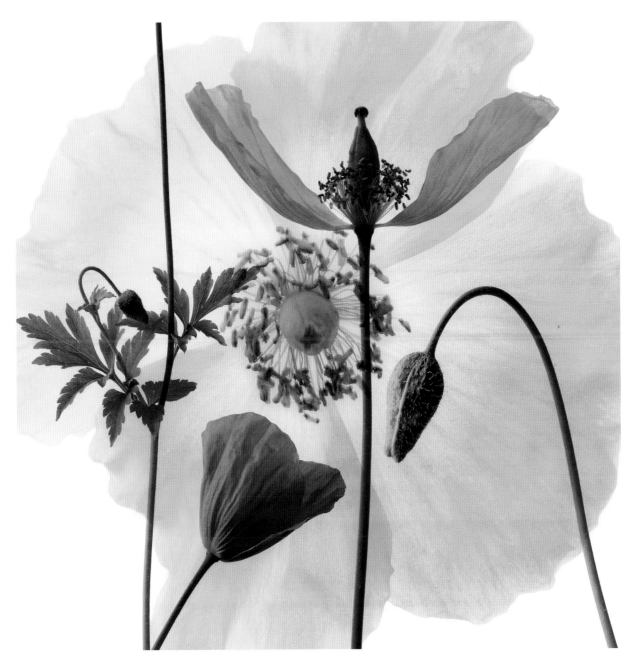

DIANE VARNER

SECOND

Bound to prosper
(*Daucus carota*). Montara, California, USA.

I was drawn to this plant for its graceful beauty, its attention to detail with its hundreds of jewel-like seeds and its ability to protect itself by compressing into a tightly woven nest. It spoke volumes about the universal aspect of new beginnings, accompanied with hope.

RICHARD FREESTONE

THIRD

Welsh poppy
(*Meconopsis cambrica*). Photographer's studio, Derbyshire, England.

I've always admired the skill of the pre-photography botanical illustrators. I particularly like the illustrations where the artist has combined a number of elements of one plant – a bloom, bulb and leaf, for example – in a single composition. This was my inspiration.

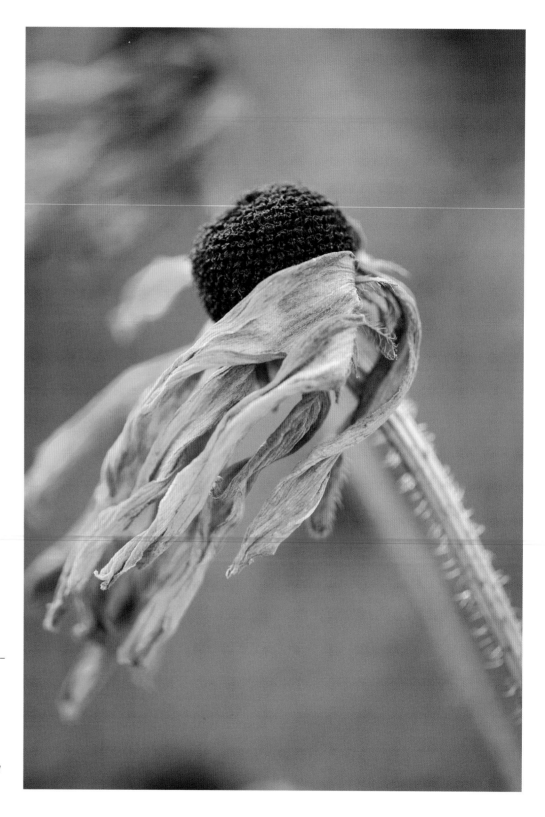

PERNILLA BERGDAHL ···❖ FINALIST

Windswept rudbeckias.
Sweden.

These beautifully coloured rudbeckias caught my eye across the
large garden I visited in late October – mainly because the orange
was so intense. As I went closer, I noticed they had been shaped by
the wind and rain. It was a quite extraordinary sight.

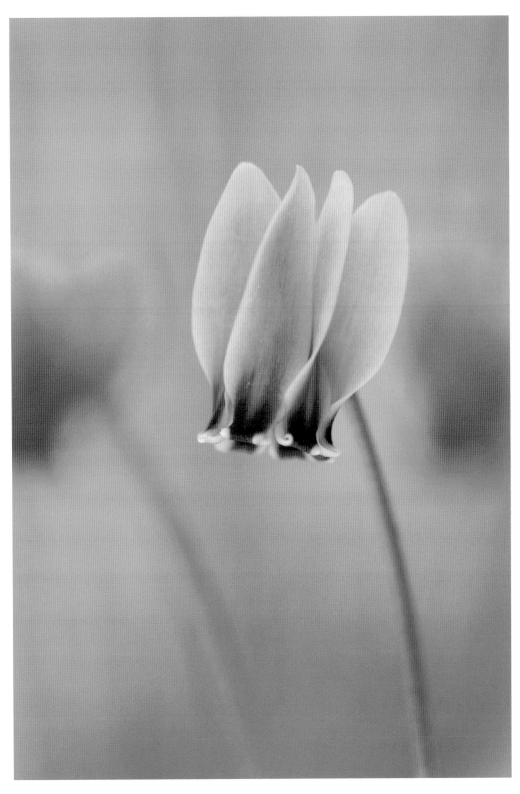

GERALD MAJUMDAR FINALIST

Cyclamen hederifolium.
Honeybrook House Cottage, Kidderminster,
Worcestershire, England.

The flowers provide a small but beautiful splash of colour in our woodland garden at a time when most plants are starting to slow down as autumn takes hold. Getting down low and close allows you to see their true beauty.

KENNETH STIRLING COMMENDED

Botanical studies. Melbourne, Australia.

These photographs are part of an ongoing series of botanical studies which is primarily concerned with life and death, with the start and the end looping around and touching. All the subjects were grown in my garden, so I had the pleasure of watching the plants grow throughout the season. This intimacy became the most crucial aspect of the photographs. I wanted to get inside the plant and project out from that place beyond the physical.

Sinar 5x4in view camera and Mamiya RB67, Nikkor-w 135mm and Mamiya 80mm, f/8, Kodak Tri-X 320
I would look at the subject for weeks or months, trying to understand it and obtain a point from which to start. From there I would allow the photograph to happen and just follow the signs until the end.

1–Bells-of-Ireland calyx. (*Moluccella laevis*)
2–Sunflower seedhead. (*Helianthus annuus*)
3–Cultivated tobacco seed pods. (*Nicotiana tabacum*)
4–Opium poppy seed pod. (*Papaver somniferum*)
5–Dandelion seedhead (*Taraxacum officinale*)
6–Honesty seed pod (*Lunaria annua*)

1

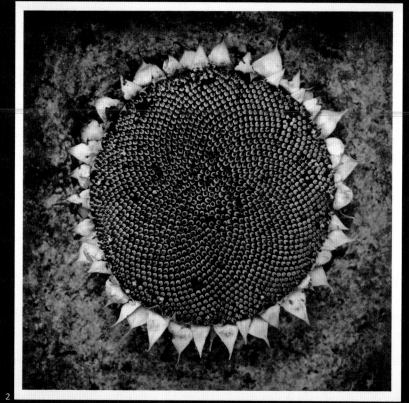

2

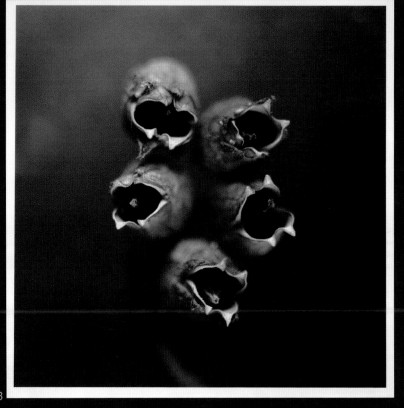

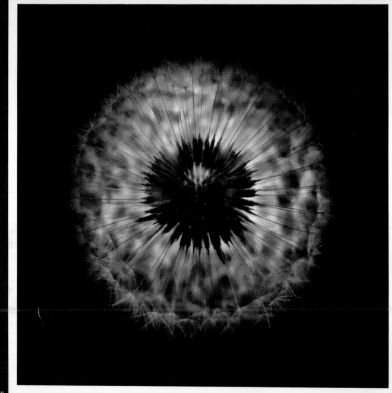

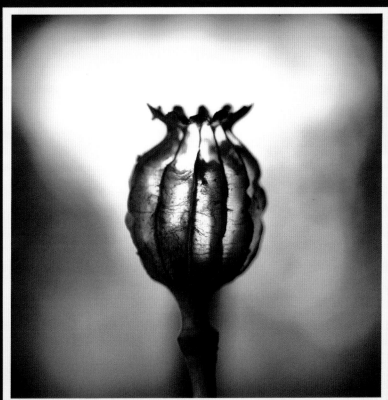

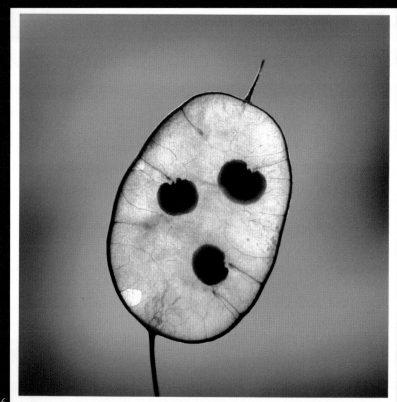

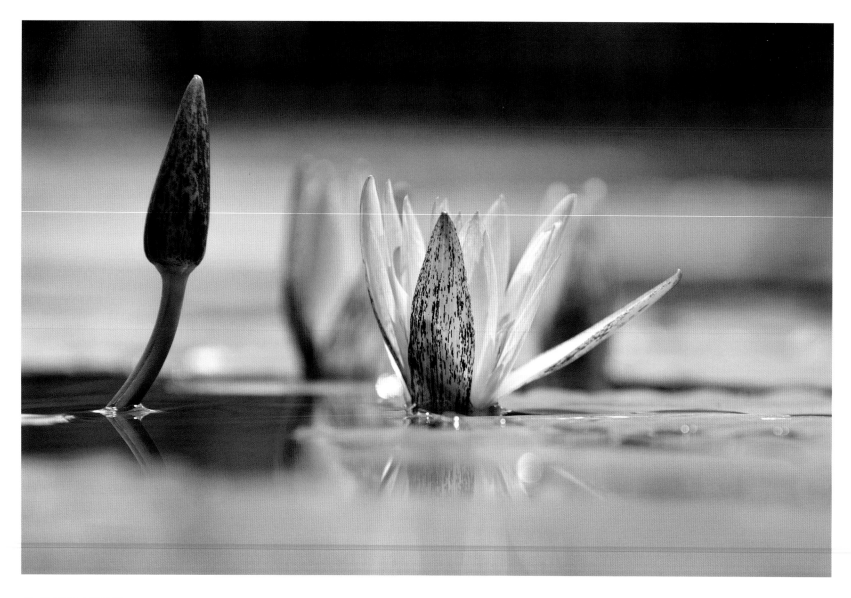

⚜ STUART ALLEN — FINALIST

JAKE EASTHAM ⋯⟩ — FINALIST

Lily pond.
Princess of Wales Conservatory, the Royal Botanic Gardens, Kew, England.

Sweet pea pod and seeds.
Salisbury, Wiltshire, England.

I felt that being able to capture this scene from an unusual perspective, and with the glow of light shining down, would bring out the calmness of the scene, where two lilies – one closed and one partially open – drank in the morning sunshine.

My wife had grown some wonderful sweet peas on hazel sticks. We were tidying up and wanted to keep the seeds for the following year, but it was only when I opened the pods that I could see how perfectly the seeds interlock when inside. Clever woman, Mother Nature!

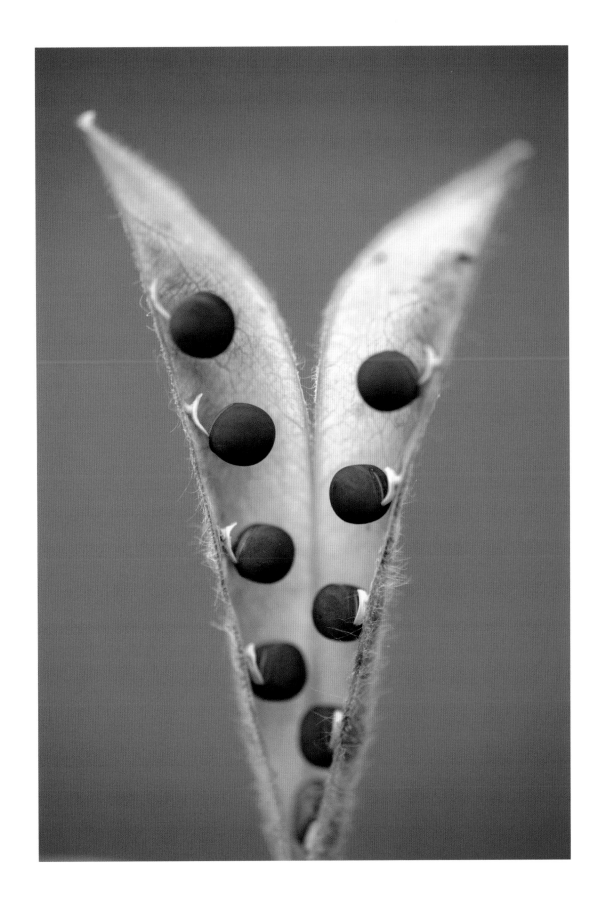

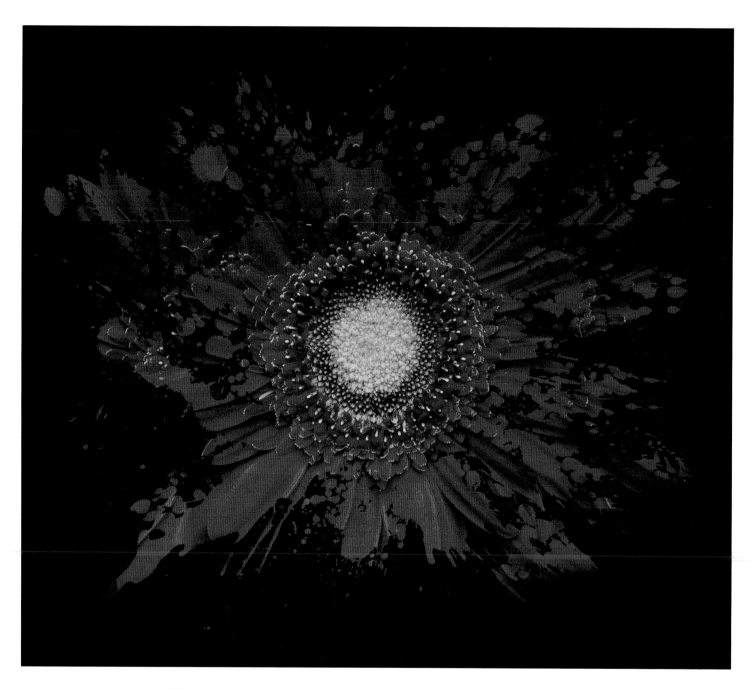

🕆 RICHARD FREESTONE COMMENDED

Red splash.
Photographer's studio, Derbyshire, England.

A pot full of red gerberas, particularly in winter, create a wonderful splash of colour. I wanted
to make an image that illustrated the word, 'splash'.

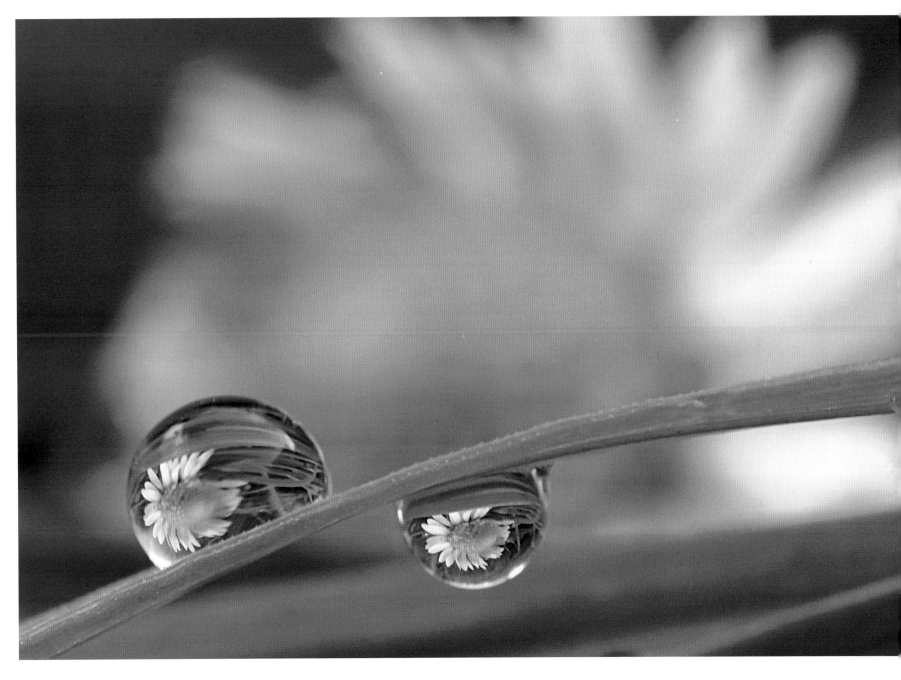

🌿 **ALAN BRYANT** FINALIST

Daisies on dewdrops.
Photographer's garden, Bristol, England.

It always amazes me how a small raindrop or dewdrop can magnify whatever is in the background. I wanted to
do something different with the common daisy, so came up with this idea, which I took in my garden following a
brief rain shower. I singled out the two drops that were on the blade of grass in front of the daisy, making sure they
created a balanced composition.

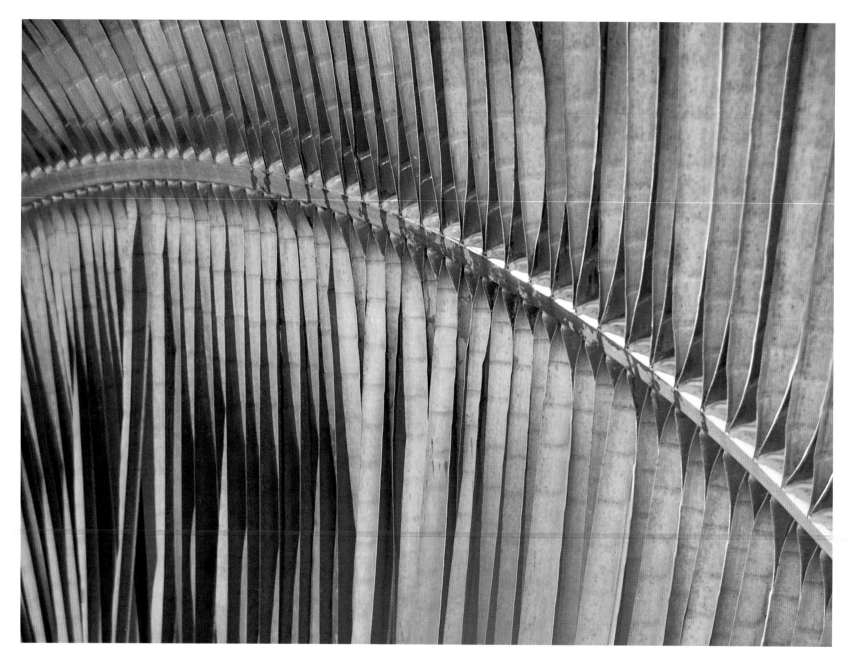

🌿 **JOANNA CLEGG** FINALIST

Jungle blind.
The Palm House, the Royal Botanic Gardens, Kew, England.

I was attracted to these huge palm fronds by their graphic details, in particular the contrast between the gentle curve of the stiff leaf stalk and the highly linear nature of the leaf blades. I was also captivated by the pleats in the leaf blades, which provided variations in tone.

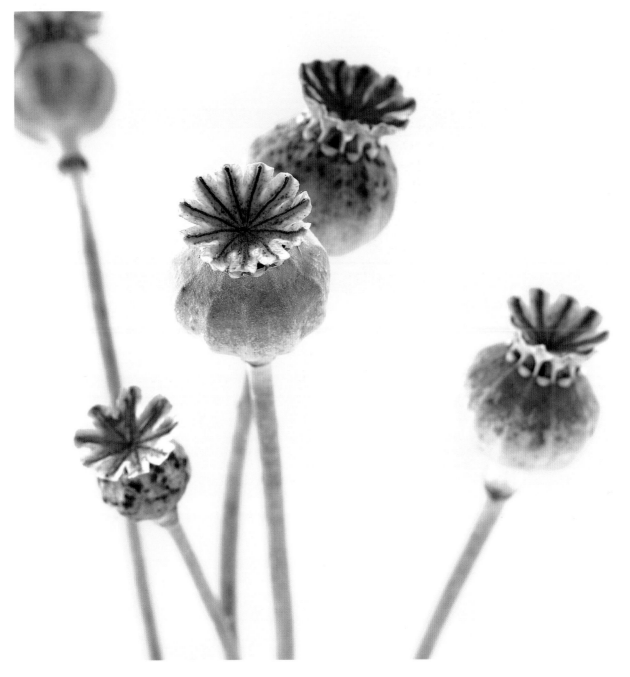

LUCY BIRNIE

Poppy seed heads.
Norfolk, England.

The amazing amount of detail in these poppy seed heads – which I came across while gardening – intrigued me.
The structure they provided to the garden really stood out, and their delicate papery texture had transformed into
something very strong with great earthy colours. This meant their appearance was very different from that which is
normally associated with the word 'poppy'.

CAROLINE HYMAN

Botanical studies.

The wonderful plant and flower prints from the Victorian era inspired me to make a botanical series using the camera and monochrome film.

Hasselblad, Ilford HP5 Plus.
The plants were photographed against plain backgrounds with soft light available. The black and white prints were sepia toned, then hand tinted.

1–*Crocus chrysanthus* and *Galanthus nivalis*
2–*Hyacinthoides hispanica*
3–*Ranunculus bulbosus*
4–*Allium schoenoprasum*
5–*Arum maculatum*
6–*Muscari botryoides*

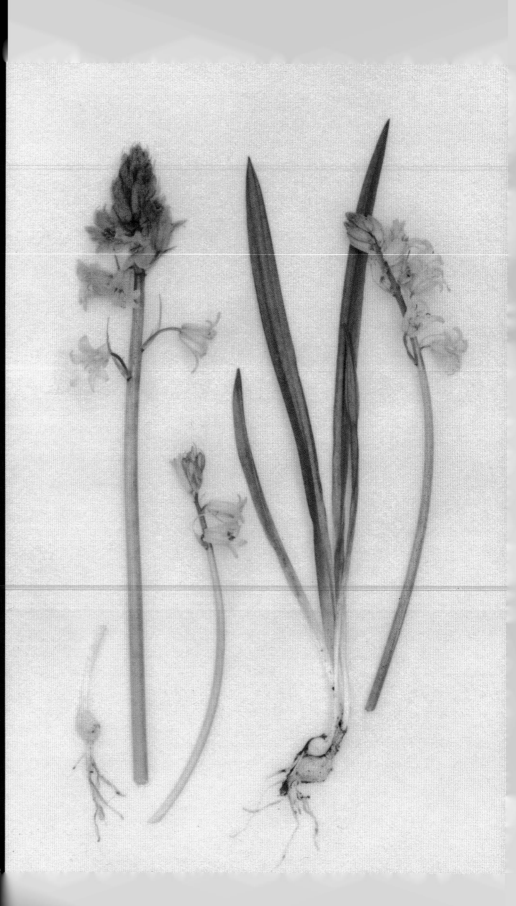

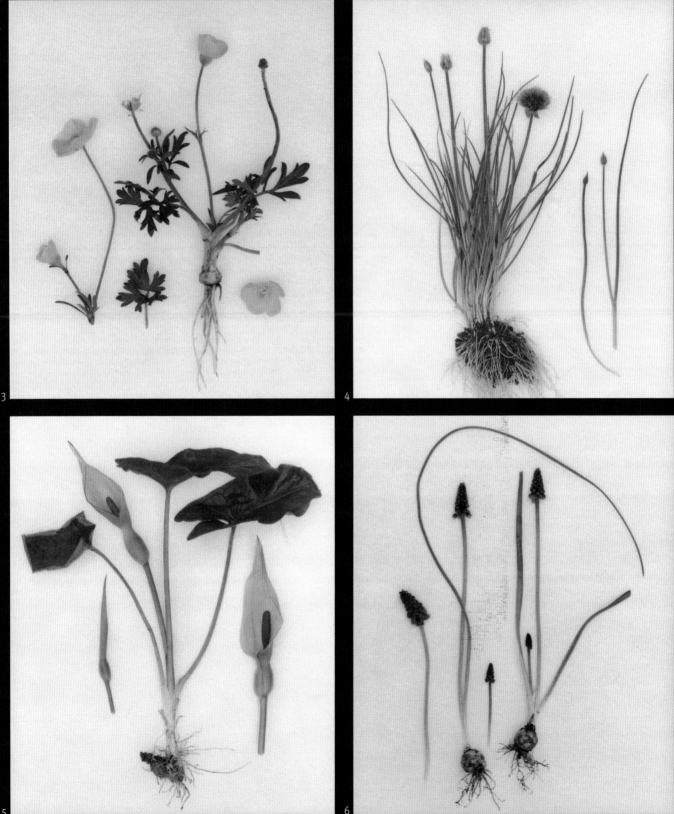

3

4

5

6

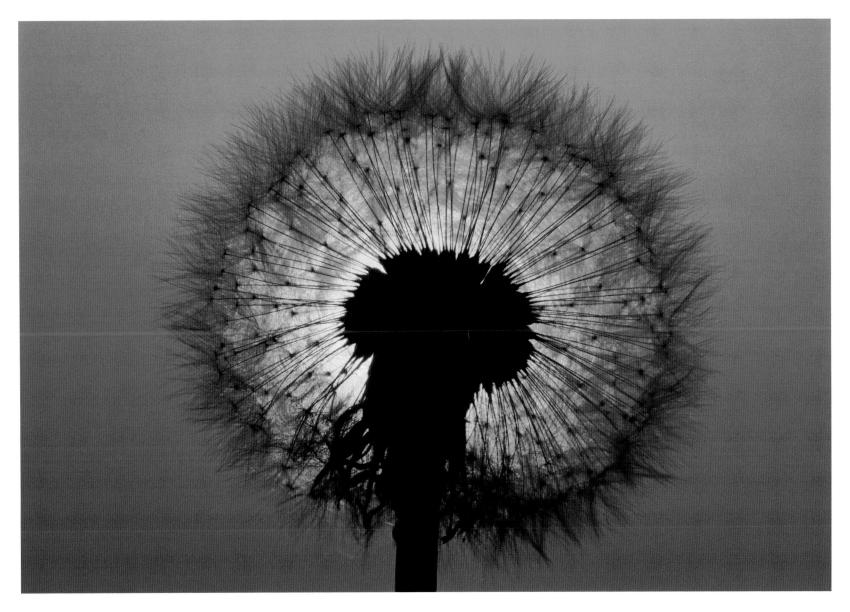

PHIL MANN FINALIST

Standing Proud.
Cornflower (*Centaurea cyanus*). Manley, Cheshire, England.

I originally intended to capture a wide view of the wild flower meadow but found myself drawn toward the vivid blue of the cornflowers. Their colour stood out among the predominant reds, whites and yellows of the others.

DUNCAN USHER FINALIST

Dandelion 1381.
Photographer's garden, Germany.

The symmetrical structure of the seed head is a visual natural work of art, and when set against the light, the seed heads and plumes are distinctive in their fragile beauty. In a late evening light they appear to glow. To achieve this backlit shot it was crucial that I placed the setting sun directly behind the seed head, achieving the effect of the individual seed heads with each plume accentuated.

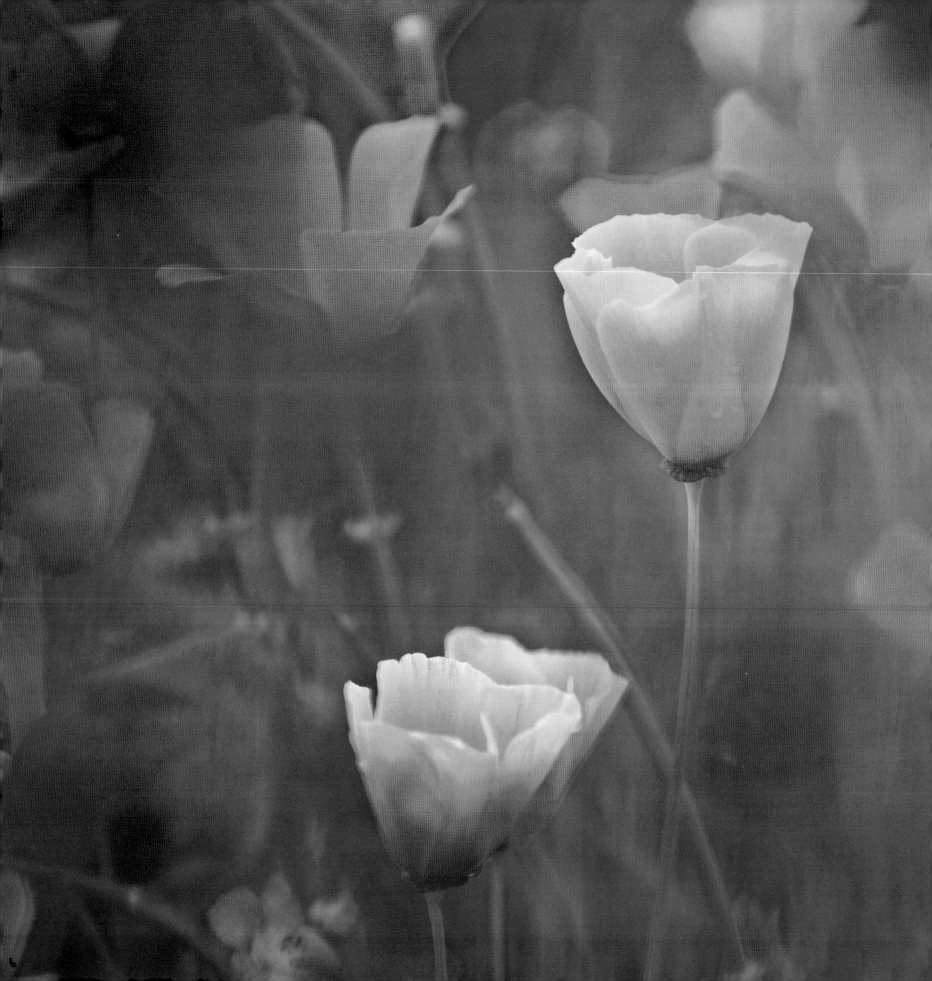

⤺ DENNIS FRATES COMMENDED

Californian poppies.
Wildflower garden, University of Oregon, USA.

I loved the complementary colours of blue and orange in this scene. I also saw that, because of the arrangement, I could blur the blue Bachelor's buttons while keeping a poppy or two in focus.

(Bachelor's buttons is the common name in the US for *Centaurea cyanus*, the common cornflower.)

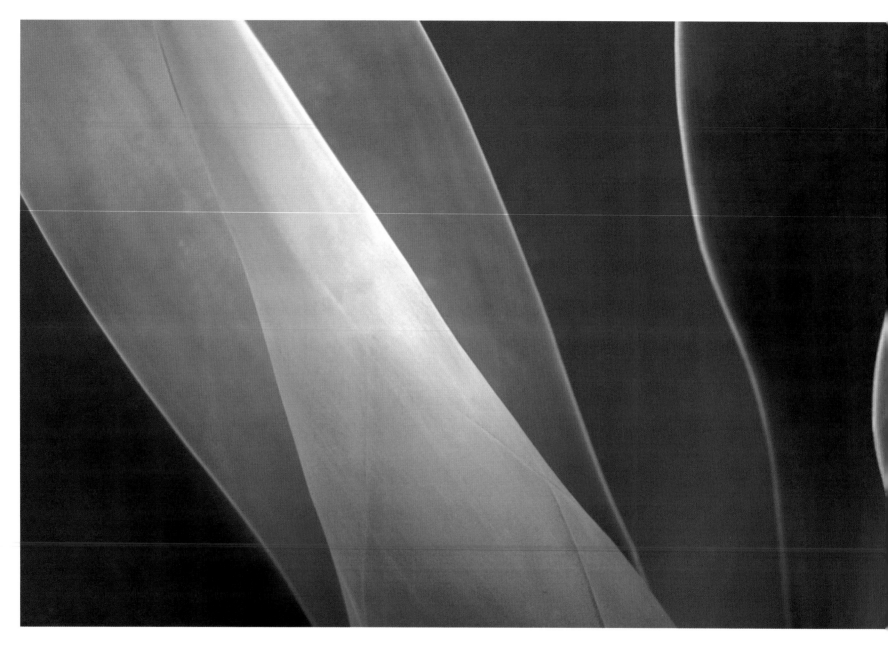

⁂ GARY BUTTLE FINALIST

Agave attenuata.
Lanzarote, Canary Islands.

The soft, blue-green shades of the agave leaves seemed to contrast with the hard
lines of the leaf edges. I liked the strong, architectural appearance of this plant, which
I photographed in a dry garden in March 2007.

ANDY SMALL ⋯⋗ COMMENDED

Nigella seed head.
Well Cottage, Hampshire, England.

I felt the beading of the rain on this plant gave it the appearance of a jewel.

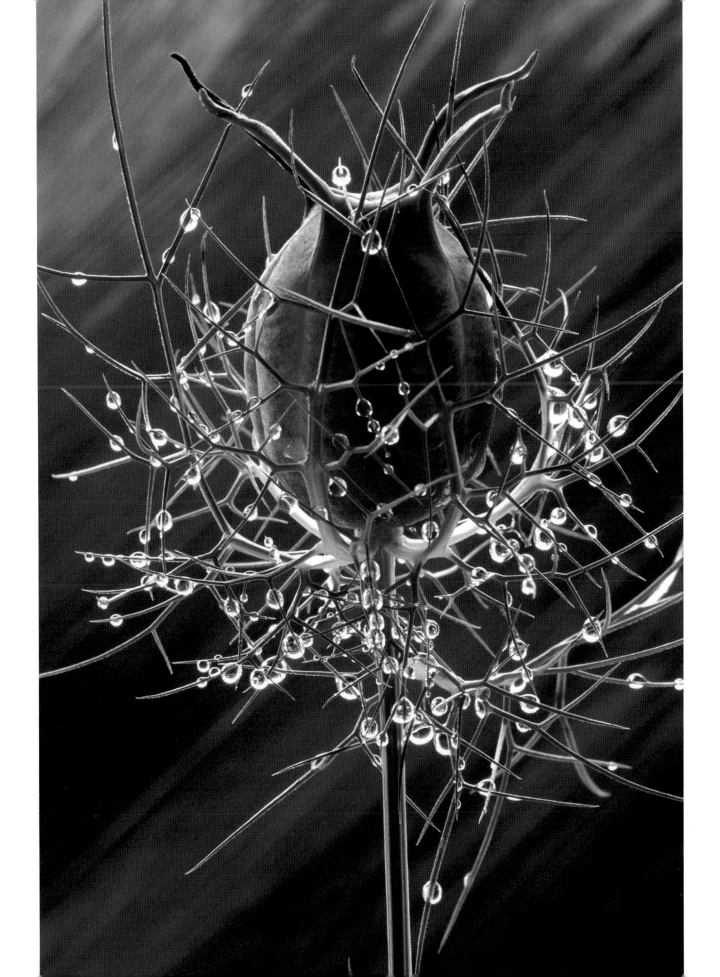

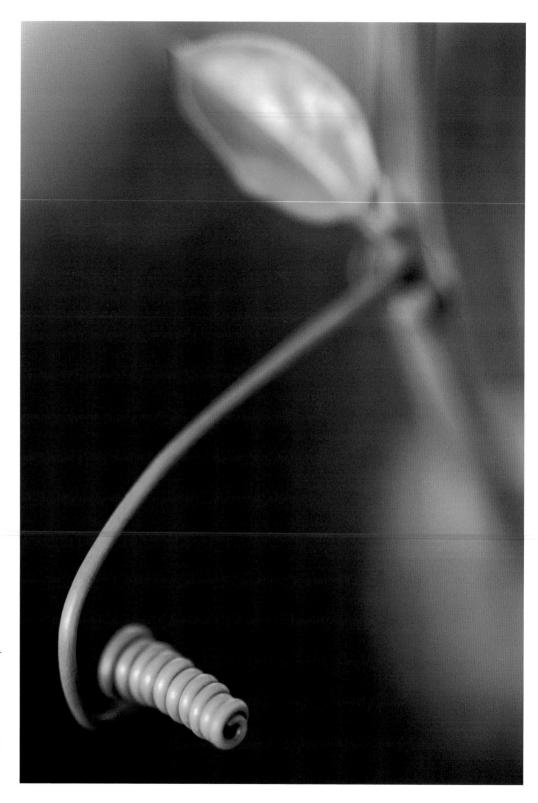

RICHARD BLOOM ···⊹· COMMENDED

Ficus pumila tendril.
Funchal, Madeira

The tendril was coiled tightly, and its strength and effectiveness
were palpable as it stretched out to find something to which it could
attach itself. It reminded me of a tightly coiled spring, and I was
inspired by its power and grace.

⟵ TINA HERZIG FINALIST

Lisianthus (*Eustoma grandiflorum*).
Photographer's studio at home, Hessen, Germany.

The unique beauty of this bud captivated me, so I decided to show off its perfect form and lines. The wonderful colour and the velvety surface of the petals act as a symbol for the art of nature and the fragile wonder of living.

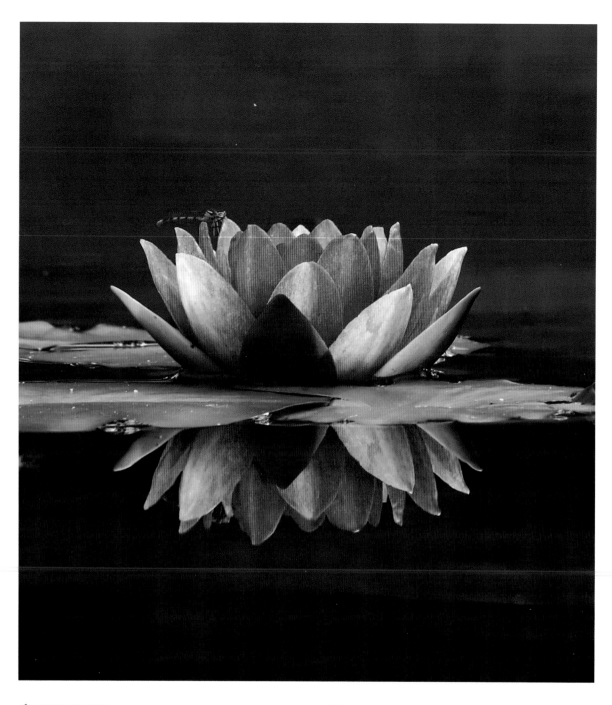

TONY KEENE

Water lily.
Photographer's garden, Somerset, England. Azure Damselfly
(*Coenagrion puella*) alights on *Nymphaea* 'Pink Opal'.

The pink of this first water lily to appear in our new pond sang out in the soft light against
the black of the pond liner and the cool greens of the reflected trees. The sharp blue
damselfly was a bonus.

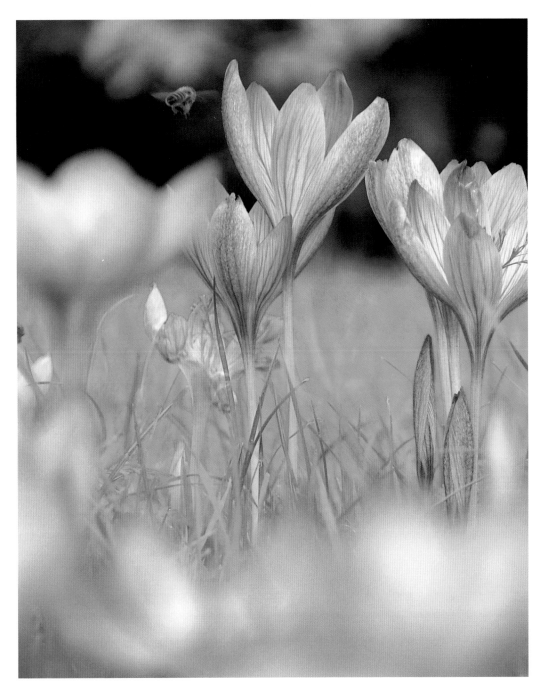

TONY WHYTE

Autumn crocuses and honeybees.
(*Crocus speciosus*). The Royal Botanic Gardens, Kew, England.

After taking shelter from a brief rainstorm, I noticed this beautiful cluster of autumn crocuses in a quiet corner of Kew Gardens. As I prepared to take the shot, a honeybee flew into the scene; I was only able to grab one photograph before it flew off. After the rain, with the weak late-afternoon sun filtering through the trees, the crocuses and especially the surrounding grass appeared almost luminous.

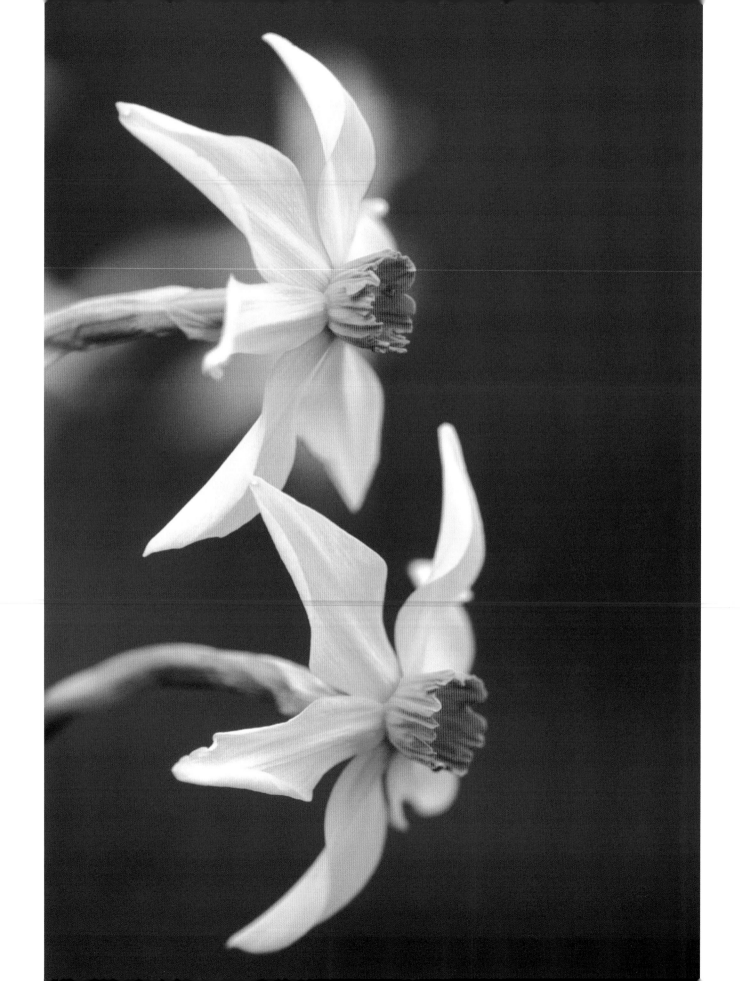

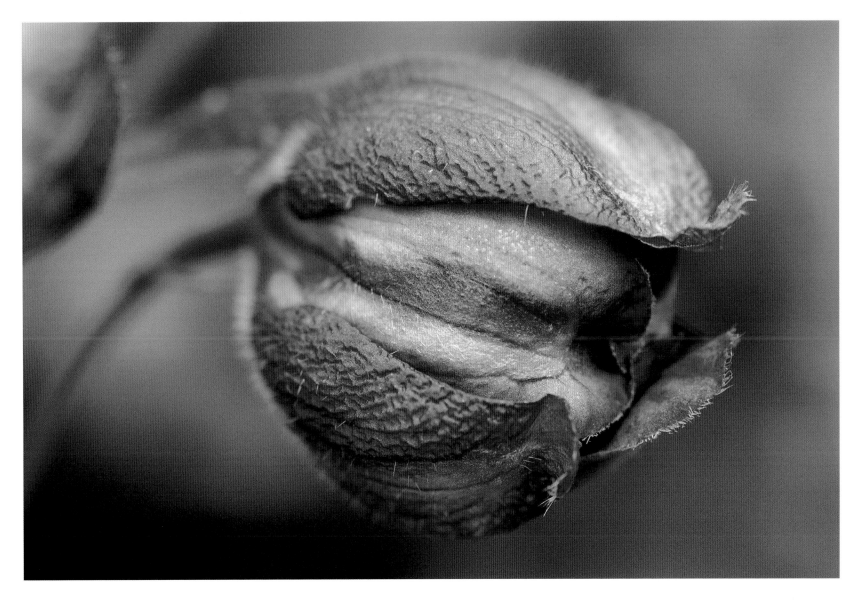

JO WHITWORTH COMMENDED

Narcissus 'Firebrand'.
RHS Garden Wisley, England.

The light was stunning – unusually diffused, evening sunlight, which gave the plants a translucent quality. These two little narcissi were enchanting: small and delicate with swept-back petals and thrusting bright little faces.

SUE BISHOP COMMENDED

Delphinium bud.

A bud almost ready to open on a *Delphinium* 'Vanessa Mae' displays a spectrum of jewel-like colours. It is set against the soft blues and mauves of an open flower on the same plant. I was immediately attracted by the glorious deep blues and purples, and noticed the colours in the buds were even richer than in the open flowers. I also liked the crinkled texture of the bud's outer petals, and the tiny hairs at the petal tips.

DIANNA JAZWINSKI

Grass flowers.

The flowers of grasses are very rarely noticed in their own right and I realised, on looking at them very closely, that they feature myriad colours and textures – many indiscernible without magnification. There is a beauty inside them that deserves to be seen.

Canon EOS 350D, Sigma 105mm macro lens
These were all taken early in the season and were under cover in preparation for Chelsea, so any breeze was minimal. I doubt I could have taken the pictures outside with the same detail.

1–*Hyparrhenia hirta villosum*
2–*Bouteloua gracilis*
3–*Stipa gigantea*
4–*Oryzopsis miliacea*
5–*Pennisetum macrourum*
6–*Muhlenbergia dumosa*

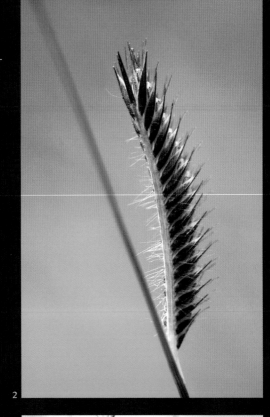

2

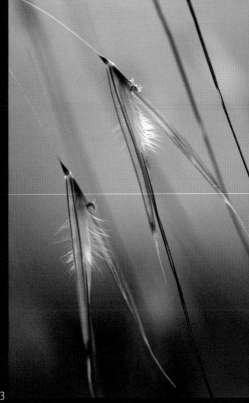

3

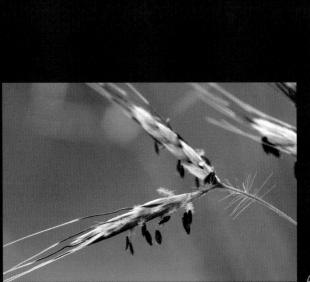

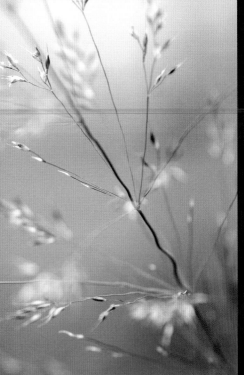

4

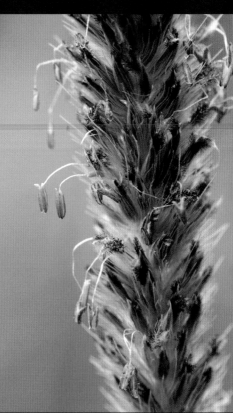

5

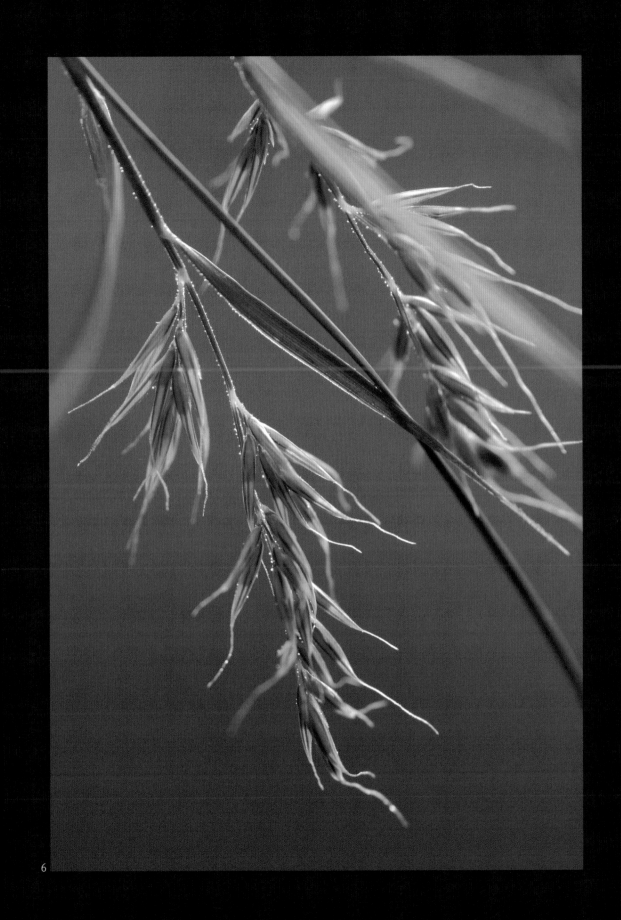

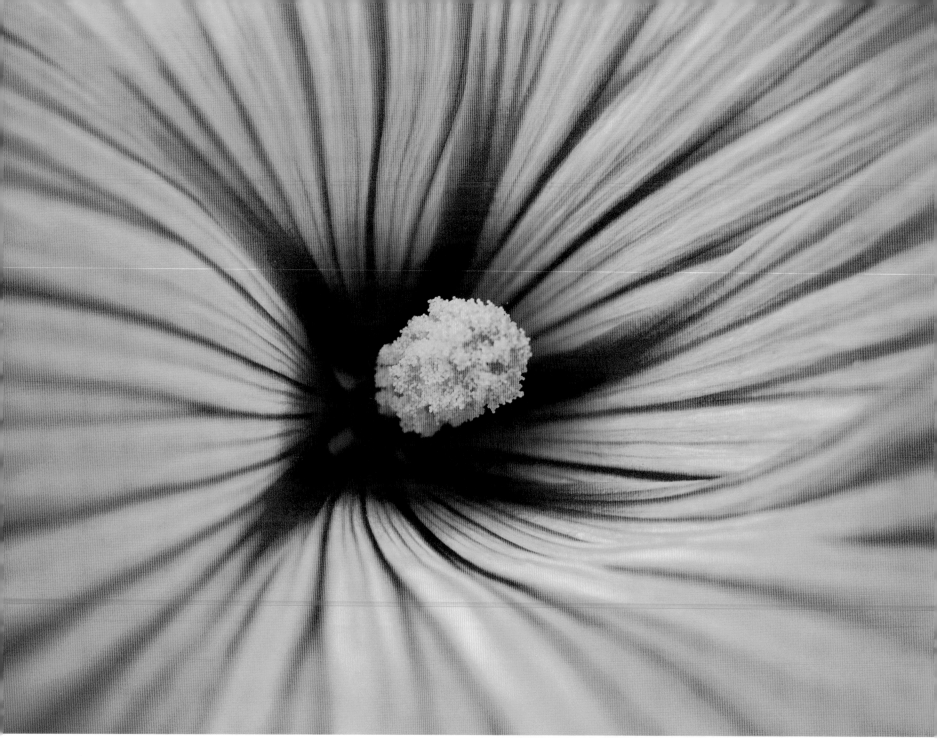

✝ JOHN PETTIGREW COMMENDED

Pink lavatera.
New Glasgow, Nova Scotia, Canada.

I had just recently bought a new camera and was experimenting with it. I took quite
a number of shots of these flowers, but this was my favourite. I was trying to show my
10-year-old daughter how to take flower pictures.

WILLIAM PIERSON ⋯⟩ FINALIST

Water lily emergence.
Freshwater, California, USA.

I was inspired to make this photograph by the beauty and compositional structure of the
image. The juxtaposition of the emerging lily leaf form in green, and the delicate monochrome
willow shadows behind it, add an additional level of complexity and subtle elegance.

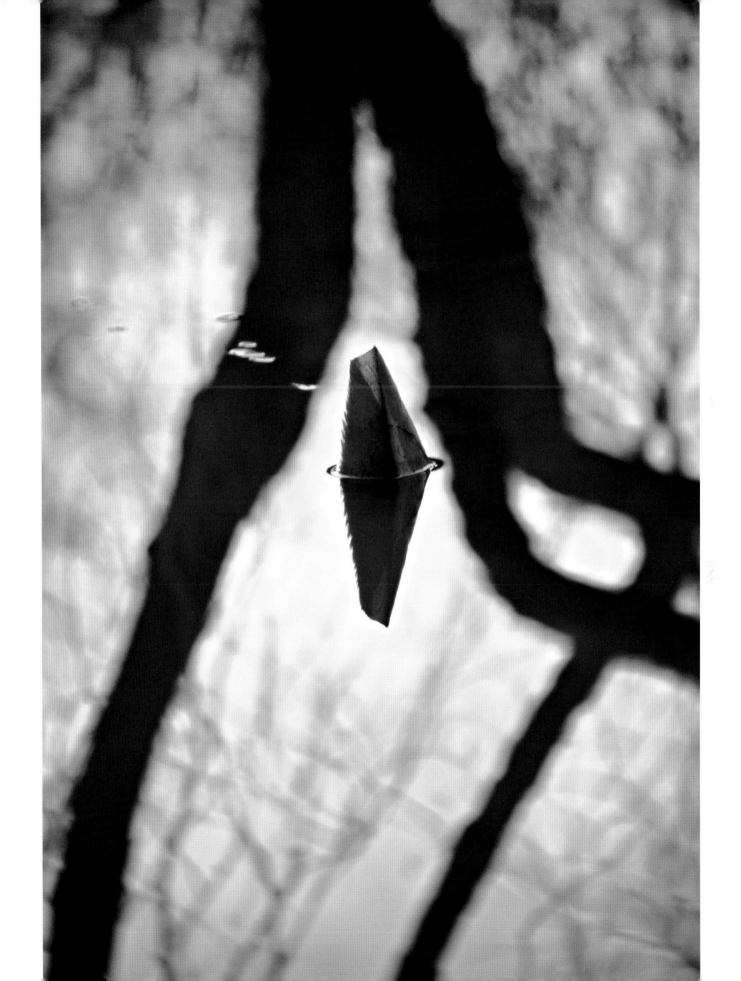

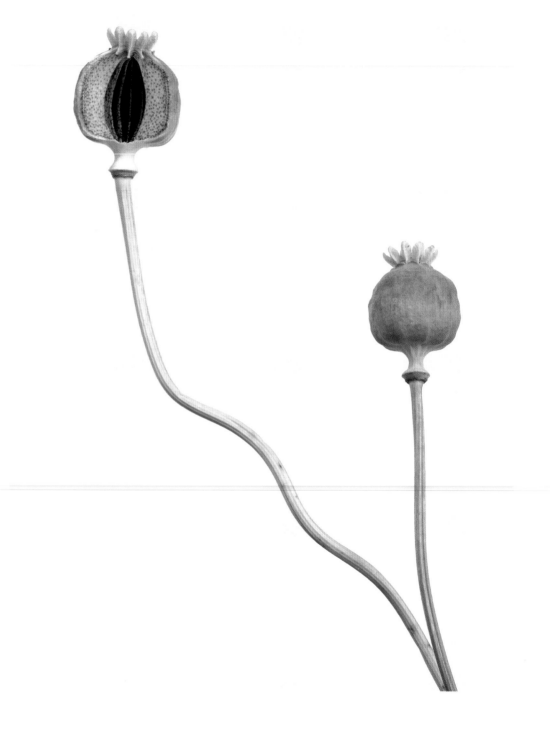

TOM LEE ···❯ COMMENDED

Poppy heads.
(*Papaver somniferum*). Photographer's glass-roofed
kitchen, Twickenham, Middlesex, England.

Two poppy heads – one complete, the other dissected – illustrate
the delicate relationship between the seed casing and its crown.
The beautiful curve of the left hand stem suggests the swimming tail
of a sperm and helps to reinforce ideas about reproduction while
animating an essentially static image.

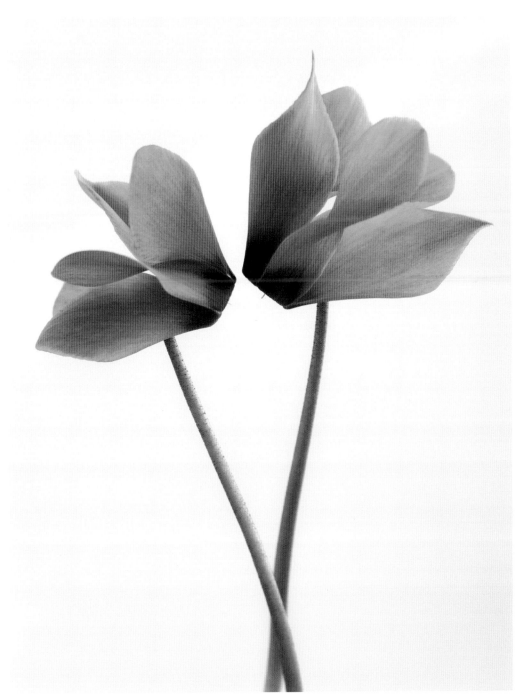

⟨··· DAVE ZUBRASKI COMMENDED

Cyclamen duo (*Cyclamen coum*).
Photographer's home in Uxbridge, Middlesex,
England.

Flowers – and the mind-blowing, endless variations of colour,
texture, pattern and structure that they possess – forever inspire
me. As with most of my photography, I tried to create an image that
has an uplifting, optimistic and harmonious feel.

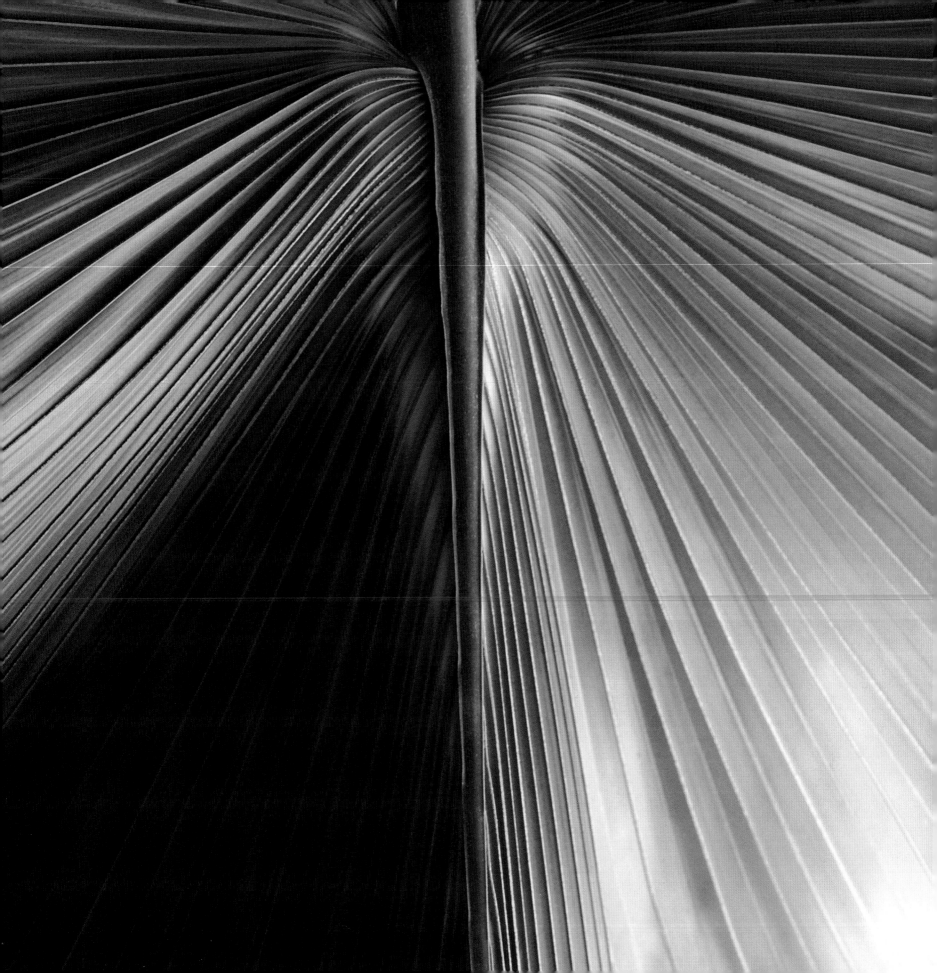

⟨··· CAROL SHARP Commended

Palm.

I wanted to create a graphic abstract image that showed off the seductive folds in a fan palm leaf.

MARTIN KNIPPEL ···⟩ Commended

Green 1.
Mitchell Park Horticultural Conservatory, Milwaukee, Wisconsin, USA.

I am interested primarily in photographing architecture and nature. As I walked through the conservatory I noted the large architectural structures before me in the form of plant life – a nice way of combining my photographic interests.

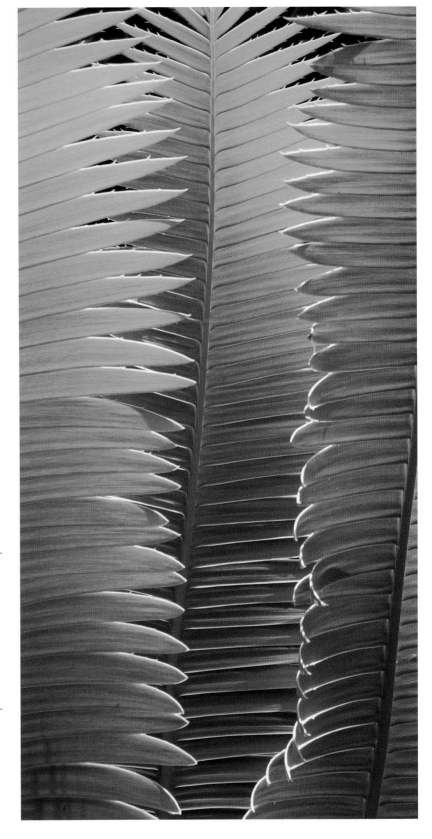

CAROL SHARP

Fascinating ferns.
Old Chimney Garden, Higher Coombe, Buckfastleigh,
Devon, England.

I felt the unfurling fronds showed off the poise, intricacy and
graceful forms of ferns.

*Nikon FM2, 60mm macro lens, Velvia 50. Some background cloning
and blurring carried out.*
I used selective focus to avoid distracting backgrounds and draw
the viewer's attention to the most interesting feature of the fern.

1–Shuttlecock fern (*Matteuccia struthiopteris*)
2–Korean rock fern (*Polystichum tsussimense*)
3–Lady fern (*Athyrium filix-femina*)
4–An unidentified fern frond
5–Male fern (*Dryopteris filix-mas*)
6–Lady fern (*Athyrium filix-femina*)

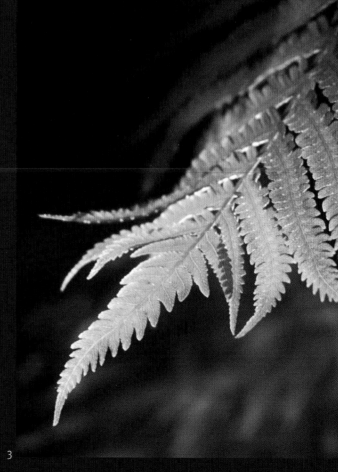

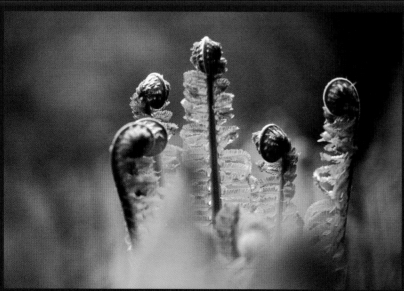

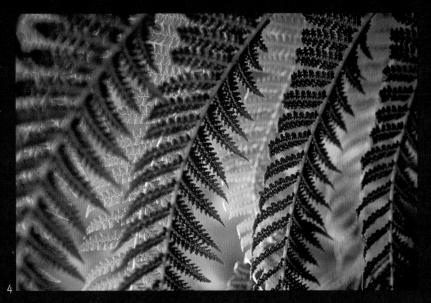

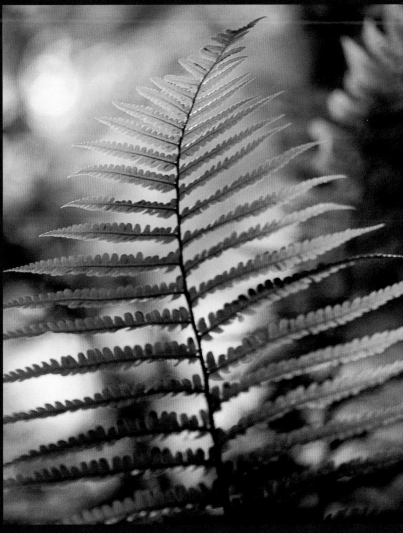

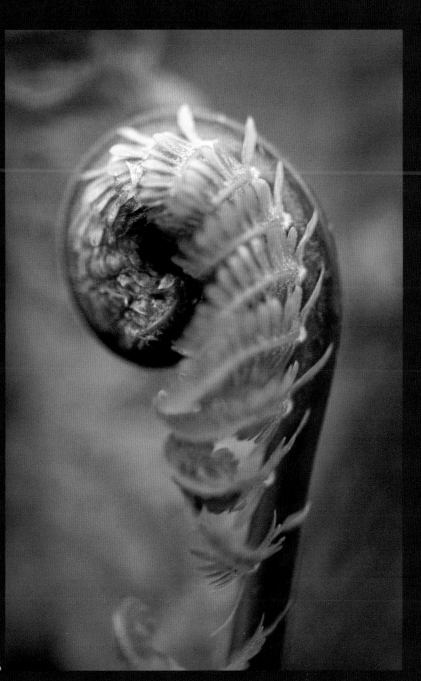

4

5

6

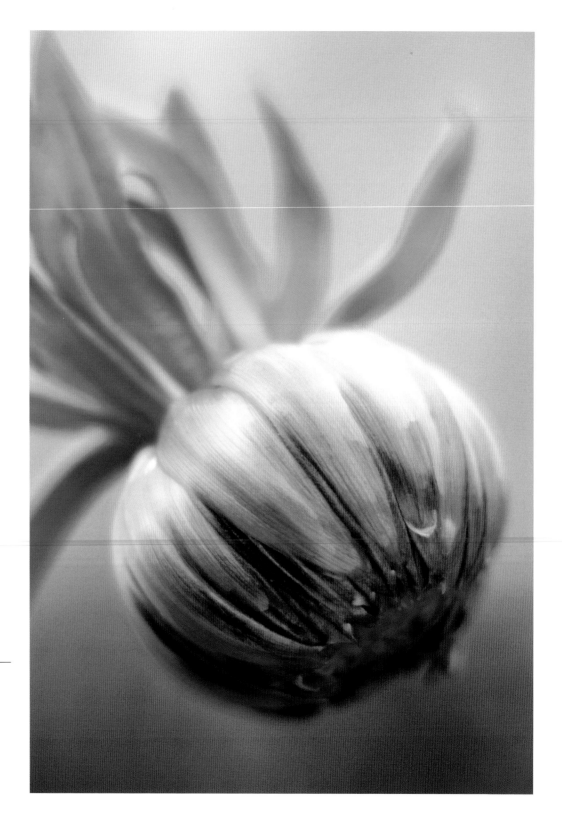

MARCUS HARPUR ⋯⋗ COMMENDED

Dahlia 'Hatfield's Memory'.
RHS Garden Wisley, Surrey. England

While other gardens are fading, Wisley is still a good place to find
beautiful colours in autumn. During 2006, dahlias were being
trialled, and these are a photographer's gift for colour and shape.
Unusually, the colour is showing before the bud is even open.

⁌⋯ CHRIS DOWNING Commended

Clematis 'Doctor Ruppel'

This image was taken in my back garden, just as the sun was coming up over the garden fence. I set myself the challenge of capturing the impact of the brightness in the background without adding flare to the image. I wanted to maintain a crisp sharp image at the point of focus and then create a slow softness towards the edges.

TREES

DANIEL KENCKE

SEQUOIA GROVE

I particularly like this photograph because it encapsulates the true sense of a Sequoia forest habitat. The detail is beautifully captured, with the upright columns of the trunks and their differently coloured barks. The young Redwood, growing through, adds new life to an ancient forest. Although a picture may take only a short time to make, this one probably took about 1,000 to 2,000 years to set up.

Tony Kirkham

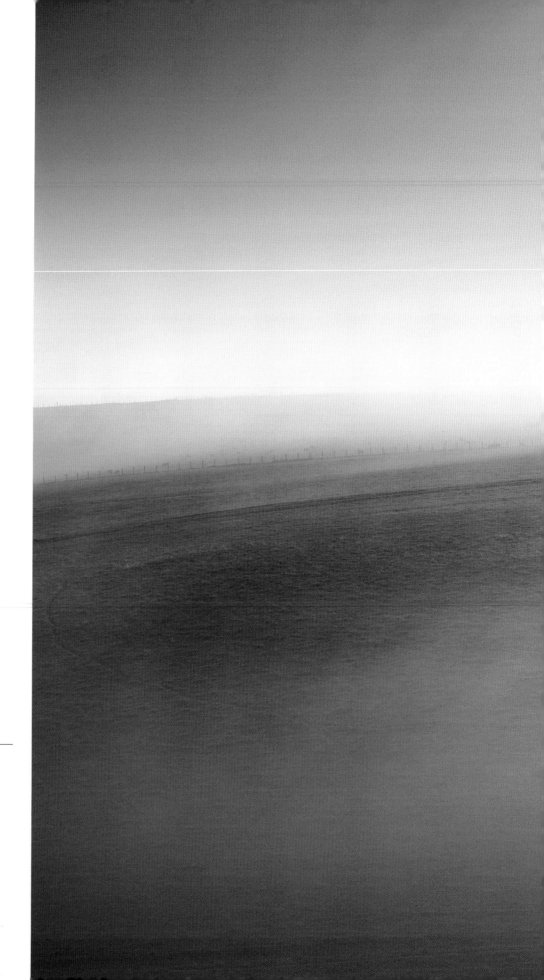

COLIN ROBERTS ⤏　　　　　　　　FIRST

Ash tree on the Downs.
(*Fraxinus excelsior*). The South Downs, England.

I'm always inspired by isolated trees, and the way in which they make a prominent focal point in the landscape. This solitary ash tree must endure some fierce gales year after year, but it still stands proud on the brow of a hill. On this occasion, I captured it in the first rays of sunlight as the mist began to clear.

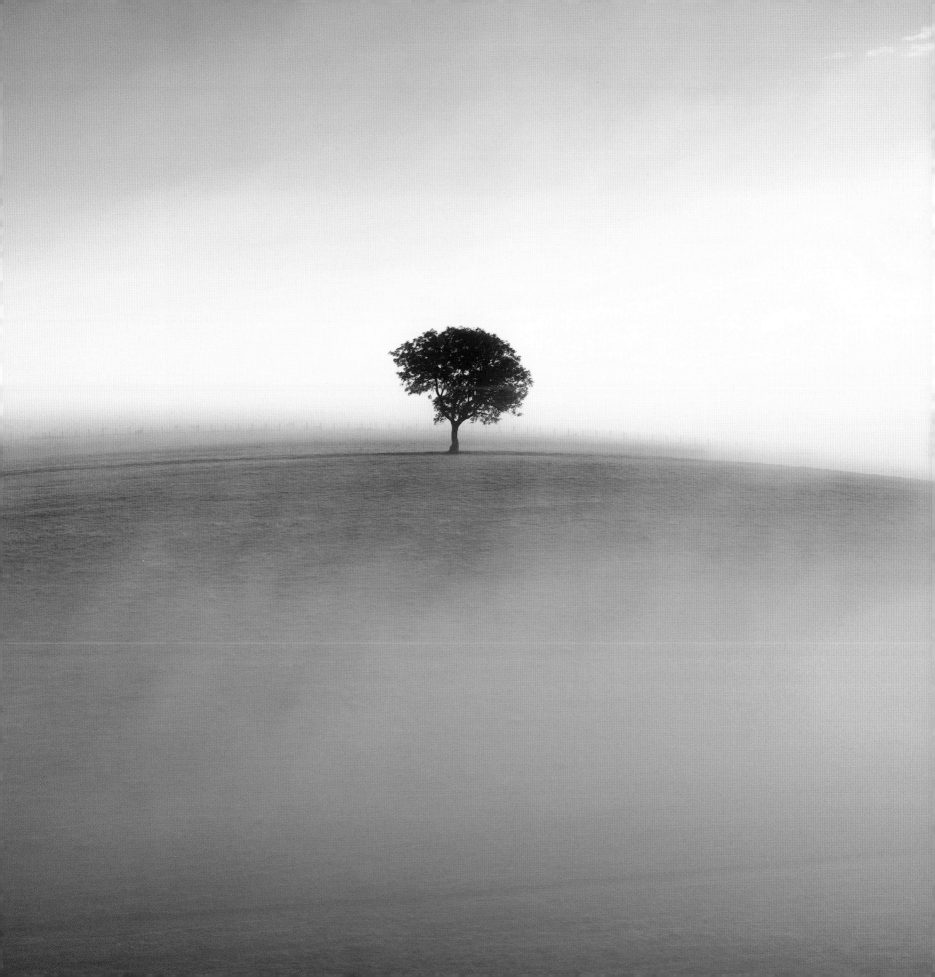

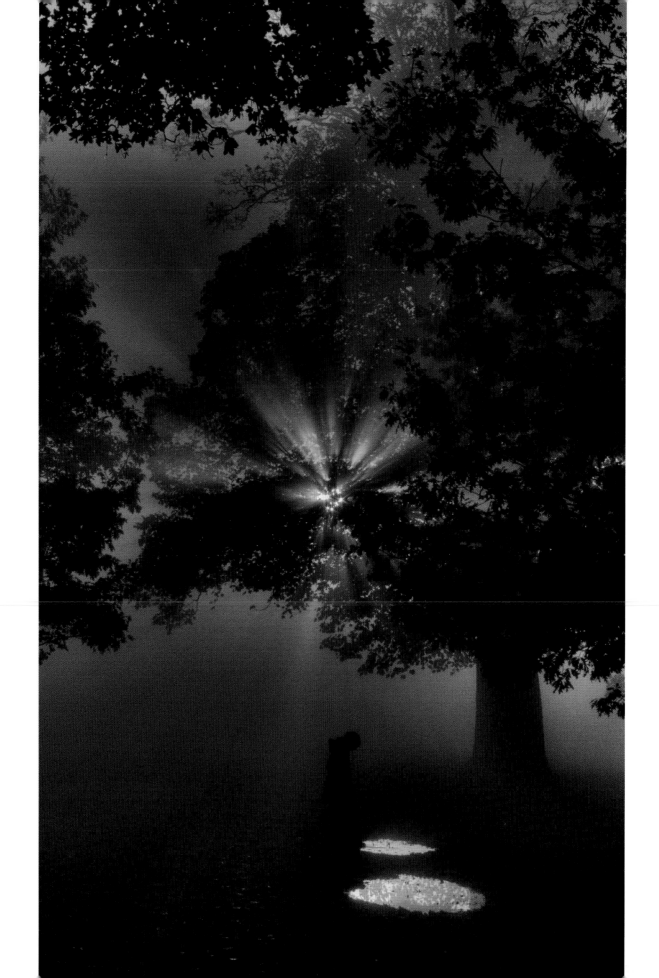

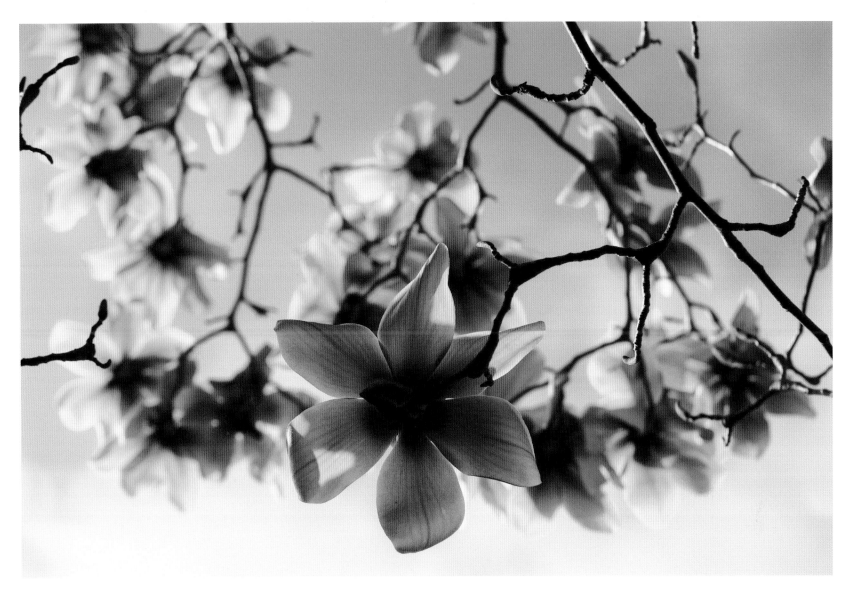

ROBERT JONES

Reflection.
Woods in West Sussex, England.

It was a frosty and misty Sunday morning, which, I anticipated, would be beautiful in the park. I even managed to persuade my 11-year-old daughter to come with me, and we were there in time to watch the sunrise through the trees.

MARK BOLTON

Magnolia blooms.
Cornwall, England.

The contrast of these blooms against the blue sky is what caught my eye on this occasion.

DANIEL KENCKE ···⟫

Sequoia grove.
(*Sequoiadendron giganteum*). Sequoia National Park, California, USA.

To walk among the ancient 700-year-old trees in this grove at Sequoia National Park inspired awe and reverence. When I found this composition, which contained a young sequoia relatively the same age as myself, I felt a connection of place and time I had never before experienced.

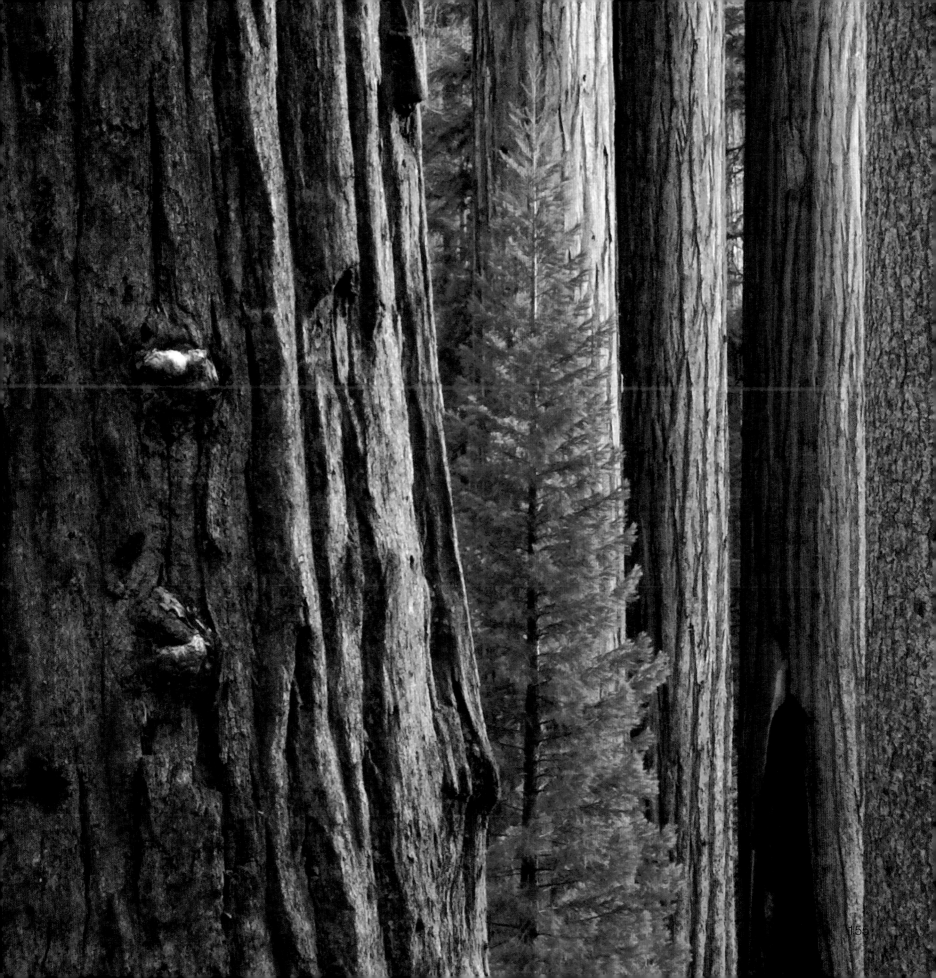

PAUL DEBOIS

Pinhole impressions. RHS Garden Wisley, Surrey, England.

My inspiration for this series of photographs came from the desire to explore motion and the effects of wind on trees, and I felt this could be best achieved with a pinhole camera. The inspiration came from seeing early pigment/platinum prints by Edward Steichen. Having spent the last seven years or so working with digital, which is usually incredibly sharp and precise, I wanted to produce a set of images that were much softer and less technical in approach.

Pinhole camera, f/158, 120 colour negative
The series was produced during just two visits to RHS Wisley. A pinhole camera has no viewfinder and you are relying on pure instinct and luck; I found this 'back to basics' approach very refreshing.

1–Weeping Beech (*Fagus sylvatica* 'Pendula')
2–Lime (*Tilia tomentosa*)
3–Poplar
4–Poplar
5–*Acer henryi*
6–Lime (*Tilia tomentosa*)

1

2

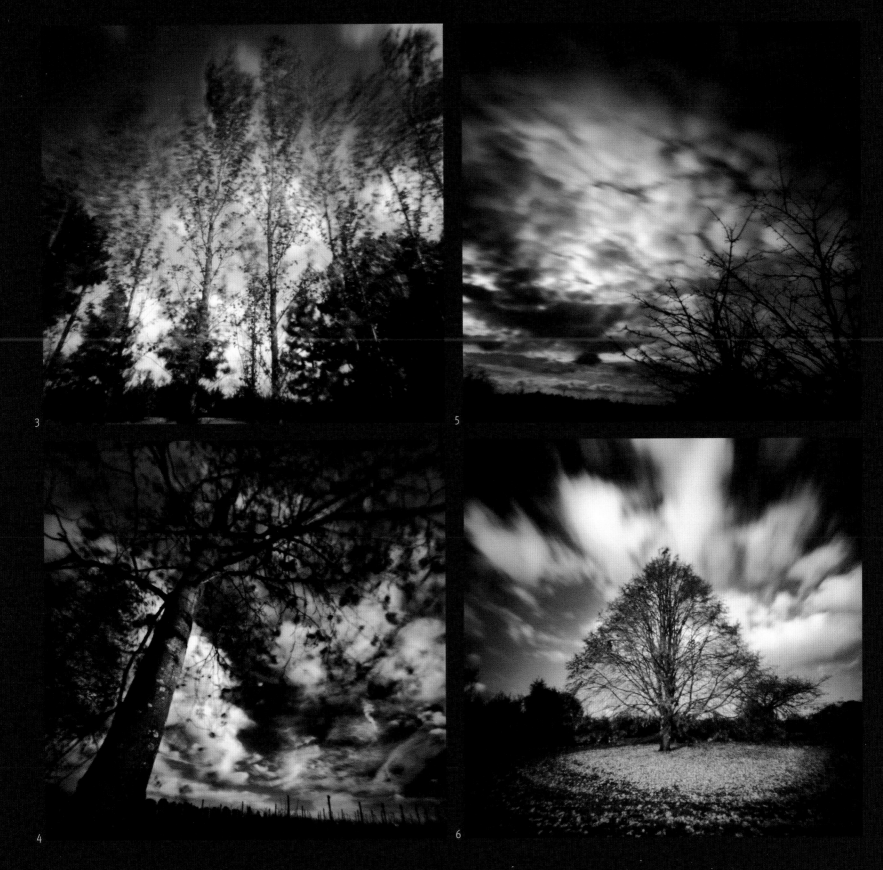

3

5

4

6

157

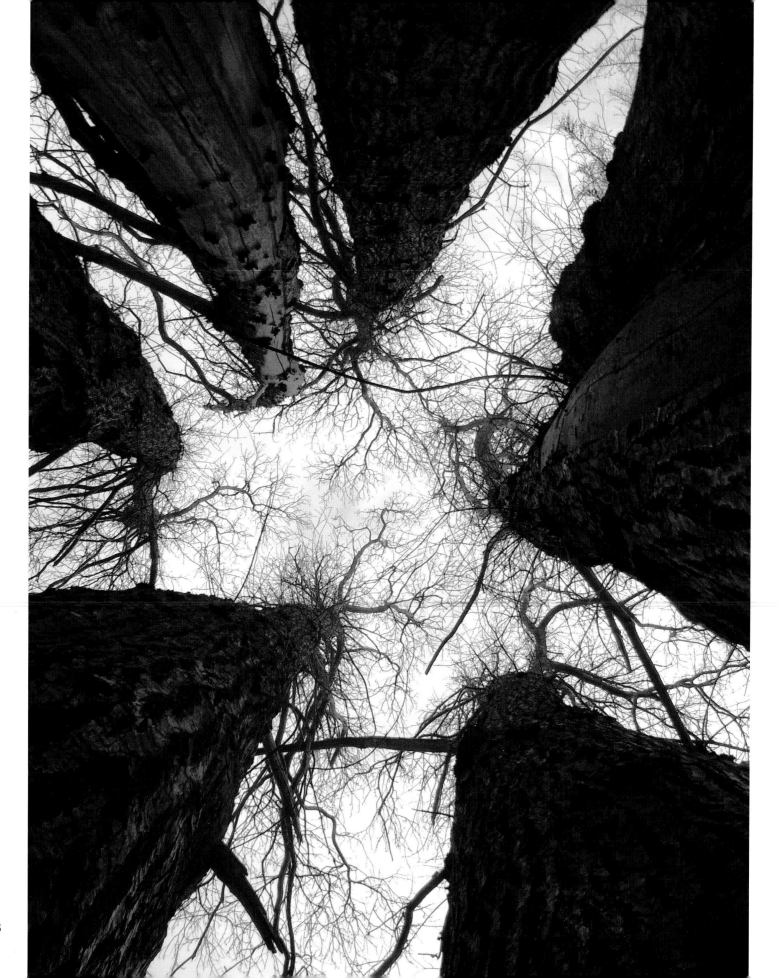

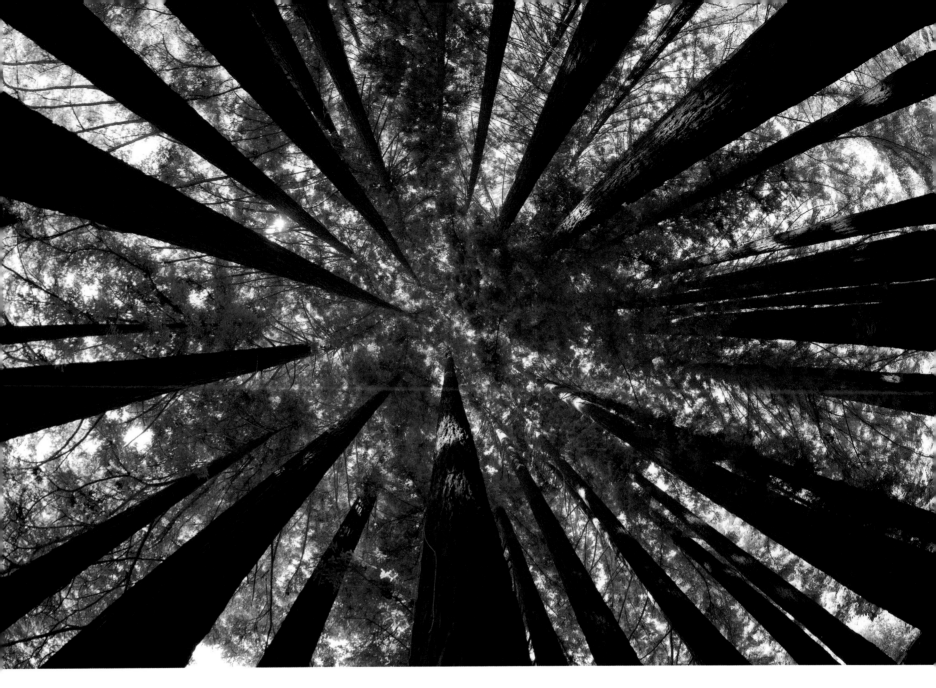

JUNE KINGSBURY FINALIST

Seven sisters.
Sweet chestnut tree (*Castanea sativa*). Pullingshill Wood,
Buckinghamshire, England.

As children, my brother and I played inside this tree, which is found in Pullingshill Wood. It provided a sanctuary. During summer the canopy conceals the sky, but in winter it is open and the seven trunks spread up towards the clouds. This photograph is taken from inside those trunks; it was late in the day and the light was failing. Although the sky is still bright, shadows are beginning to obscure any detail.

DAVID SIMCHOCK COMMENDED

Reach for the sky.
Giant Redwoods (*Sequoiadendron giganteum*). Loma Mar, California,
USA.

The title of this photograph is self-explanatory; I wanted to draw the viewer into the image and towards the sky beyond the grove of giant Redwood trees. The fisheye lens was essential to help me achieve this.

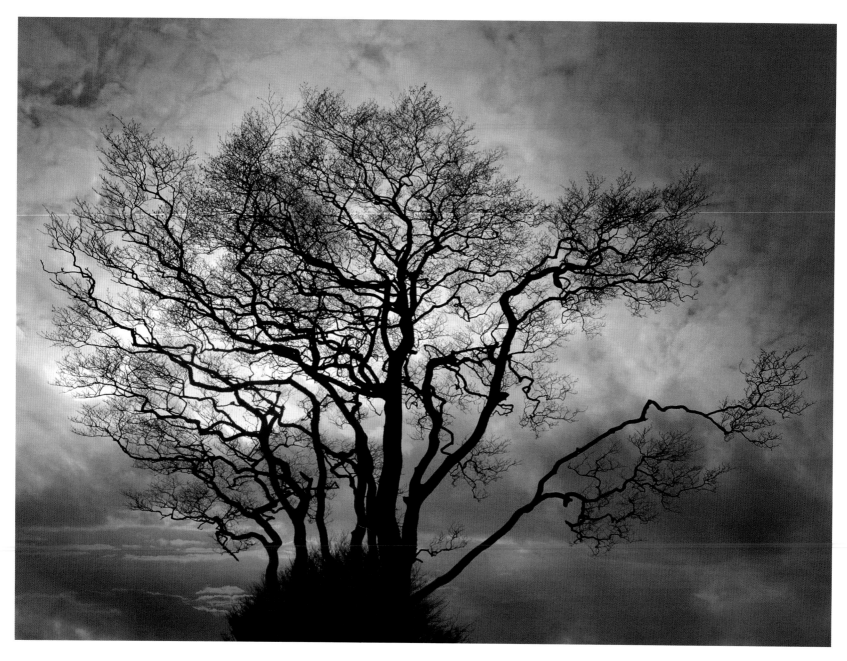

NICK SHEPHERD ⋯⋗ FINALIST COMMENDED

Naked beauty.
Near Blackawton, South Devon, England.

It was winter when I noticed this tree – silhouetted against a moody sky and anchored to a raised mound of earth – from a remote country lane between the villages of Strete and Blackawton in South Devon. I believe that the true beauty of a tree's form can only be appreciated in isolation and once it has shed its leaves – hence the title I chose for this photograph.

Autumn alder reflections.
(*Alnus glutinosa*). Hembury Woods, South Devon, England.

The beauty of the trees and their associated autumnal colours were reflected in the River Dart on this calm morning. I wanted to capture a different sort of photograph, so made the reflection the main element of the composition in order to emphasise the scene's tranquillity, warmth and depth of colour.

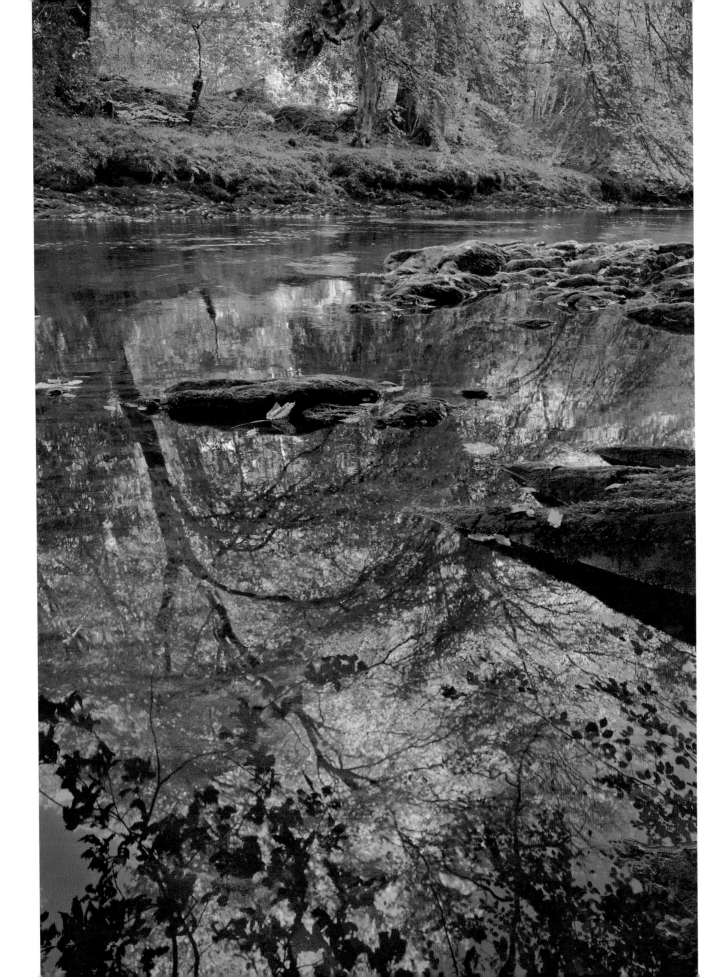

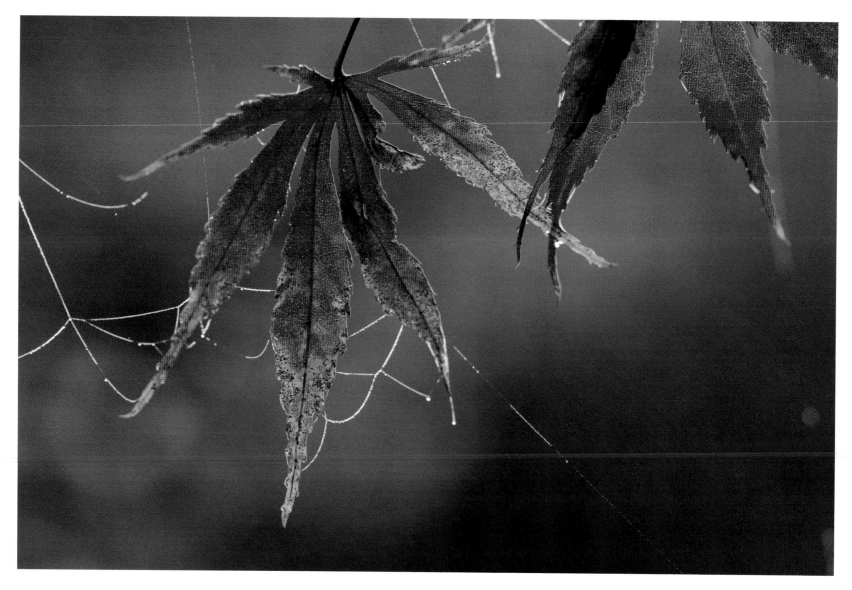

⚕ GERALD MAJUMDAR FINALIST

Japanese maple leaves.
(*Acer palmatum* 'Suminagashi'). Photographer's garden, Kidderminster,
Worcestershire, England.

The morning was misty and there had been a heavy dew, so cobwebs were visible all around
the garden. The backlit leaves of the acer with the glistening dew dripping from its attached
cobwebs caught my eye as I made my way around the garden.

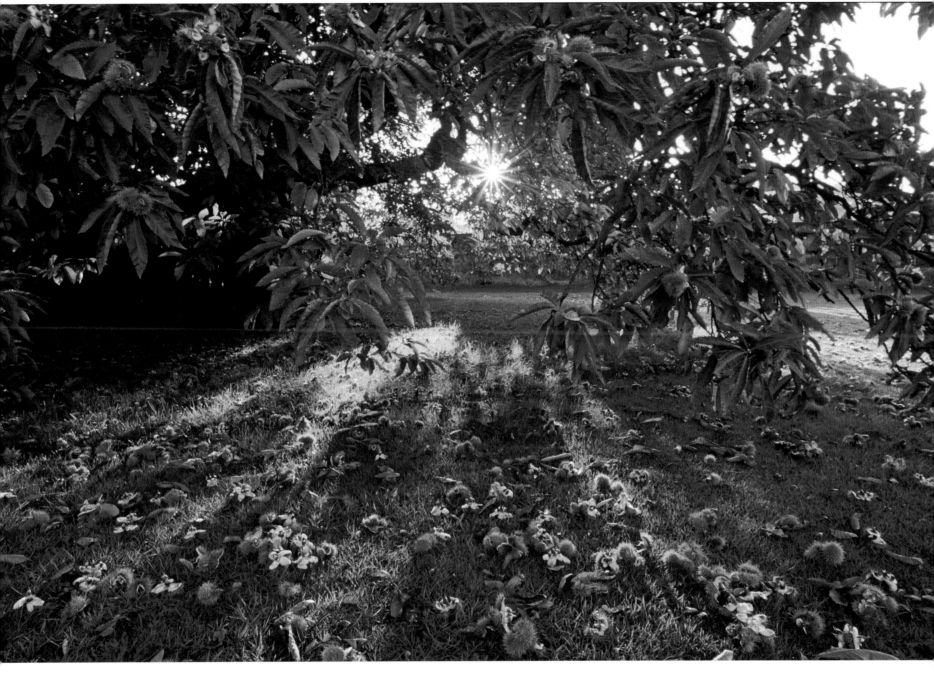

✝ GARY ROGERS COMMENDED

The Archduke's chestnut.
(*Castanea sativa*). Chatsworth, Derbyshire, England.

This is the Spanish chestnut situated in the west grounds of the fantastic garden of Chatsworth. Archduke Nicholas of Russia, who became Czar in 1825, planted it in 1816. It is one of my favourite places in this garden I know so well and, on a beautiful summer evening such as this, I like to stand under this tree and think of all that has taken place in the world while it has been growing and spreading its branches.

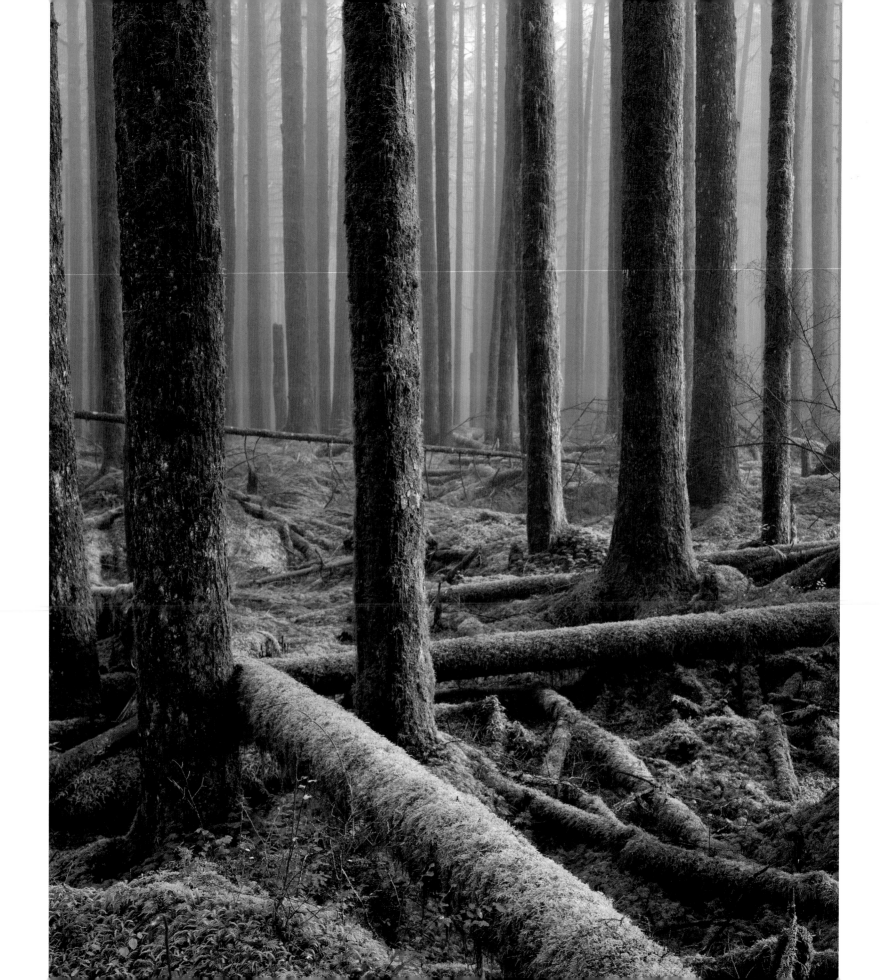

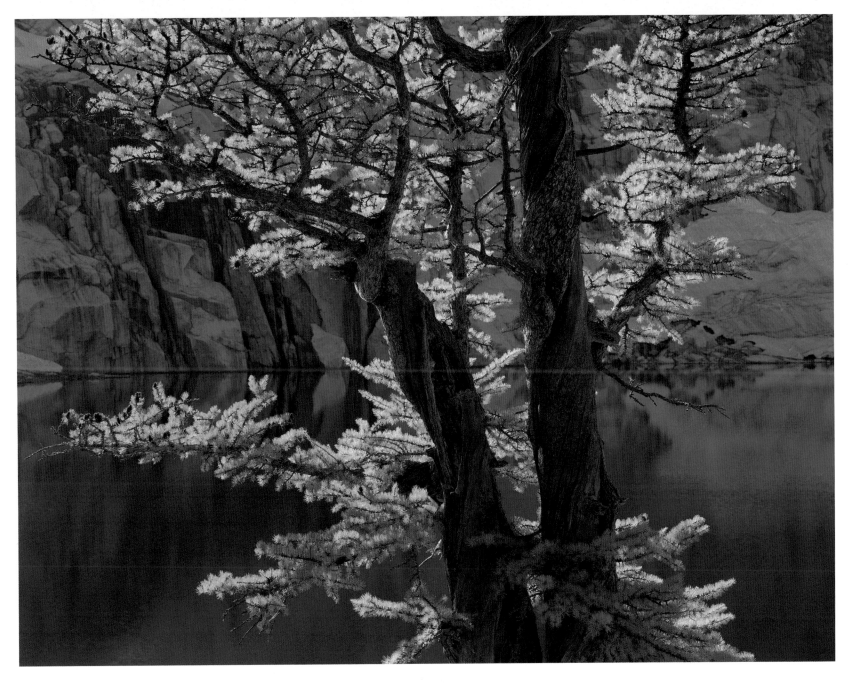

⟨⋯ ADAM GIBBS ⟩　　　　　　　　COMMENDED　　　　　　　　　　　FINALIST

Second chance.
Douglas fir (*Pseudotsuga menziesii*), Western Red cedar (*Thuja plicata*).
Golden Ears Provincial Park, British Columbia, Canada.

Alpine larch.
(*Larix lyallii*). Enchantments Alpine Lakes Wilderness, Washington State, USA.

Much of Western Canada's old growth forest is now gone due to logging. This second growth forest in Golden Ears Provincial Park, British Columbia, is now nearly 100 years old. Stumps from earlier giants can be found throughout the area. The light on this day was quite magical. The fog was heavy but the sun was trying to push through, creating some wonderful diffused light.

Larch needles in the fall are wonderful to photograph, especially when they are backlit. The white cliff in the background was in deep shade, and I knew from past experience that on a bright sunny day anything in shade would record the blue ambient light reflected from the sky. The larch was in direct afternoon sun, so the backlit needles stood out magnificently against the blue background.

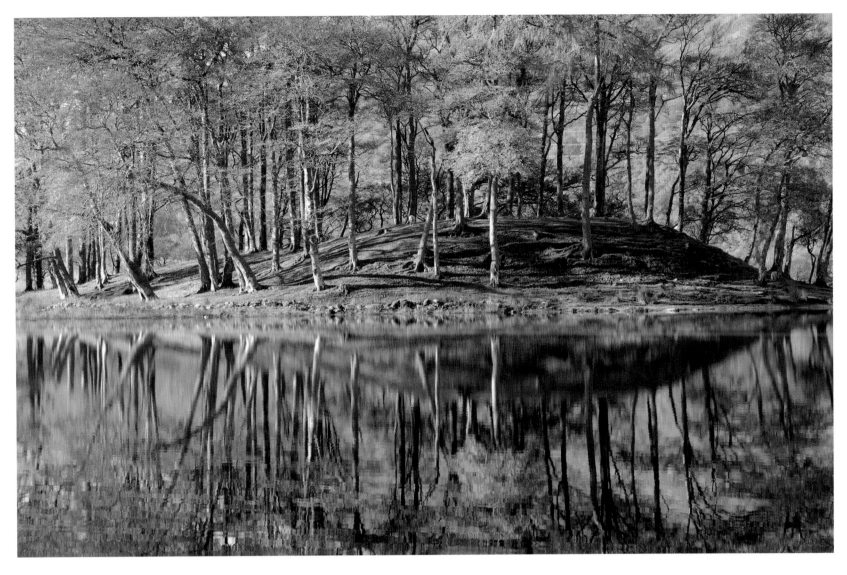

FIONA KEENE — FINALIST

Tree reflections.
RHS Garden Rosemoor, Devon, England.

On a cold, blustery winter's day, and I felt that the birch reflections which appeared in the water once the sun came out were reminiscent of a Monet painting. The texture from the rippling water, plus the strong background colours, created a natural canvas for the sprite-like trees.

JEFF OVERS — COMMENDED

Loch Awe in autumn.
Argyll, Scotland.

I first noticed the wonderful reflections from the road as I passed the loch. I had headed for Scotland on the spur of the moment after seeing a very unusual (for November) perfect weather report.

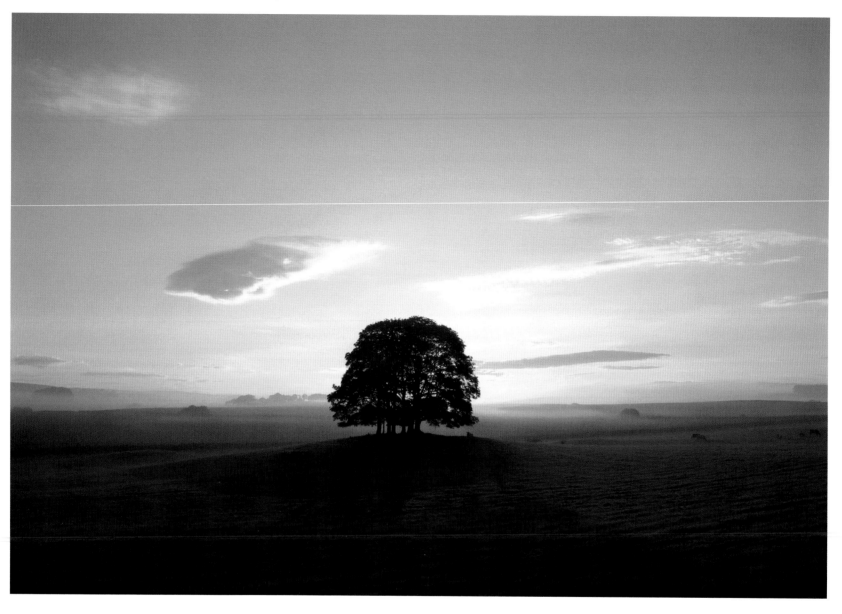

TERRY ROBERTS FINALIST

A new dawn.
Malhamdale, Yorkshire, England.

I have photographed and painted these trees many times and, on this occasion, was up early to explore the mist in Malhamdale and take pictures in the first light. There had been terrible weather and flooding in England, so the break in the weather was very welcome – not to mention atmospheric. The trees seemed to announce a new dawn and create a sense of magic.

ERWIN SCHERIAU ⋯⟩ FINALIST

Four trees in a frame.
Lake Thalersee, Austria.

From the south side of the lake, two large trees framed the subjects on the opposite side. Although the weather had been rather dull and windy, just as I arrived at this spot the sun began to show. The scene reminded me of a trip to Milan, where I'd seen a Da Vinci painting where he had attempted to capture a three-dimensional view of a forest.

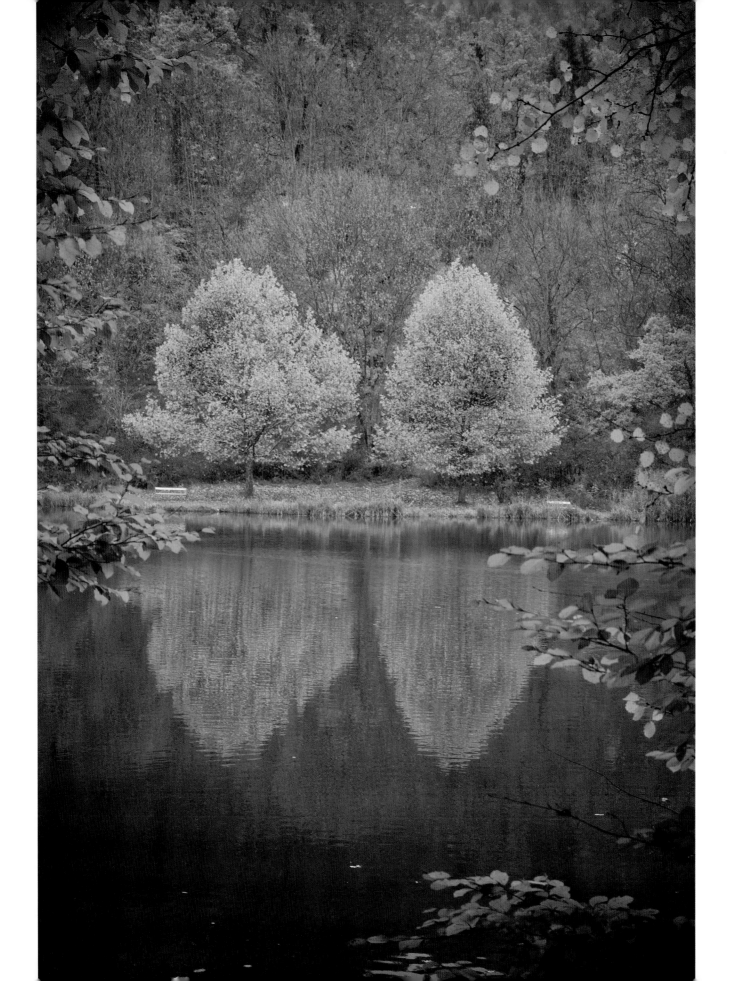

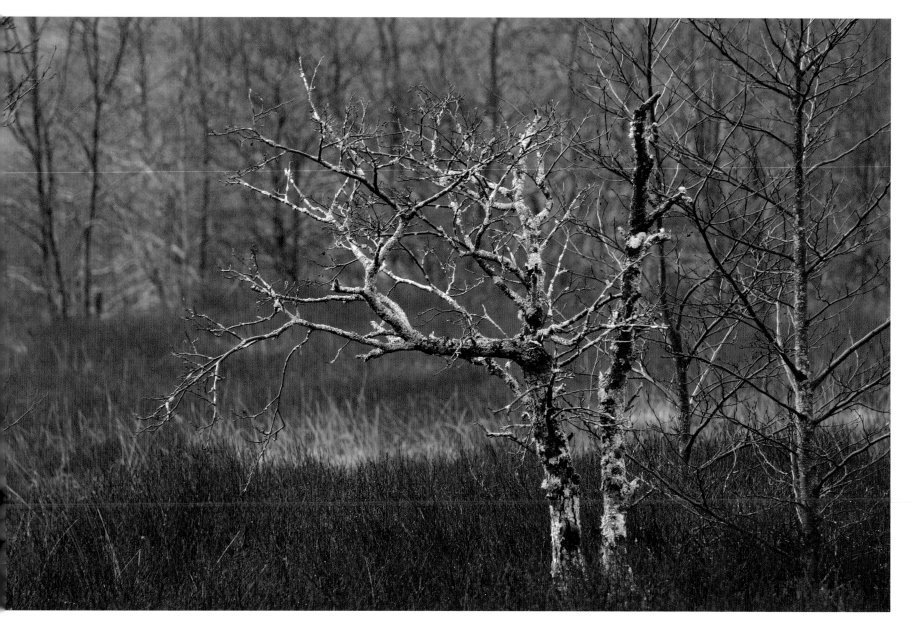

✝ MURIEL DYGA

Silver tree on purple carpet.
Loch Long, Highlands, Scotland.

As the changing light highlighted the colours of these trees, I would zoom in on a section of
the scene in the hope of capturing its magic.

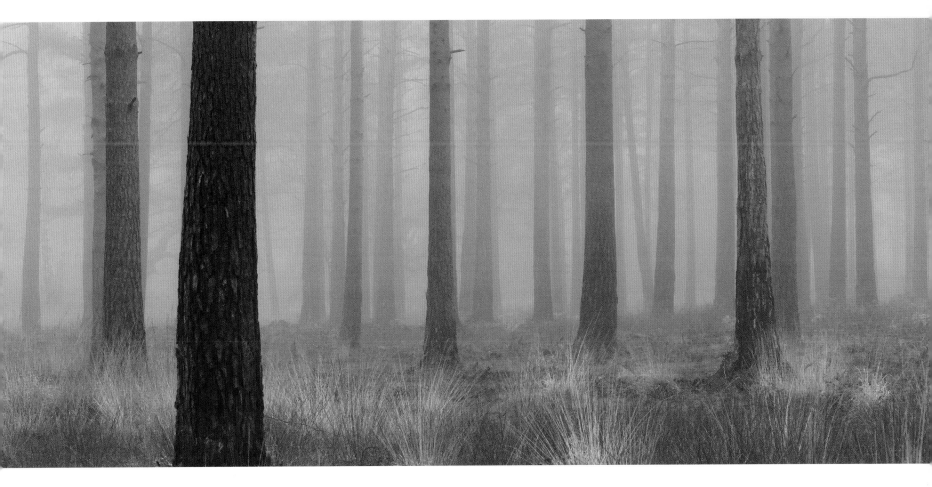

COLIN ROBERTS

COMMENDED

Pine plantation.
The New Forest, Hampshire, England.

The regimented, pillar-like trunks of the pine trees in this tightly planted forest stood out against the foggy atmosphere of a winter morning. I was also attracted by the contrast between the pale yellow grasses and the pale blue atmosphere.

GARDEN
PHOTOGRAPHER OF
THE YEAR

WINNING PORTFOLIO

JUDGE'S CHOICE

HENRIQUE SOUTO
LEAVES

These leaves, while simple, possess an almost mystical quality. In particular, I am drawn to the ginkgo (that most ancient of trees) and the oriental air of its fan-shaped leaf. A touch of light on its edges makes for an image whose appeal is enduring. This portfolio shows that, for all the importance we give to flowers, leaves have a beauty all of their own. It's a joy to behold.

Janine Wookey

PORTFOLIO

Leaves. Lisbon, Portugal.

I don't have a garden but I love the natural world, gardens and, above all, trees. I take pictures of trees, flowers and seeds but realised that their leaves were often disregarded.

Pentax Z1-P, Sigma 105mm macro lens, f/16, Velvia 50
I wanted to show the beauty of the leaves and the uniqueness of each, and only succeeded after several attempts. By shooting in the studio it is possible to simultaneously obtain an artistic and an objective perspective on the leaves.

1–*Ficus religiosa* (Bodhi tree, Peepal tree, Sacred tree)
2–*Populus* x *canescens* (Grey Poplar)
3–*Platanus* x *acerifolia* (Hybrid Plane, London Plane)
4–*Quercus rubra* (Red Oak, Northern Red Oak)
5–*Eryngium sp.* (Sea Holly)
6–*Ginkgo biloba* (Maidenhair tree)

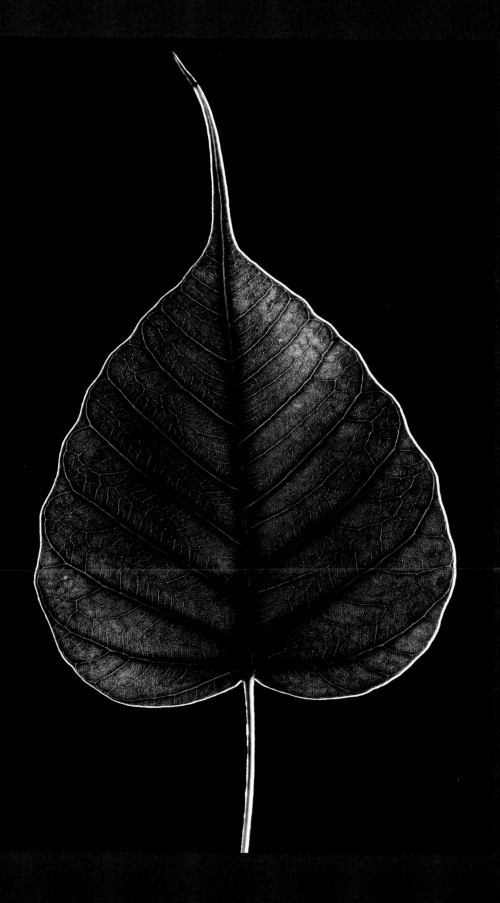

1

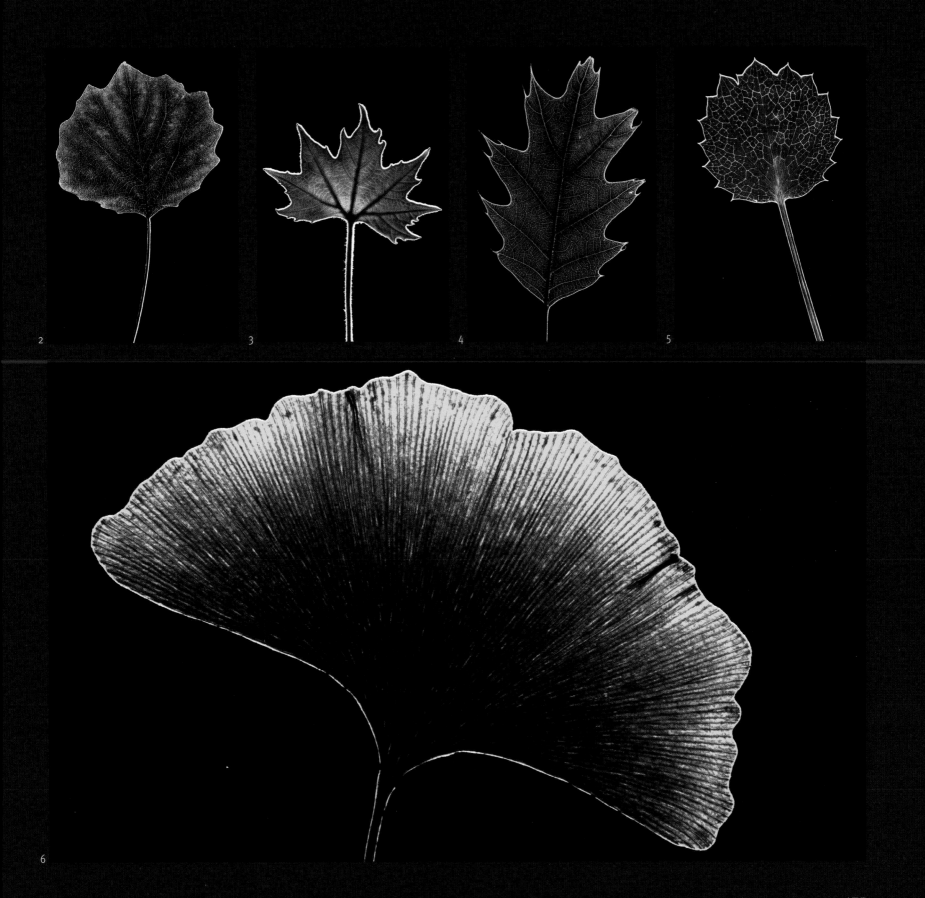

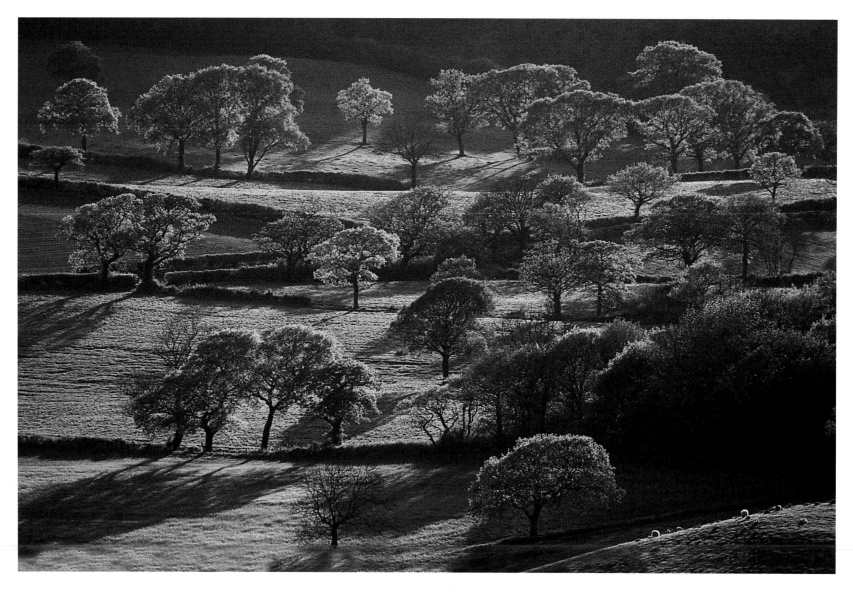

⚡ COLIN VARNDELL FINALIST

DAMIAN GILLIE ⋯⋗ FINALIST

Spring oaks on hedges.
(*Quercus robur*). Eggardon Hill, Dorset, England.

Lonely trees in Korea IV.
The Olympic Village site, Seoul, South Korea.

I was taking landscape photographs on Eggardon Hill just before sunset one spring, and noticed the shadows from these trees helped to create an attractive composition. The trees are on hedges below the west side of the hill.

Massive communities are being created from scratch in this part of Seoul, formerly the Olympic village. Only the mature vegetation planted during construction gives any identity to what would otherwise be a completely anonymous and repetitive environment. Great care is taken to protect the trees from the building activities, but the lifespan of these buildings is short; all will be demolished and replaced in just a few years, outlived by the trees that are planted to complement them.

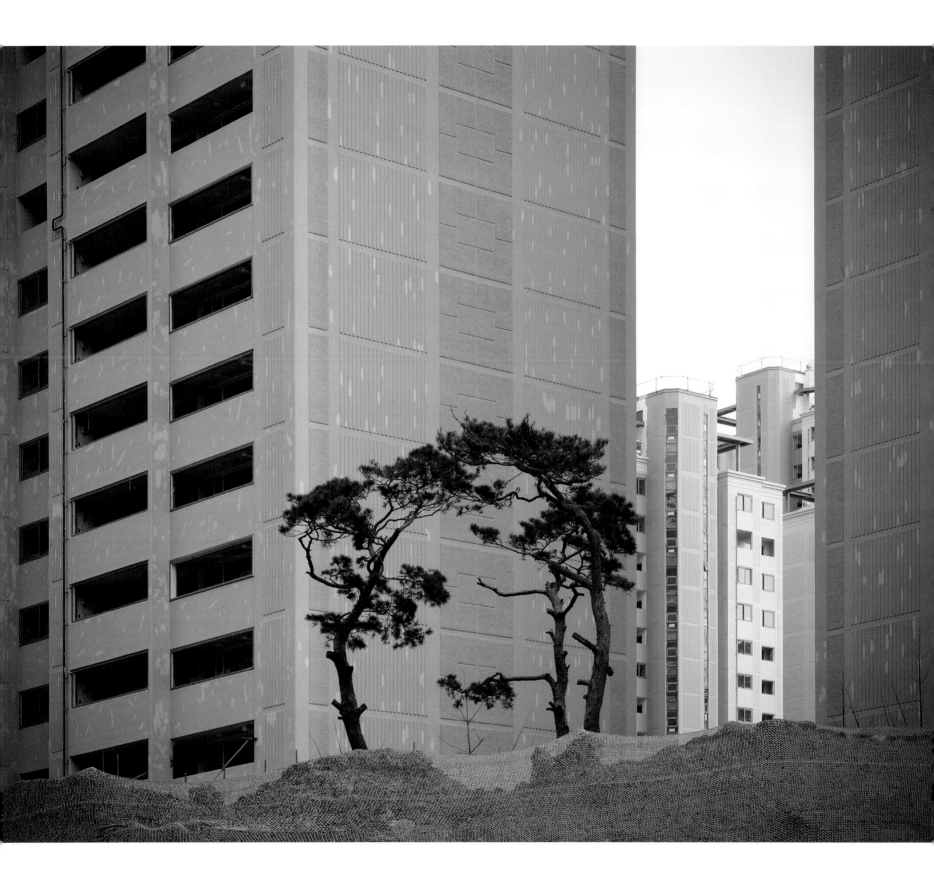

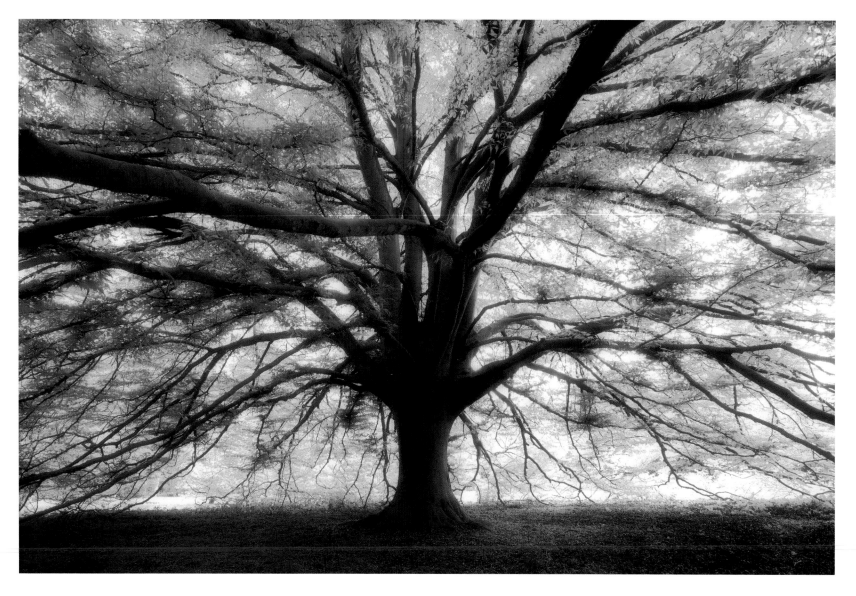

✝ TONY HOWELL COMMENDED

Fern-leaved beech.
(*Fagus sylvatica* var. *heterophylla* 'Aspleniifolia'). Bath Botanical
Gardens, Somerset, England.

In April the leaves under the tree canopy of the fern-leaved beech in Bath Botanical Gardens
are particularly fresh in colour. I had photographed crocuses under the bare canopy in
February, and visualised using a wideangle lens to capture the limbs reaching out towards
me. I waited two months for the fresh leaves to appear, knowing they would add colour to
the potential image.

ADAM GIBBS ⋯⟫ COMMENDED

Cattail moss.
(*Isothecium myosuroides*). Golden Ears Provincial Park,
British Columbia, Canada.

The temperate rainforests of British Columbia are quite magical and I love their hanging
mosses and vibrant greens, which make me feel as if I'm entering the world of hobbits and
dragons. The arching maples gave the impression of looking through a tunnel.

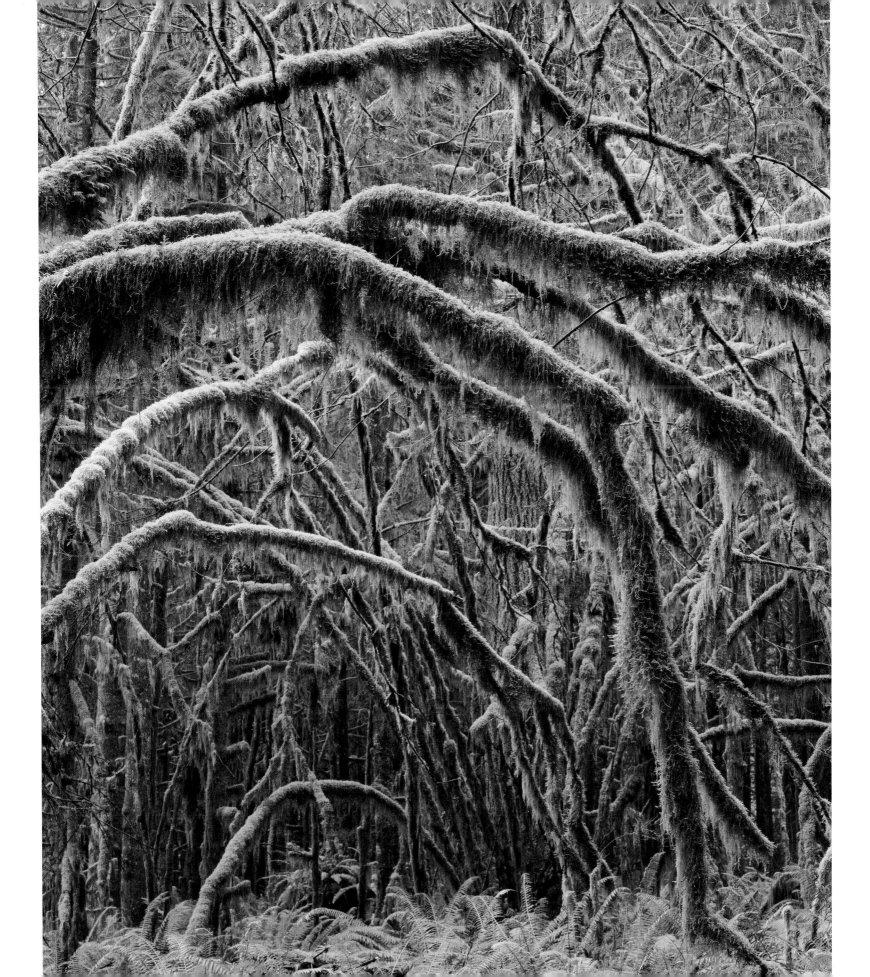

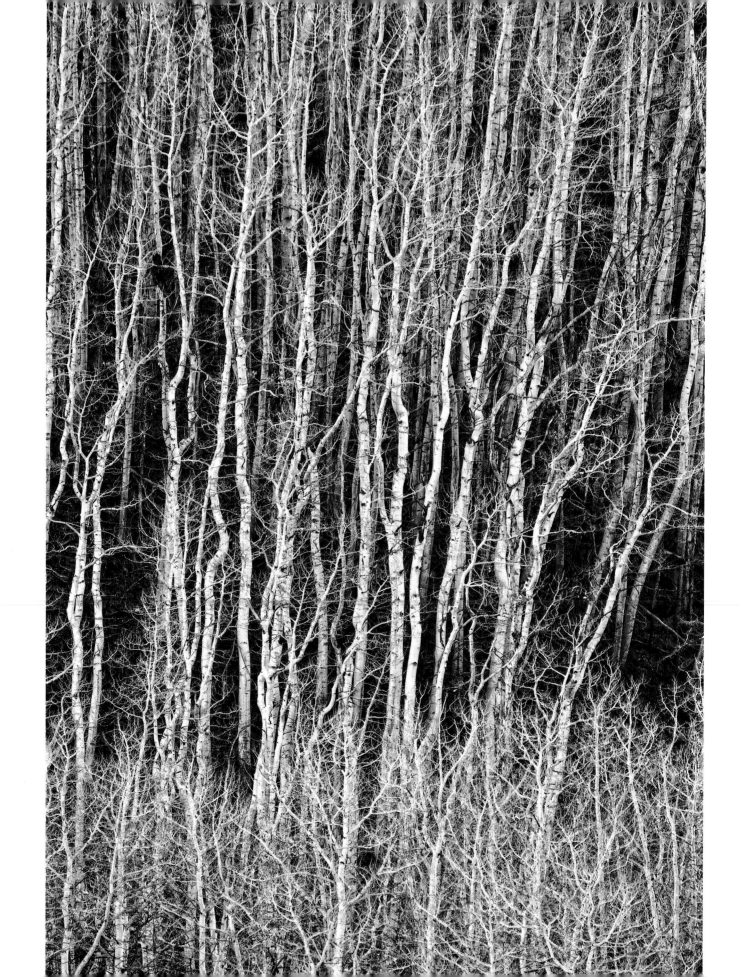

⋯ DANIEL KENCKE COMMENDED

Winter aspens.
(*Populus tremuloides*). The San Juan Mountains near
Hermosa, Colorado, USA.

In subdued light at the end of the day these twisted and bent
aspens presented an image that spoke to me of the power of nature
and an organism's strength and ability to adapt to – and survive –
adverse conditions. The trees show an abstraction of form due to
winter and a constant wind.

⋯ SUNA AKTAS FINALIST

Tree on the road.
Kilburn, London, England.

I spotted this potential composition from the bus and thought
the reflection of the tree juxtaposed with the road sign was a
little surreal.

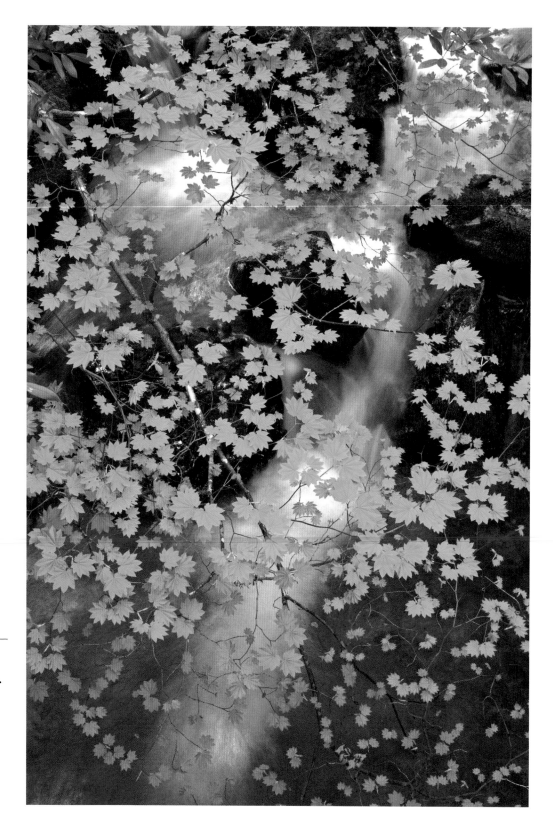

KEVIN SCHAFER ⋯⋗ FINALIST

Vine maple and stream.
(*Acer circinatum*). Siskiyou Mountains, Oregon, USA.

I have always loved vine maples in the spring, with their vivid
colour and striking leaf pattern, but, invariably I have always been
forced to photograph them from below. On a bridge above a small
creek in southern Oregon, I found myself, for the first time, above
a spreading maple branch. With the gentle creek as a backdrop I
thought the scene was charming, and unusual.

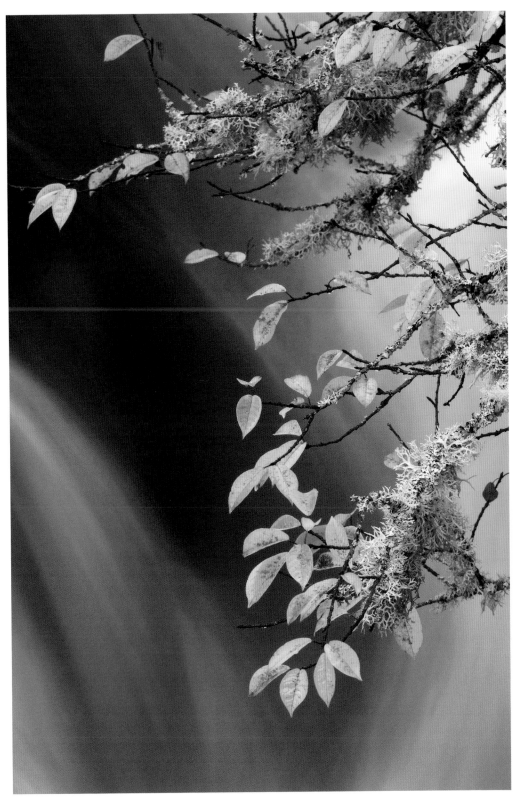

⋘ MARSHALL BLACK COMMENDED

Autumn falls.
Tromie Bridge, Strathspey, Scotland.

The direction of the fall's flow in the river seemed to be mirrored in the flow of the branch. The mixed autumnal hues of browns, yellows and reds create a colour palette that is lively but calming at the same time.

YOUNG GARDEN
PHOTOGRAPHER
OF THE YEAR

JUDGE'S CHOICE

ZOE WITHEY
LEANING PINE

As a gardener I am always moved by the power of plants, and this photograph captures that power particularly well. Trees are the kings of the plant arena. Photography is the perfect vehicle to encourage a young person's passion for plants and gardens; it provides a wonderful visual entry point.

Chris Collins

I love the way the photographer has looked at the subject in a new way. The camera angle emphasises the rough texture of the bark and draws the eye to the treetop in the sky.

Iben Lund Gladman

YOUNG GARDEN PHOTOGRAPHER OF THE YEAR

WINNER

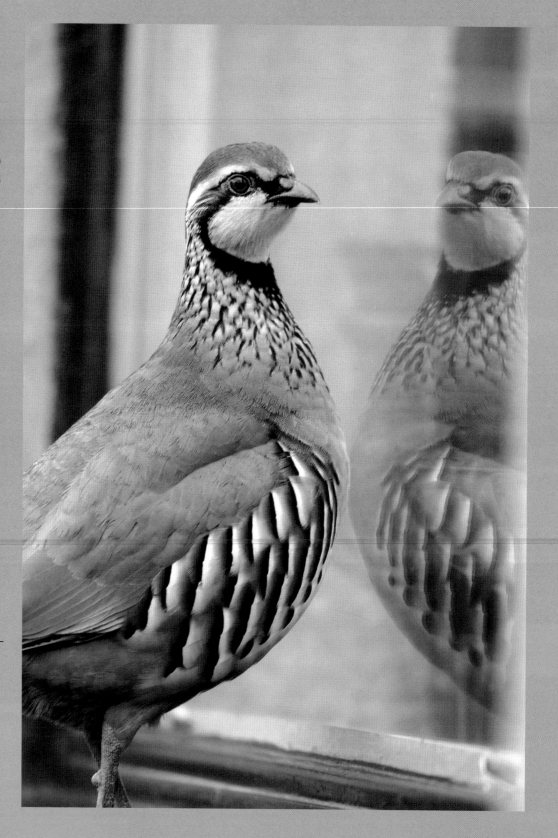

FERGUS GILL (age 15)

Partridge reflection.
Red-legged Partridge (*Alectoris rufa*). Perthshire, Scotland.

I noticed two partridges in the field opposite my house as I walked home from school. By the time I got my camera, the two birds had come into the garden and were eating birdseed. As one jumped up to the window I couldn't believe what I was seeing, and grabbed a shot before it jumped back down.

RICHARD STARK (age 15)

Garden orb.
Hayes, Middlesex, England.

I took this photo of my garden and pond during winter. I decided to turn it into an orb so that the viewer would look through the effect to see the garden. The photo sets the water against the planting, giving the orb two contrasting halves. The subject is my koi pond and waterfall. The planting is marginal water plants with jasmine around the borders, and a willow tree.

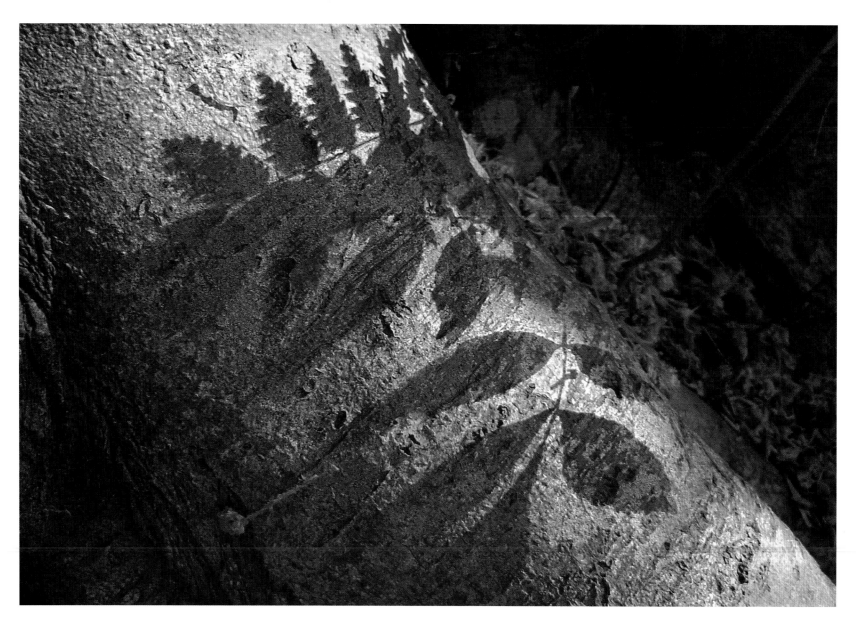

KAT WATERS (age 14) THIRD

JULIETTE COLACO (age 15) FINALIST

Shadow.
Surrey, England.

I had taken my camera out in the hope of spotting potential photographs. I saw these amazing shadows in a pool of light on a tree trunk. The shadows really were such a vivid green – no Photoshop involved!

In the runner beans.
Trumpington Allotments, Cambridge, England.

My sister is studying for an A-level in photography and encouraged me to take photographs myself, so I started taking a camera with me everywhere. I was harvesting runner beans in my mother's allotment, and spotted this green shield bug sitting on the runner beans, very well camouflaged.

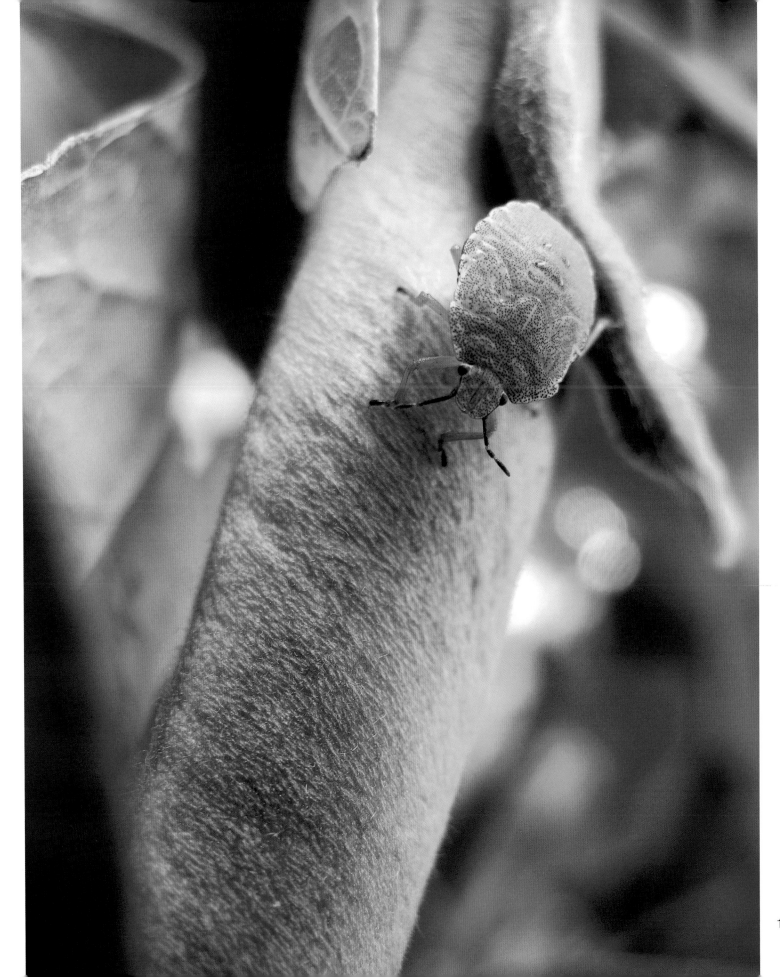

OLIVER TREW (age 14) COMMENDED

My little friend.
Dorset, England.

I have a keen interest in wildlife, so was delighted to spot this mouse looking through a blue carpet plant in the border by the patio at the bottom of my garden.

RAPHAELLA PHILCOX (age 10) FINALIST

Come back Ken, I want my sunglasses!
Photographer's garden, Leamington Spa, Warwickshire, England.

It was a hot summer's day, and Barbie, Ken and their friends were relaxing in the garden. Not one to enjoy sunbathing, Ken decided that it would be more fun to tease Barbie, and run off with her sunglasses into the bushes. He thought he looked quite good in pink, but she wasn't so impressed. (I don't actually play with my Barbies, but they make good props.)

WILL JENKINS (age 5) FINALIST

My brother Harry loves snails.
London, England.

My big brother Harry, who is six, loves snails so much that he lets them crawl all over him in our back garden. He let his favourite snail, Sam, sit on his nose. He said it felt like a slimy tickle. Mummy was laughing so much, she couldn't hold her camera still so I asked her if I could take some photos. I said that I liked his new nose better than his old one. We took care not to hurt Sam and he lived happily in a little house in the garden all summer.

KAT WATERS (age 14) COMMENDED

The Privy Garden at sunset.
Hampton Court Palace, Surrey, England.

While photographing close-ups of a sundial's gnomon as the sun
was going down, I noticed this reflection of the Privy Garden.

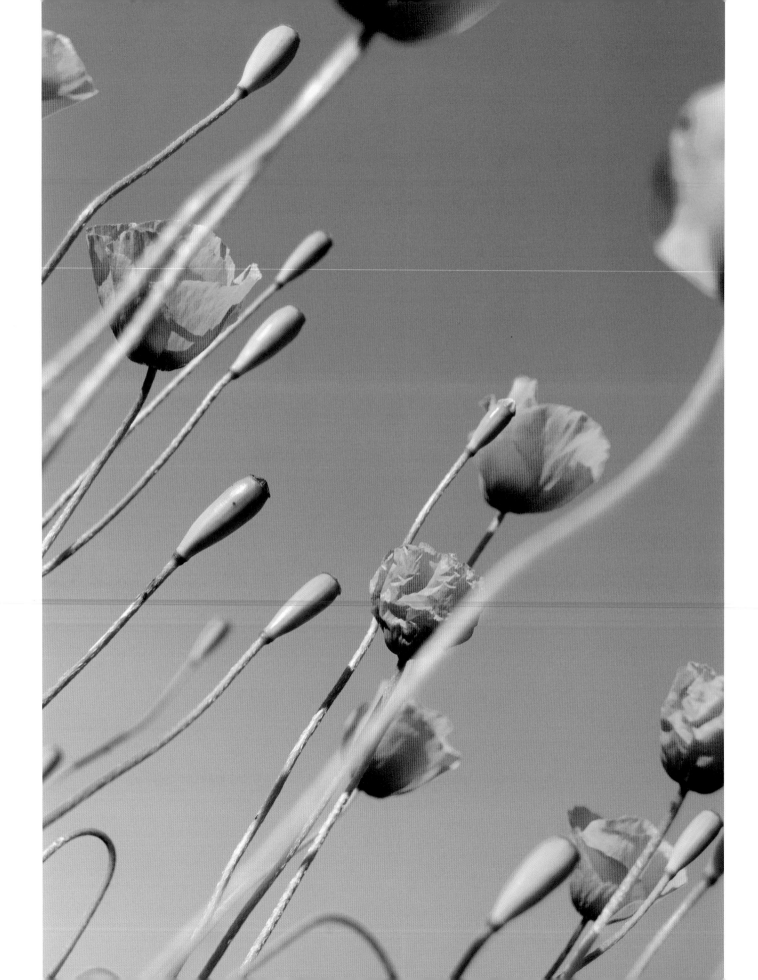

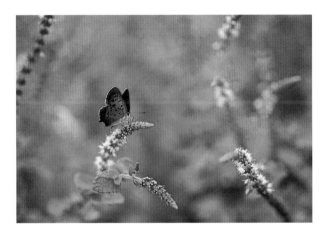

DAZYL YOUNG (age 13) COMMENDED

The wings of life.
The Philippines.

The cool air and sweet smell of dew in the morning make me fall in love with nature even more. On this occasion, I couldn't help but photograph these beautiful butterflies, flocking to take the sweet sip of nectar.

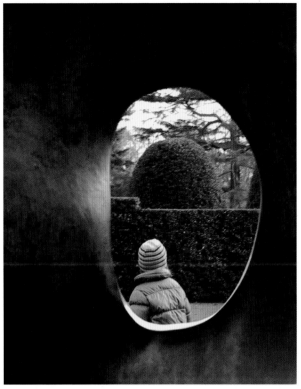

CHRISTIAN MAROT (age 12) FINALIST

Through the hole.
Henry Moore sculpture at the Royal Botanic Gardens, Kew, England.

I had been taking pictures on a bright winter's afternoon at Kew when I came across the sculpture as it was starting to get dark. The shot was taken as I looked through the sculpture, which framed the gardens. A girl walked into view, and I suddenly noticed that her hat mirrored the shape of the sculpture.

GRAEME SMITH (age 15) FINALIST

Red poppies.
Aviemore, Scotland.

While on an early morning walk during my holiday in Aviemore I spotted this cluster of poppies and knew they had potential as a photographic subject.

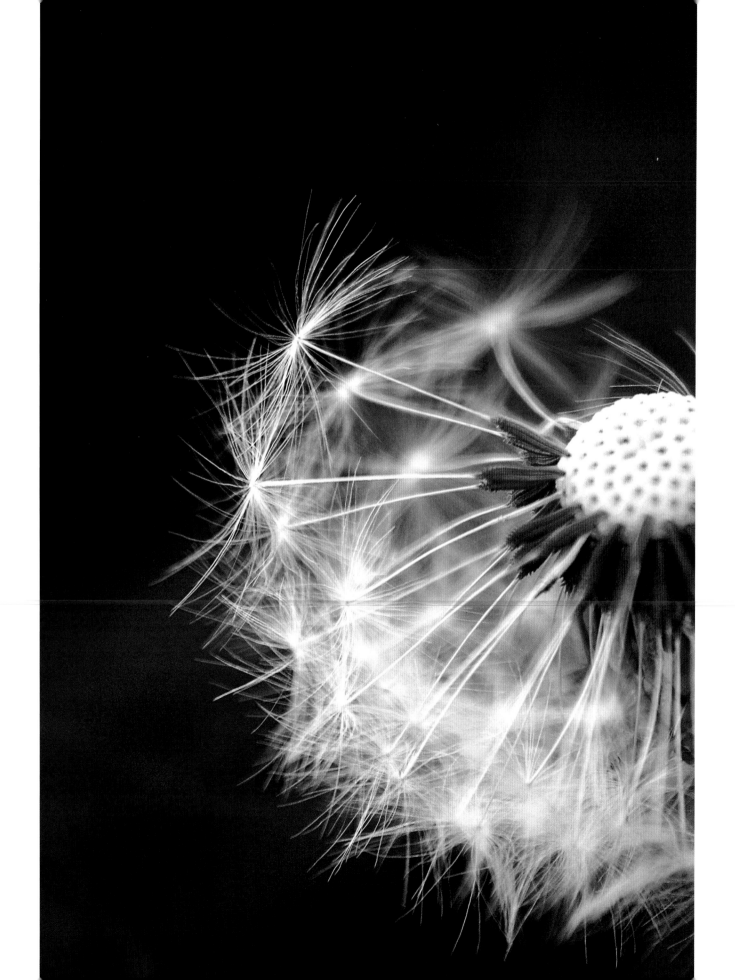

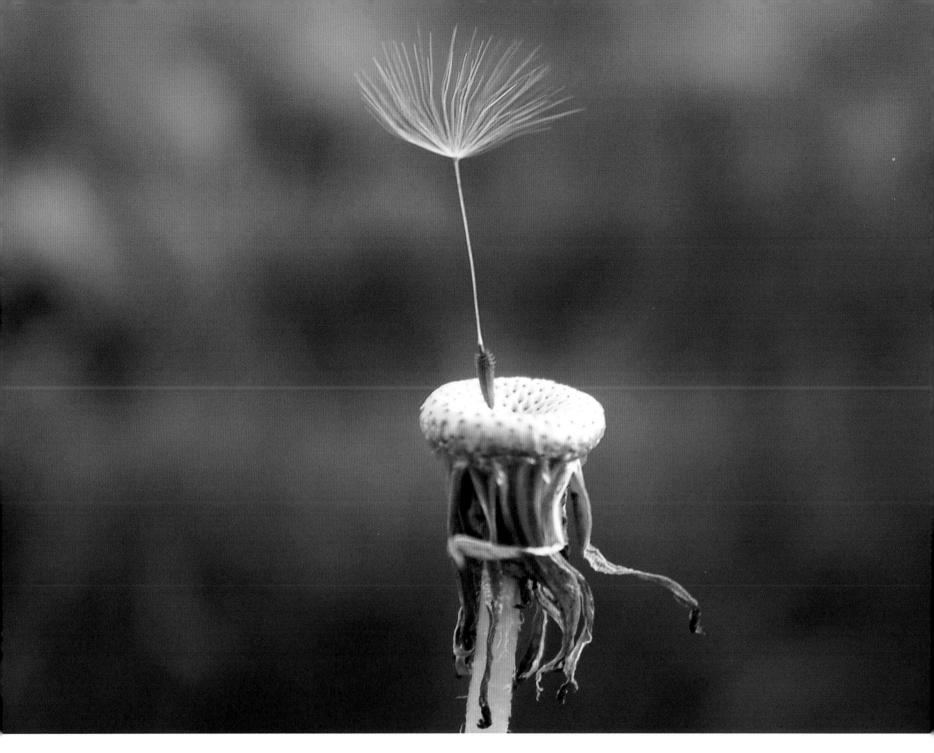

LIAM LESLIE (age 15)

Dandelion.
Darroch Park, Gourock, Scotland.

I was interested in the complexity and beauty that exists within such a common subject, so I set out to show the elegance and pattern contained in the seed head.

NADIA AZARHOUCHANG (age 14) COMMENDED

Dandelion.
France.

The pleasure of blowing on a dandelion is always the same!

HOWARD BUDZYNSKI (age 14)　　　　　　COMMENDED

Can you spot the second fox?
Photographer's garden, Dorset, England.

There were foxes living in the undergrowth in our garden, and I heard them screeching and screaming every night. I wanted to observe them close up, as I found it strange that a wild animal should seem so at home near our house.

⚘ FERGUS GILL (age 15) COMMENDED

Sparrowhawk gaze.
Perthshire, Scotland.

I had seen this particular bird visit our garden several times a day, hunting the newly fledged
sparrows that were feeding there. He always seemed to perch in this one tree and, one
autumn night, the combination of colours was quite beautiful.

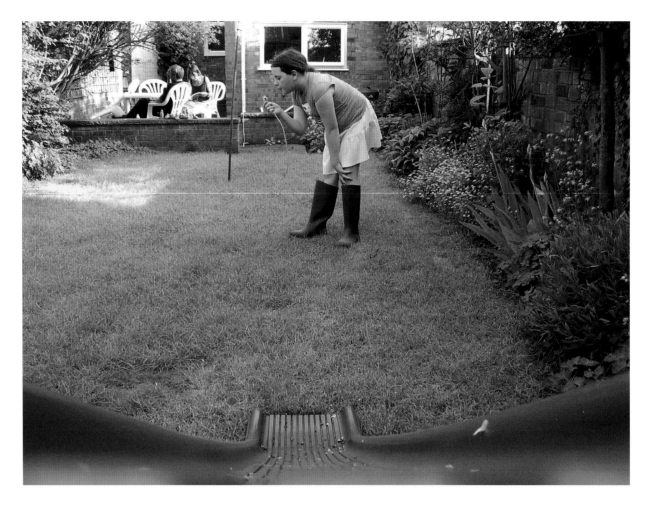

RAPHAELLA PHILCOX (age 10)

ERIN MCAULEY (age 15) ···⟩ COMMENDED

Self-portrait in Photographer's garden.
Leamington Spa, Warwickshire, England.

Tennis anyone?
Gawler, South Australia.

I take a lot of pictures in my garden (and in my house), often using my toys, my cat, or myself as my subject. I wondered what sort of picture I could take if I put my camera on top of my slide, and then set the timer…

My sisters were playing tennis in the back garden, with their 'ball boy'. Our state has been put on water restrictions due to drought, and I like to look at this picture as a reminder of when it was green. The court is all dried up now and we are unable to play on it as it hurts our feet. We can't wait for rain to bring it alive again.

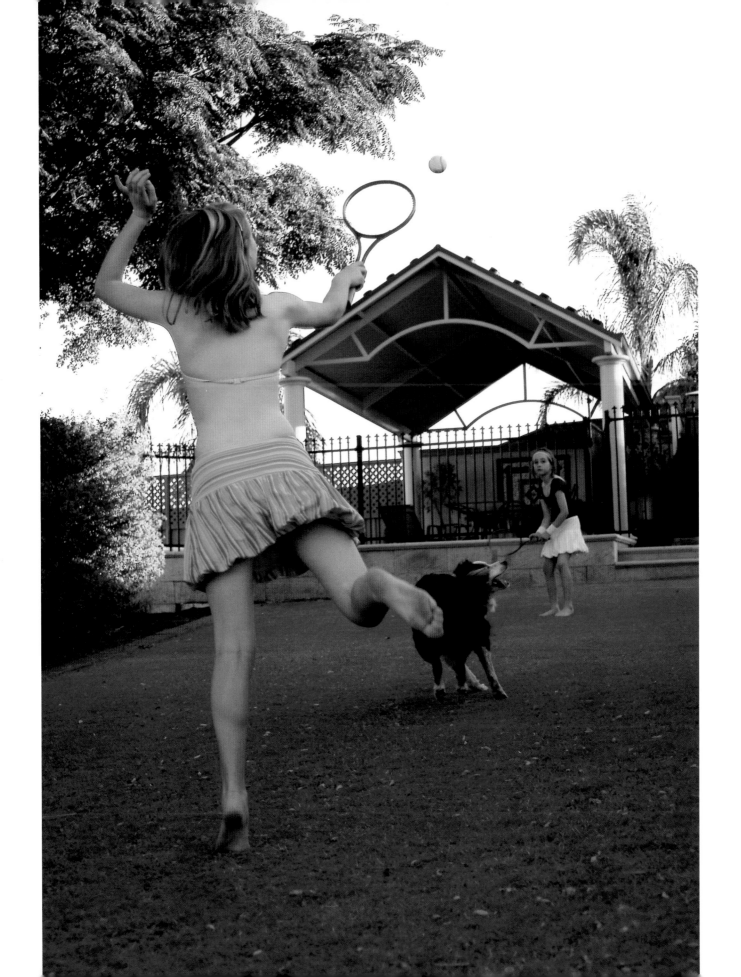

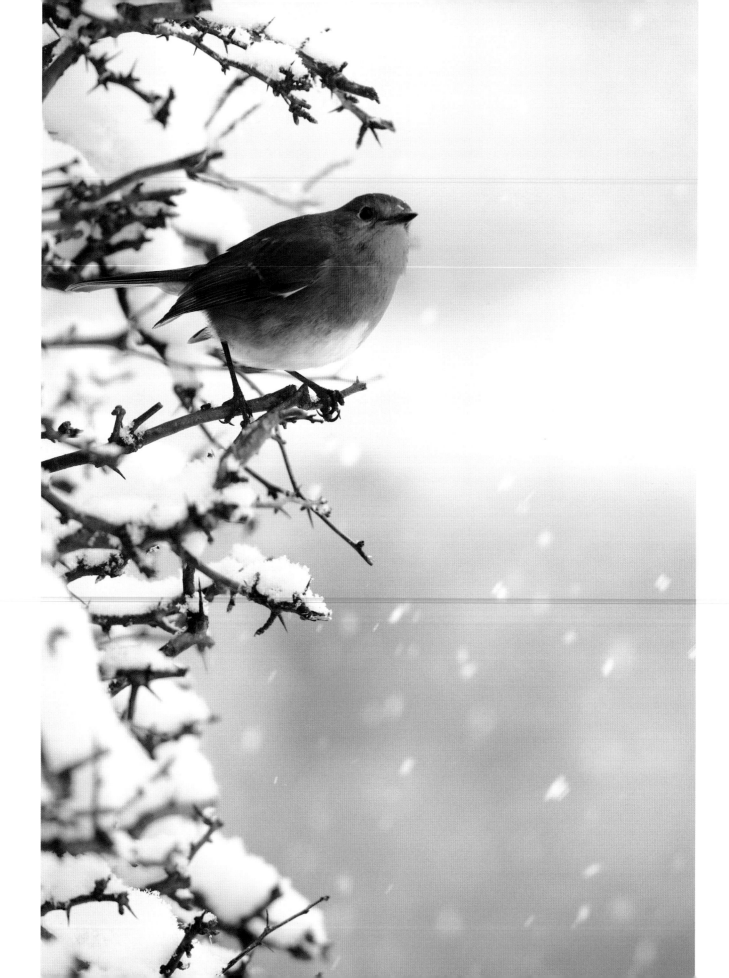

FERGUS GILL (age 15) COMMENDED

Winter robin.
Perthshire, Scotland.

One day in March we had a very heavy snowfall, so I quickly filled up the bird feeders knowing that it would create good photographic opportunities. I noticed a robin that kept perching in a hawthorn hedge before darting out into the open in a foray for food.

SAM ROWLEY (age 13) COMMENDED

Snail shell.
London, England.

One bright winter morning, I went into my cramped London garden to search in the bushes for something to photograph. I spotted this snail shell and placed it on a purple leaf to give the picture a soft background. After sprinkling some dirt on top of it, I switched to a macro lens to take the picture.

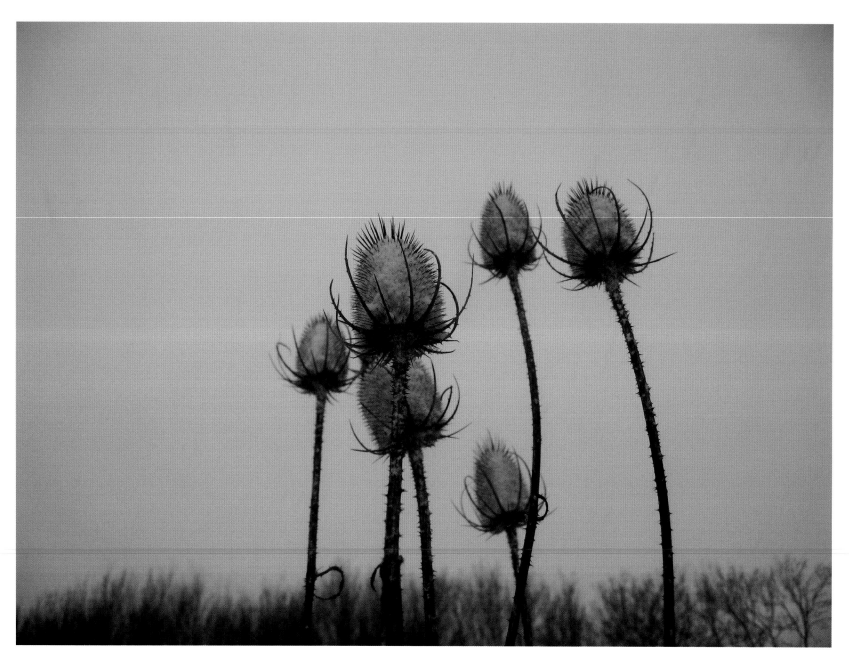

LYDIA GREENAWAY (age 15) COMMENDED

Frozen in time.
Teasel (*Dipsacus fullonum*). Wheathampstead, Hertfordshire, England.

I am fascinated by the patterns and shapes of plants in different seasons, light and weather. I found that the simple, bold shape of the teasels looked particularly interesting frozen in the snow, silhouetted against the sky. I chose to include the skyline of trees at the bottom of the frame to give a sense of depth, and to suggest loneliness on the part of the teasels, which were far from the trees.

ZOE WITHEY (age 11) FINALIST

Leaning pine.
(*Pinus sylvestris*). the Royal Botanic Gardens, Kew, England.

I liked the shape of the tree against the clear, blue, winter sky and the way in which it was leaning. All the branches were at the top, so you could see the texture of the trunk all the way up.

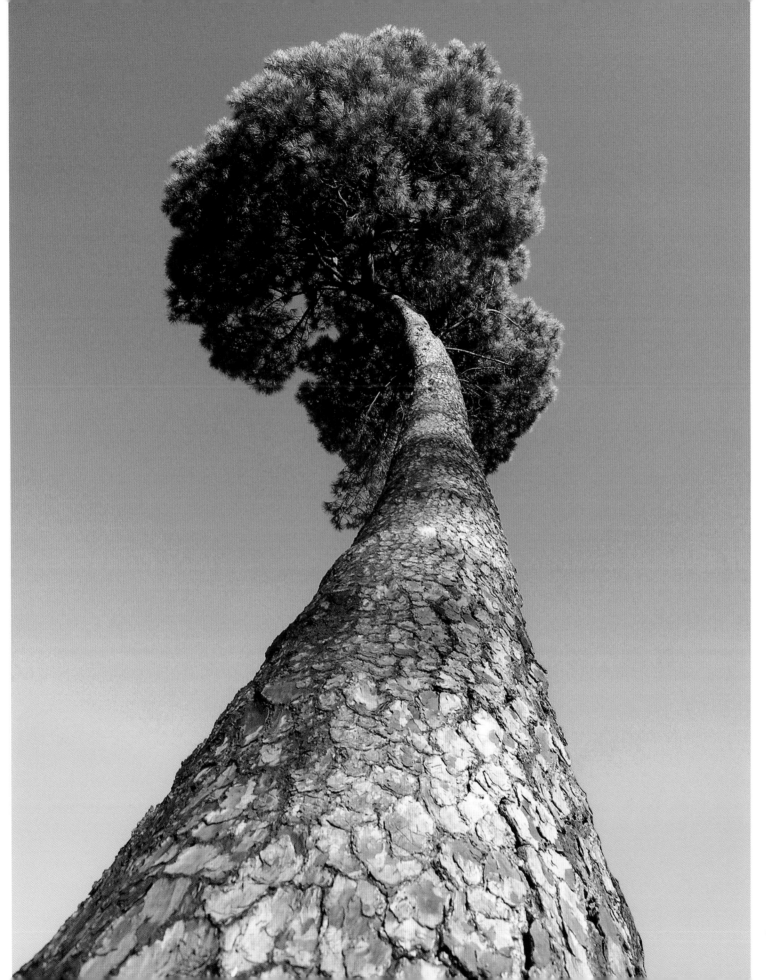

TECHNICAL INFORMATION

NICOLA STOCKEN TOMKINS (p.3)
Wayford Manor in spring

Hasselblad 503CW, CF 120mm lens, f/32, Velvia 50
I had spotted the potential for this shot 24 hours earlier. Ready from dawn, it was only possible several hours later as the mist cleared to allow through, grudgingly, a watery sun.

CAROL SHARP (p.5)
Tulip 'Queen of Night'

Nikon FM2, 80–120mm lens, f/3.5, Velvia 50
I used selective focus to avoid distracting backgrounds and draw the viewer's attention to the gorgeous quality of the petals.

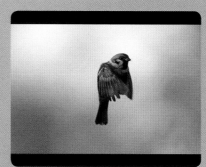

FERGUS GILL (p.9)
Hovering tree sparrow

Nikon D200, Nikon 300mm f/2.8 lens, f/2.8
I had to use a hide for this photograph. An aperture of f/2.8 gave me a fast enough shutter speed to stop the action. With such a shallow depth of field I took many shots before achieving this picture.

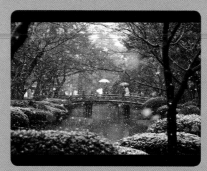

CLAIRE TAKACS (pp.22–23)
Kenrokuen

Canon EOS-1Ds, 70–200mm lens, f/4. Adjusted using Levels and Curves in Photoshop.
A large aperture and fast shutter speed were necessary to capture the falling snow. I photographed for as long as my fingers could withstand the cold!

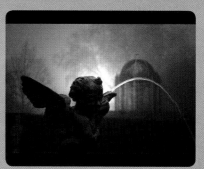

JAKUB GWALBERT FIGURA (p.24)
Secret

Canon EOS 300D, Canon EF 28–300mm lens, f/2.8
I always carry a camera with me, and often take a day off to wander around places I know will be photogenic under certain conditions. This was one such day.

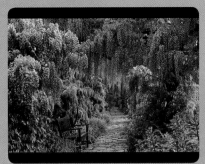

JERRY HARPUR (p.25)
Japanese walk

Nikon F3, Nikkor 28mm lens, Velvia 50, f/22, polariser

It was important to record the disappearing curve of path and the depth of the wisteria tunnel, so a moderately wide-angle lens was chosen. The varying sizes of the seats, by comparison, emphasise the effect.

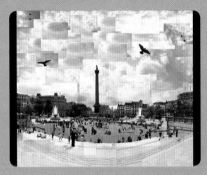

PAUL DEBOIS (p.26)
City garden

Kodak Pro SLR/C, 105mm lens, f/16

The elements were used without any special treatment after converting from RAW files. This is important as the photographs must start with the same colour and contrast range – otherwise they will not fit together.

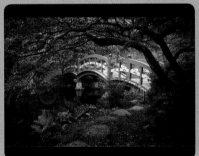

DAVID BALLANTYNE (p.27)
Japanese bridge and maple

Canon EOS 20D, Takumar 24mm lens

When I saw this view from a tiny wooded island looking back at the bridge I knew I'd found something special. I liked the feeling of being sheltered and the arch of the branches over the arches of the bridge.

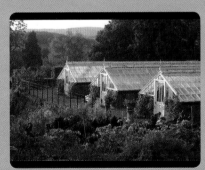

MATTHEW BULLEN (p.30)
Kitchen garden glasshouses

Olympus C-7070

I mounted the camera on a tripod and composed the shot showing the wealth of vegetables in the foreground, with the glasshouses beyond and the distant horizon giving some idea of the glorious setting.

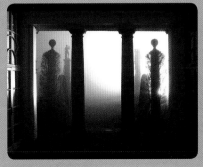

MATTHEW BULLEN (p.31)
The Orangery

Olympus OM2, Zuiko 28mm lens, Velvia 50. Distortion corrected in Photoshop.

I mounted the camera on a tripod, took a meter reading from the floor, and positioned myself so the spotlight was partially obscured by the pillar.

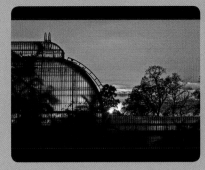

JOHN SWITHINBANK (p.32)
Palm House sunset

Canon EOS 400D, Canon 180mm macro lens, f/16

Hordes of garden visitors had sensed that something special was unfolding. I dashed from side to side to find the perfect spot, leaving me only a couple of seconds to record the image.

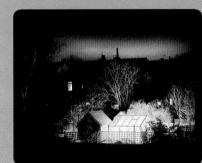

JILL JENNINGS (p.33)
The night gardener

Mamiya RZ, 127mm lens, f/5.6, Kodak 160 VC

I wanted to depict the strange sight of the greenhouse looking like an alien form in the relative normality of the suburban housing.

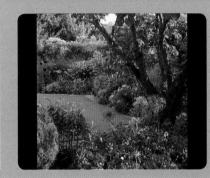

NICOLA STOCKEN TOMKINS (p.33)
Autumn profusion

Hasselblad 503CW, CF 120mm lens, f/32, Velvia 50

My 120mm lens helped cram in all the colour and texture, while placing the garden within its wider landscape. An aperture of f/32 ensured maximum depth of field. As the light was shifting, I bracketed two half stops each way.

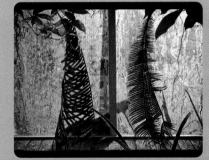

DAMIAN GILLIE (p.37)
Dried cycad leaves

Canon G9, 60mm lens, f/3.2. Slight increase in contrast and saturation, as well as enhancement of shadow areas.

I love the way these plants seem to be acting on a stage while behind we get just a hint of what is going on in the garden outside.

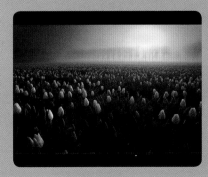

MACIEJ DUCZYNSKI (p.38)
The One

Canon EOS 5D, Canon 16–35mm lens, f/16, ND grad

I needed as much depth of field as possible, so closed down to f/22, and used an ND grad to help control the exposure.

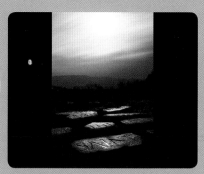

ALLAN POLLOK-MORRIS (p.39)
Searchlight 2

Nikon D2X, grey grad
I was interested in the flow of light, which was sharp in the foreground, and softened as it travelled across the stones and loch, towards the clouds.

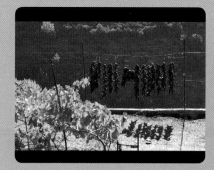

PAUL HORRELL (p.47)
Chillies

Pentax K100D, Tamron SP 24–135mm lens, f/8. Local contrast enhancement of chillies.
I chose to shoot into the sun to get backlight streaming through the subject, and used a moderately wide aperture for a fairly narrow depth of field.

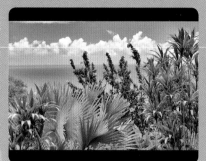

DENNIS FRATES (p.42)
Ocean view garden

Canon EOS-1Ds MkII, Canon 70–200mm L IS lens, f/9, polariser
There were many similar plants at this location but I narrowed it down to a small portion of the scene by using a telephoto lens. I also worked to include a portion of the ocean and clouds in the background.

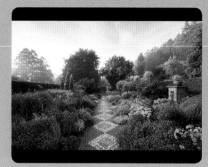

CLAIRE TAKACS (p.48)
Sunrise at Cloudehill 1

Canon EOS-1Ds, 16–35mm lens, f//14. Two exposures (one for the sky and one for the foreground) were blended in Photoshop.
The borders always look superb in autumn, and I've found the classical, symmetrical approach does them most justice. It was a misty morning, and then the sun started to break through.

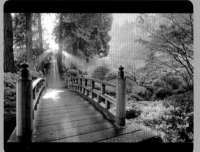

DENNIS FRATES (p.43)
Garden bridge

Canon EOS-1Ds MkII, Canon 16–35mm lens, f/13
The fog and sun lasted only a few moments so I had to react quickly. Within a minute of making the image, the sun started hitting the trees, which made it too contrasty, and the fog was gone.

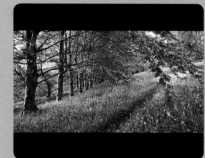

CLAIRE TAKACS (p.49)
Sunrise at Cloudehill 2

Canon EOS-1Ds, 16–35mm lens, f/11
The branch curling over the right of the frame balances the scene and leads the eye up the path through the bluebells on the right and then back down and around through the avenue of beeches.

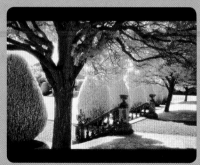

COLIN HOSKINS (pp.44–45)
Montacute House

By kind permission of the National Trust

Canon F-1N, Canon FD 35mm lens, f/11, Kodak HIE
I waited two and a half years to be able to make this image. It was a case of being able to visit the garden when the lighting conditions were favourable.

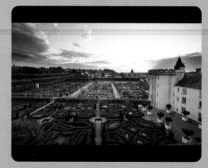

CLAIRE TAKACS (pp.52–53)
Sunset at Château de Villandry

Canon EOS-1Ds, 16–35mm lens, f/16. Two images blended in Photoshop.
I took two exposures to capture the scene – one for the foreground, the other for the sky – as I wanted to show the detail and colour of both sunset and garden.

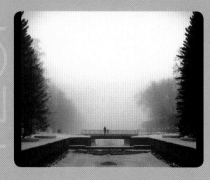

KATYA EVDOKIMOVA
Fog in Peterhof (p.46)

Mamiya RZ67, 140mm, Kodak 160NC. Desaturated in Photoshop, sepia effect added.
My camera got stuck because of the cold weather and I was desperate to get it working again as I had no back-up and was miles away from any camera shop!

NIKKI DE GRUCHY (p.54)
Fiery Seville

Canon EOS 350D, Canon EF 35–70mm lens, f/10
The formality of the garden was emphasised by the angle of view so that the three pots were seen symmetrically. It was a considered response within a fleeting time frame as the light changed very rapidly.

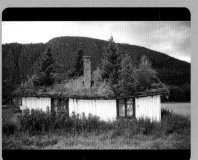

RENATA GIERLACH (p.55)
Roof garden

Canon EOS 300, Canon EF 28–80mm lens, Kodak GC 400
I waited for 20 minutes hoping for the rain to stop. As it kept on pouring I had to cover the camera with a blanket and use flash to take the picture.

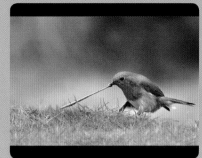

ANDREW BAILEY (p.66)
Tug of war

Canon EOS-1D MkII, Canon 100–400mm zoom, f/7.1. Used clone, eraser and move tools, as well as duplicating Layers to improve appearance of lawn.
I used a small tent for a hide and chose a low camera angle to create a worm's-eye view of the action. A high ISO setting gave me a fast shutter speed.

VADIM KUSHCH (p.58)
Garden pond

Kiev 88 CM, Flektogon 50mm lens, f/8, Fuji Neopan Acros 100
When shooting neglected gardens and parks, I try to avoid overly obvious and expressive meaning and compositional accents. The monochrome tonality helped to express the atmosphere of the photograph's subject to the greatest extent.

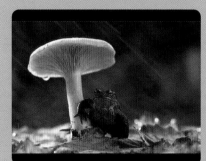

DAVID CHAPMAN (p.67)
Toad in the rain

Minolta 700si, Tamron 90mm macro lens, f/8, Fuji Sensia 100
I took the photograph from a low angle facing into the sun, with a dark background, and used a golden reflector to bring more light onto the subject.

RAY SANTELLA (p.59)
Valley spring

Nikon F, 50mm lens, f/8, Kodachrome 64. Shadows opened, highlights brought down, colours saturated in Photoshop.
Sometimes an image will just present itself, and this is one such instance. The composition is a simple one but the colours keep your eyes moving.

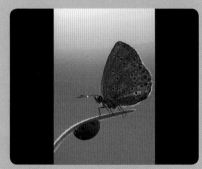

ANDRAS MESZAROS (p.68)
Friends

Canon EOS 20D, Tamron 180mm f/3.5 macro lens, f/4.5
The sun was still below the horizon, so I used a tripod and mirror lock-up. Because of the time of day, I was able to play a little with the presentation of the colours.

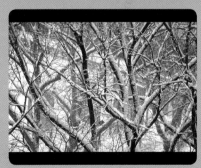

BARBARA MACKLOWE (p.60)
Christo's Gates

Canon EOS Elan VII, Canon 100–400mm lens, f/8, Kodak E100VS
I worked with a 400mm lens, balancing the camera on the windowsill. The convection caused the snow and cold air to blow through my window, making it quite difficult to proceed.

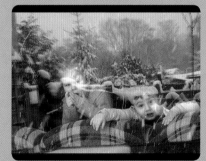

SUNA AKTAS (p.69)
New play

Olympus C-740
I used my compact camera and took several pictures from different angles, but I liked this one most.

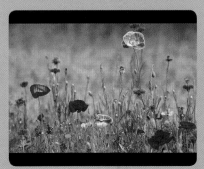

BARBARA MACKLOWE (p.61)
Wild flower field

Canon EOS Elan VII, Canon 28–70mm lens, f/2.8, Kodak E100VS
I held my breath, waiting for the constant prevailing wind to lessen, as the flowers here are never still. I wanted the tall, pink poppy to be the focus of the shot and to blur the background.

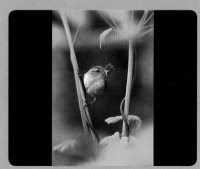

DAVID CHAPMAN (p.70)
Wren

Minolta 7D, Sigma 400mm lens, f/6.3
The Wren had perched once on this stem and I could only just see this one point on the stem through the surrounding vegetation. I set up my camera on a tripod pointing at this spot and it returned once more.

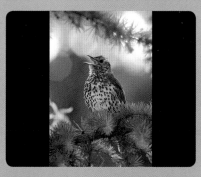

DAVID CHAPMAN (p.71)
The Song Thrush

Canon EOS 5D, Sigma 500mm lens, f/10
I waited for the Song Thrush to perform, photographing it through an open high window of our campervan. I deliberately photographed it backlit to give the photo more atmosphere.

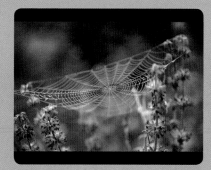

TORIE CHUGG (p.76)
Dew-covered spider's web

Nikon F100, Nikon 105mm lens, f/4.8, Velvia 50 rated at ISO 32
I was drawn to the perfect pattern made by the spider and the way the dew had settled upon it. I used a shallow depth of field.

JOHN MACPHERSON (p.72)
Rainy day at Sissinghurst

By kind permission of the National Trust

Canon EOS-1Ds MkII, 70–200mm lens, f/2.8, ISO 250. Contrast and saturation tweaked in Photoshop.
If it's wet, why try to take pictures that look dry? So I tried really hard to take images that shouted 'wet' – in fact 'very wet'.

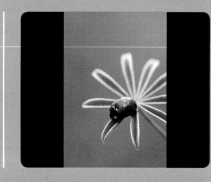

JONATHAN BUCKLEY (p.77)
Ladybird on lupin foliage

Nikon F100, Nikon 200mm macro, f/8
I used a long macro lens and relatively shallow depth of field, making sure there were no other distracting colours or textures in the shot and deliberately leaving space at the top of the picture.

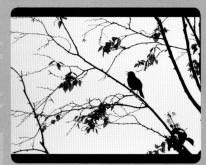

MICHAEL WALKER (p.73)
Blackbird singing

Canon EOS 30D, EF 80–200mm lens, f/5.6. Image cropped to remove tree trunk. Levels and Curves adjusted to bring out yellow of beak.
I set the ISO to 400 and took the photograph at 1/800sec to compensate for camera shake as I was leaning forward as much as I dared, and using a 200mm lens.

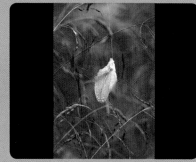

SALLY SMITH (p.78)
Calling card

Canon EOS 400D, EF-S 60mm f/2.8 macro USM, f/2.8. Saturation, exposure and colour balance adjusted.
My aim was to capture the central image, with dew, at dawn light. I then concentrated on highlighting textures, foliage form, and the sense of movement.

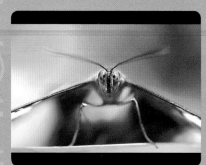

SHARKAWI CHE DIN (p.74)
Looking at you

Canon EOS 300D, Tamron 90mm macro lens, f/2.8. White balance changed in postproduction.
I used a wide aperture for a soft, pastel background, and manually focused on the moth's head to reveal its detail and emphasise the illusion of space.

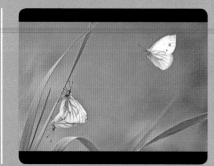

SVEN GRÄFNINGS (p.79)
Green-veined white butterflies

Canon EOS 5D, Canon EF 100–400mm IS lens, f/8
I tried to achieve a sense of harmony in the picture, capturing a flying butterfly at the same time.

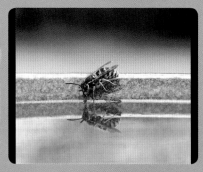

MARY SUTTON (p.75)
Thirsty work

Olympus E-1, Olympus 50mm macro with 1.4x teleconverter
I set up the camera on a tripod one still, overcast day. I wanted to be parallel to the wasp, which meant adopting a low position. The short lens meant being extremely close to the wasps!

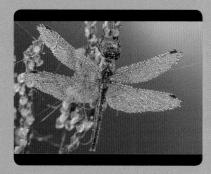

OLEGAS KURASOVAS (p.80)
Waiting for the sun

Canon EOS 20D, Canon 100mm f/2.8 macro lens, f/6.3. Channel blending, noise reduction and sharpening in postproduction.
There was a little wind, so I boosted the ISO to 1600 in order to achieve a fast enough shutter speed.

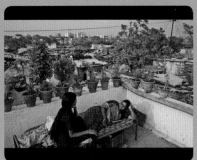

STUART FREEDMAN (p.81)
Radhika and her neighbour, Saroj

Canon EOS 5D, 28mm lens, f/16
I was working on a story for Channel 4 about water issues. I'd noticed the gardens and the many plant pots, so asked if I could spend an hour or so with Saroj and some of her friends.

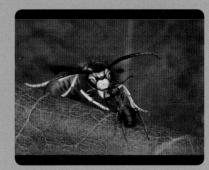

PAWEL BIENIEWSKI (p.86)
The kiss

Sony DCS-H5, 250mm lens, f/8. Noise reduced in Neat Image; exposure tweaked in Photoshop.
I had time to take a number of photographs during the fight.

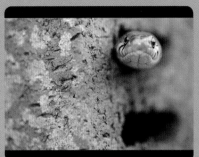

DAVID MAITLAND (pp.82–83)
Grass snake

Canon EOS-1Ds MkII, 100mm macro lens, f/2.8. Adjustments in Levels, slight sharpening.
I try to capture an intimacy in the life of the animal I am photographing. I get in close and make eye contact. Here the snake is looking straight at me, enabling the viewer to look straight back.

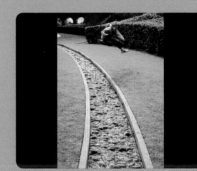

ZARA NAPIER (p.87)
Jumping the rill

Nikon D200, Nikkor 35mm lens, f/16
I crouched low and straddled the rill. My son was playing a game; jumping the rill as he went up the hill. I set the shutter speed at 1/125sec so that any movement would be visible rather than frozen.

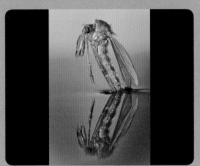

MATTHEW BURRARD-LUCAS (p.84)
Mosquito emerging

Canon EOS 5D, Canon 65mm f/2.8 macro lens, f/16
As the time drew close for the larvae to emerge, I waited for hours. I already had my equipment prepared – with three flash guns to provide the necessary illumination.

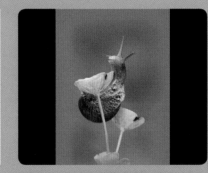

JACKY PARKER (p.88)
Forever blowing bubbles

Nikon D200, Micro Nikkor 105mm lens, f/8. Edges vignetted in Photoshop.
I had to work fast and, unable to erect a tripod in time, I lay in the wet grass, hand held the camera and managed to capture this image before he disappeared.

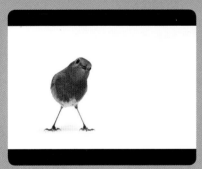

TIM GAINEY (p.85)
Robin

Canon EOS 20D, Canon 70–200mm f/2.8 lens, f/5
The time spent gaining his trust meant that in the end I was able to put a 100mm macro up to the robin's face without him being at all concerned. Most of all, I wanted a simple photograph of him.

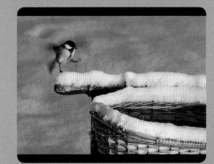

SVEN GRÄFNINGS (p.89)
Great tit

Canon EOS 5D, Canon EF 100–400mm L IS lens, f/8
I took the picture from an open window in my house. I tried to catch the bird in motion for a sense of action.

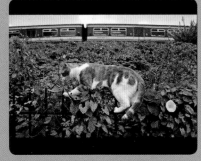

SILVIA DEMETILLA (p.85)
Acrobatics in my garden

Nikon N5005, Sigma 28–80mm lens, Fuji film
I go everywhere with my camera, and immediately spotted the potential for a picture with the juxtaposition of cat, train and wild flowers.

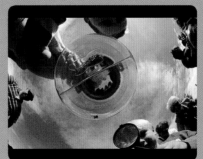

DAVE CHARNLEY (p.90)
Come and see

Nikon D200, Nikkor 10.5mm lens, f/8
The mood was a little relaxed before I arrived – then Charlie struck gold finding a common garden spider and was proud of the fact. The challenge was then on to find more creatures.

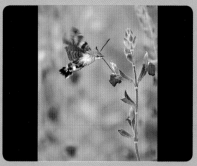

Nikon D3, Nikon AF-S Micro 105mm f/2.8 lens, f/5.6. White balance and saturation adjusted.
I chose to carry out this project during the mid-afternoon to get direct overhead light to help avoid casting of shadows. An attempt at this a few days earlier helped me to perfect my settings for this image.

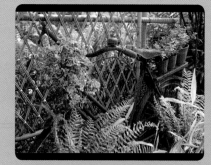

Pentax 645N, 75mm lens, f/11, Velvia 50
The bike was in a shady spot at the time, but with appealing light filtering in from above. I decided on a jaunty angle to emphasise the humorous aspect of the subject.

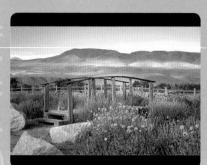

Canon EOS-1Ds MkII, Canon 24–105mm IS lens, polariser
I used a moderate telephoto lens to compress the elements of the hills and garden.

Nikon D200, 105mm f/2.8 Micro Nikkor lens, f/7.1
The positioning of the camera had to be correct so that the sun hit the deckchair at the right angle, and it was important that the fence in the background was almost invisible so I used a relatively wide aperture of f/7.1.

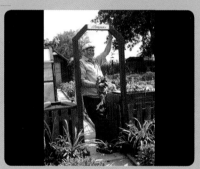

Pentax 645N, 70mm lens, f/8, Velvia 50
I just wanted Eric to be himself, so we chatted and joked and I snapped away. I only wanted to focus on Eric and the name of his allotment so used an aperture of f/8 and handheld the camera to keep it informal.

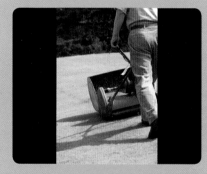

Nikon D200, Nikon 105mm micro Nikkor lens, f/6.3
I had to work fast to grab the moment. I set the shutter to 1/400sec to freeze the movement. The angle and cropping of the figure in this shot with the balance of the shadow was the most successful of the series.

Canon EOS 5D, Canon EF 24–105mm f/4 L IS lens, f/4.5
The garden is divided into several areas. The red curtain leads into the sensual garden, the yellow into the sunny garden, and behind the blue one is the meditation garden.

Canon EOS-1Ds MkII, 500mm lens, f/4
I had a 500mm lens on a monopod and set an aperture of f/4 to make the subject stand out and give a simple, diffuse background. I made sure there was nothing else in frame to detract from the subject.

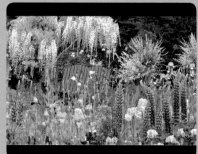

Canon EOS-1Ds MkII, Canon 70–200mm f/2.8 L IS lens, f/14, polariser. To get the entire scene in sharp focus I combined two images with different focal points in Photoshop CS3.
I used a telephoto lens to compress the scene and make the flowers and bench appear closer together. Even though this is a busy composition, I was able to frame the bench.

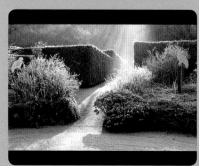

Canon EOS 3, Canon 28–80mm f/2.8 L lens, f/16, Velvia 50
Taking pictures in the frost and snow is tricky as far as exposure is concerned. Automatic metering underexposes such a shot so I overexpose by at least 1.5 stops and bracket.

TECHNICAL INFORMATION

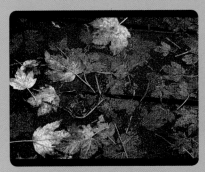

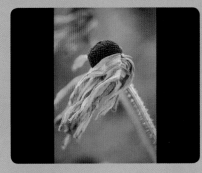

ERIC CLEAVELY (p.104)
Autumn abstract

Konica Minolta A200, Konica Minolta GT zoom, f/3.2
The day was dull, with rain, and the brightness poor, so I set my camera to ISO 400. It was not possible to use a tripod so I set the camera's built-in stabiliser to stop camera shake.

PERNILLA BERGDAHL (p.112)
Windswept rudbeckias

Canon EOS 5D, Canon 180mm macro lens
I had to lower my tripod so my camera was facing the flower straight on, but I also made sure I included some more of the orange rudbeckias in the background.

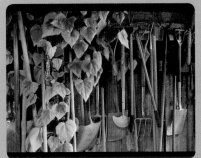

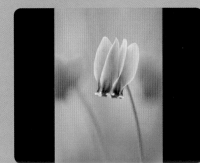

LIAM GRANT (p.105)
Tools

Mamiya RB67, 65mm lens, f/8, Velvia 50. Levels and saturation adjusted.
As the rain came down I made a dash for the shed. However, instead of packing my camera away, I noticed the diffused light falling through the door, so composed and took the shot.

GERALD MAJUMDAR (p.113)
Cyclamen hederifolium

Canon EOS 40D, Sigma 150mm macro lens, f/3.2
I used a wide aperture, so the background was out of focus, and a white card to add some fill light.

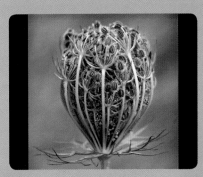

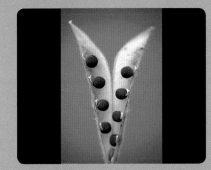

CHINCH GRYNIEWICZ (pp.108–109)
Marguerites in rain

Fuji S3 Pro, Nikon 24–85mm f/2.8–4 F lens, f/13. Increased brightness of centres; sharpened the raindrops, petals and stems.
I already had the camera set up to take close-ups of flowers. All I needed when the rain started was to run back into the house to get an umbrella.

STUART ALLEN (p.116)
Lily pond

Nikon D300, Nikon AF-S 70–200mm VR lens, f/4.5
At the rear of the pond in the Princess of Wales Conservatory is a walkway to allow observation of underwater fish. From here you can get a shot across the pond from only a few centimetres above the water's surface.

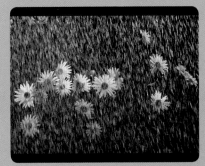

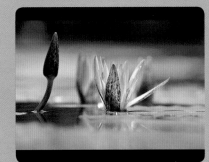

DIANE VARNER (p.110)
Bound to prosper

Canon EOS Digital Rebel XT, 100mm macro lens, f/7.1. Curves adjusted, colour fill overlay, dodge and burn, contrast adjustment, noise reduction.
All my images are taken on my daily walks with my handheld camera. I find myself noticing nuances of light and detail; hence this particular shot.

JAKE EASTHAM (p.117)
Sweet pea pod and seeds

Canon EOS-1Ds MkII, 105mm macro lens, f/2.8. Levels tweaked in Apple Aperture.
I picked a pod with all the seeds intact and pushed its stem into a crack in our garden table. I then set up my tripod and made sure the angle was set to give the cleanest background possible.

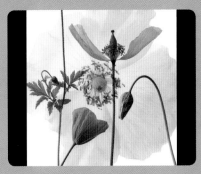

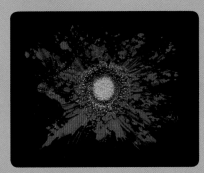

RICHARD FREESTONE (p.111)
Welsh poppy

Canon EOS-1Ds MkII, Canon 90mm TSE lens. Background image softened and brightened.
I photographed the separate elements of the composition and then created the multiple exposure on the computer using Photoshop.

RICHARD FREESTONE (p.118)
Red splash

Canon EOS-1Ds MkII, Canon 90mm TSE lens
This picture is a blend of old technology (liquid emulsion) and digital technology (Photoshop).

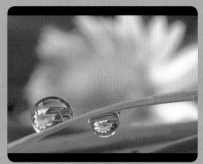

ALAN BRYANT (p.119)
Daisies on dewdrops

Canon EOS 20D, Canon EF 100mm f/2.8 USM macro lens, f/9. Saturation, levels, contrast, curves and sharpening adjusted in Photoshop.
I had to choose my aperture carefully, as I wanted to throw the background out of focus, but not so much that it would be impossible to tell what it was.

DENNIS FRATES (pp.126–127)
Californian poppies

Canon EOS-1Ds, Canon 20–200mm f/2.8 lens, f/4
I used a 200mm lens and a wider aperture to blur the Bachelor's buttons. The long lens also served to compress the flowers, making them appear close to one another.

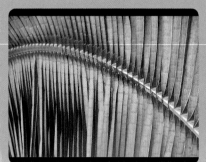

JOANNA CLEGG (p.120)
Jungle blind

Fuji FinePix S5000, f/3.2. Clone stamp and heal tool used to eliminate dirt and dust on the leaves.
I aim to capture the subject without the distraction of the surrounding environment – in this image the detail was the all-important factor. The narrow area of focus also brings about a 3-D quality.

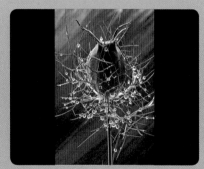

GARY BUTTLE (p.128)
Agave attenuata

Nikon D200, 200mm lens, f/5.6. Cropped, and blemishes on leaves removed.
I try to shoot only with natural light earlier or later in the day, as it gives a softer look. This approach has worked well with the soft sheen of the fleshy leaves.

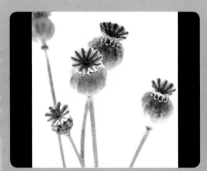

LUCY BIRNIE (p.121)
Poppy seed heads

Canon EOS 20D, 100mm macro. Saturation enhanced.
I decided to take this against a white background as I didn't want anything to detract from the simple, strong elements.

ANDY SMALL (p.129)
Nigella seed head

Contax RTS III, Zeiss 100mm macro lens, f/16, Velvia 50
In order to separate the subject from the background I carefully moved it to the studio and created a suitable background that enhanced the jewel-like quality.

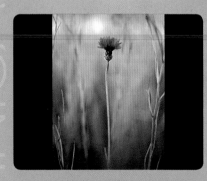

PHIL MANN (p.124)
Standing Proud

Mamiya Pro TL, 80mm lens, Velvia 50
I wanted to emphasise the simple beauty of the flower so found one I could isolate. The shallow depth of field and central placement are important, as are the in-focus stems either side that hold the eye in the frame.

RICHARD BLOOM (p.130)
Ficus pumila tendril

Nikon F90X, Tamron SP 90mm macro lens, f/4, Velvia 50
Having discovered the plant earlier in the day I went back to photograph it at dusk to make the most of the low, warm winter light. I composed the image diagonally and, using a wide aperture, focused on the coiled tendril.

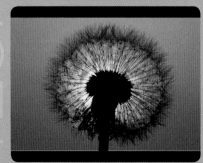

DUNCAN USHER (p.125)
Dandelion 1381

Canon EOS-1v, Canon 70–200mm lens, f/16, Velvia 50
I wanted to highlight the structure, symmetry and fragile beauty of the seed head, but also create an unusual shot of a common plant, which is usually seen as a nuisance in most gardens.

TINA HERZIG (p.131)
Lisianthus

Nikon D200, Sigma 150mm macro lens, f/4
For a natural but also modern close-up of the bud I shot in daylight and used an open blossom of the same flower as background. Additionally, the softness accentuates the fragile beauty of flowers.

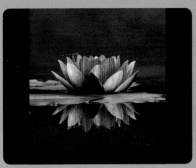

TONY KEENE (p.132)
Water lily

Canon EOS 20D, Sigma 200mm f/2.8 lens, f/8
Inspired by the contrasting colours, I could only get all the reflected information right with the camera just above water level. This meant putting a tripod in the water, shielding the screen and leaning precariously out from the bank.

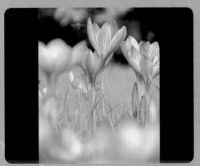

TONY WHYTE (p.133)
Autumn crocuses and honeybees

Fuji FinePix S5000
I wanted to get as low as possible (without getting soaked) to give a flower's-eye view. I chose the widest possible aperture which, combined with a long focal length, threw the foreground and background out of focus.

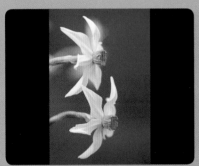

JO WHITWORTH (p.134)
Narcissus 'Firebrand'

Nikon F100, 200mm macro lens, f/4, Velvia 50
In retrospect, I realise that I subconsciously left plenty of clear, green space to the right of the shot, because the narcissi appeared to be poised for take off. So I left them plenty of airspace for their flight.

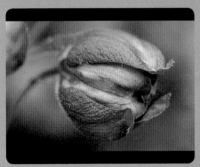

SUE BISHOP (p.135)
Delphinium bud

Nikon D1X, micro Nikkor 105mm lens, f/9
I chose an angle where I could photograph the bud against an open flower, and selected an aperture that would give sufficient sharpness in the bud itself, while allowing the background to become an out-of-focus wash of colour.

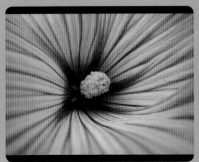

JOHN PETTIGREW (p.138)
Pink lavatera

Nikon Coolpix P5000, f/3.4. Adjusted brightness, and boosted colour slightly.
I took several pictures, but this one stood out from the rest. I like the way the markings lead you into the photograph.

WILLIAM PIERSON (p.139)
Water lily emergence

Canon EOS 5D, Canon EF 70–300mm lens, f/5.6
When I saw the image, I made it as quickly as possible so as not to lose the opportunity and the beautiful diffused light.

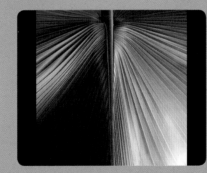

TOM LEE (p.140)
Poppy heads

Canon EOS-1Ds MkII, Canon 100mm macro lens, f/32. Tidied up scalpel work on poppy in postproduction.
Having opened one of the poppies with a scalpel I positioned them above some watercolour paper by clamping the stems. Then it was a matter of waiting for the sun to move into position.

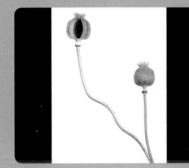

DAVE ZUBRASKI (p.141)
Cyclamen duo

Canon EOS 5D, Canon 100mm f/2.8 lens, f/8
I was simply striving to portray a little of the mesmerising beauty that flowers possess.

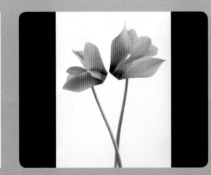

CAROL SHARP (p.142)
Palm

Nikon FM2, 6mm macro lens, f/3.5, Velvia 50
Careful framing was the order of the day.

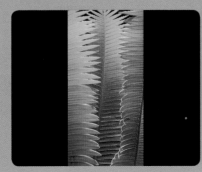

MARTIN KNIPPEL (p.143)
Green 1

Canon PowerShot S3 IS. Colour adjustment and cropping in Photoshop Elements.
I like using the vertical orientation with narrow cropping to bring out the architectural aspects of the plants. Most of the photos also employ the use of backlighting with natural light.

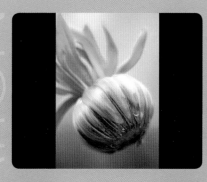

MARCUS HARPUR (p.146)
Dahlia 'Hatfield's Memory'

Nikon D2X, 70–200mm lens with 2x adapter
My main concern, having chosen a good, clean specimen, was to model the plant against a complementary colour in the background. I tried others but this is set off well.

CHRIS DOWNING (p.147)
Clematis 'Doctor Ruppel'

Canon EOS 5D, Canon 100mm macro, f/2.8
This image took 34 attempts, as I had to constantly move around the flower – just enough to keep the flare out but keep the brightness in – all the time with a moving sun.

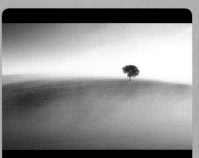

COLIN ROBERTS (pp.150–151)
Ash tree on the Downs

Canon EOS-1Ds MkII, 50mm lens, f/8. Contrast, colour and saturation adjusted in Photoshop.
Once in position, I waited for a long time until finally the mist began to burn away, revealing the outline of the tree.

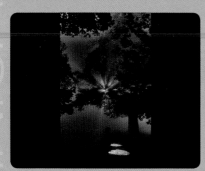

ROBERT JONES (p.152)
Reflection

Samsung GX10, Schneider 18–55mm lens, f//25
I shot the picture in RAW to give me optimum exposure leeway, in order to bring out the detail in the shadows.

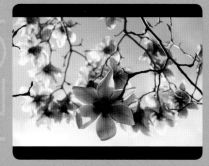

MARK BOLTON (p.153)
Magnolia blooms

Canon EOS 5D, 80–200mm zoom, f/8
The contrast of these blooms against the blue is what caught my eye on this occasion.

DANIEL KENCKE (pp.154–155)
Sequoia grove

Canon EOS 40D, Canon EF 16–35mm lens, f/16. Sharpened in Photoshop.
The sequoias are so tall that I quickly gave up on trying to photograph a single tree and focused instead on colour and composition. The young sequoia really is the story of this image.

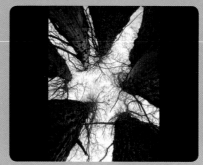

JUNE KINGSBURY (p.158)
Seven sisters

Minolta
The sky creates interesting negative space against the solid mass of the tree. The expanse of the tree's trunks lead upwards to produce a star-shaped image and, when viewed from a distance, a visual conundrum.

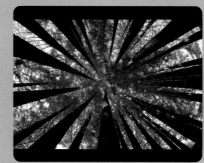

DAVID SIMCHOCK (p.159)
Reach for the sky

Nikon D200 with Nikkor 10.5mm fisheye lens, f/4. Slight adjustments to Levels and Contrast in Photoshop.
To emphasise the 'reaching' of the trees, I used a fisheye lens. It was important that I point the camera directly upwards as any tilt would have resulted in an unnatural curving of the trees.

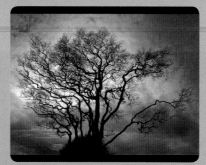

NICK SHEPHERD (p.160)
Naked beauty

Nikon D80, Nikkor 18–200mm lens, f/11. Bottom corners slightly dragged using 'distort' in Photoshop; remnants of hedge cloned out; perspective corrected.
A wide-angle lens, coupled with a low viewpoint, allowed me to isolate the tree against the vast, moody sky. Exposing for the sky created the silhouette.

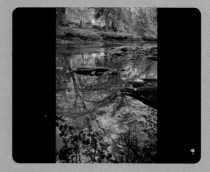

NICK SHEPHERD (p.161)
Autumn alder reflections

Nikon D80, Nikkor 18–200mm zoom, ND grad, f/11. Exposure between water and sunlit trees balanced in Photoshop.
Rather than take a conventional shot of autumn trees beside a river, I composed with the emphasis on the reflection.

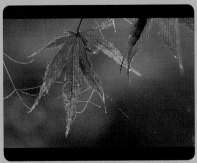

GERALD MAJUMDAR (p.162)
Japanese maple leaves

Canon EOS 40D, Sigma 150mm macro, f/4.5. Slight boost to saturation.
I positioned the camera so that the leaves were backlit and used my 150mm macro lens for a shallow depth of field.

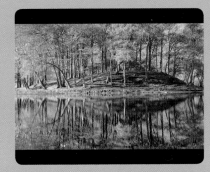

JEFF OVERS (p.167)
Loch Awe in autumn

Nikon D200, Nikkor 70–200mm lens
The waterlogged, boggy terrain ruled out a tripod, so the picture was handheld on a 70–200mm lens.

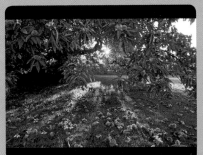

GARY ROGERS (p.163)
The Archduke's chestnut

Nikon F3, Velvia
This is the Spanish chestnut in the west grounds of Chatsworth.

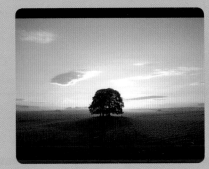

TERRY ROBERTS (p.168)
A new dawn

Sony α100, Sony 18–70mm lens, f/10
When the sun came up, it was directly behind the trees. I had a few seconds to shoot so, with no tripod or filters, I had to trust my judgment.

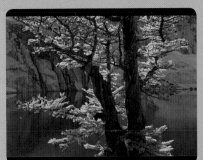

ADAM GIBBS (p.164)
Second chance

Toho-Shimo FC-45X, 200mm lens, f/45, Velvia 100
I wanted to find something in the foreground that would draw the viewer into the image, and the fallen timber created a zig-zag entry. It took me some time to find a group of trees that I could frame without foreground and background trees overlapping.

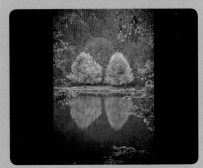

ERWIN SCHERIAU (p.169)
Four trees in a frame

Canon EOS 10D, Tamron 17–50mm zoom, f/5.6. Selective increase in saturation; edges darkened to frame the composition.
After waiting for the sun for around ten minutes, I took several photographs in order to ensure I had the correct exposure.

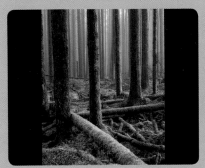

ADAM GIBBS (p.165)
Alpine larch

Toho-Shimo FC-45X, 300mm lens, f/45, Velvia 50
I used a relatively long lens to isolate the tree from the distracting bright sky. The sun was directly in front of me so the hardest part was trying to shade the lens from the penetrating sun.

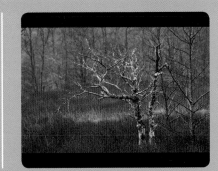

MURIEL DYGA (p.170)
Silver tree on purple carpet

Canon EOS 300D, 80–200mm lens, f/5.6. Brightness and saturation tweaks in Levels.
The effect of the light on this scene seemed to make it three-dimensional.

FIONA KEENE (p.166)
Tree reflections

Canon EOS 30D, Canon 100–400mm lens, f/9
Because there were only short breaks in the cloud, I had to make the most of a very brief opportunity when the light was right. For maximum colour impact, I used the lowest possible ISO and shutter speed.

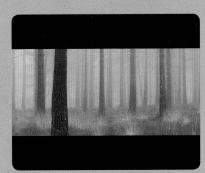

COLIN ROBERTS (p.171)
Pine plantation

Canon EOS-1Ds MkII, 135mm lens, f/16. Contrast, colour and saturation adjusted in Photoshop.
My aim was to use the outlines of the trunks fading into the mist to convey a feeling of depth. To do this I included trees in the foreground, middle distance and background.

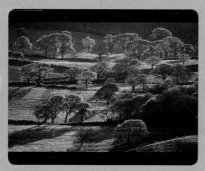

COLIN VARNDELL (p.176)
Spring oaks on hedges

Nikon F100, Nikkor 300mm lens, Velvia 50, f/16. Film uprated to ISO 200 and push processed to increase contrast.
Once I had framed this shot with a camera and telephoto lens on a tripod it was a case of waiting for the best light. It was taken about 20 minutes before sunset.

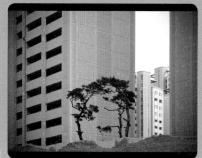

DAMIAN GILLIE (p.177)
Lonely trees in Korea IV

Canon EOS-1Ds, 80mm lens, f/11. Verticals corrected.
This is one of a series of photographs. I wanted to show how an entire area was being transformed, with gardens and trees being created at the same time as the buildings.

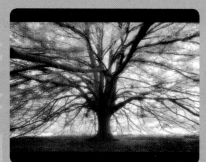

TONY HOWELL (p.178)
Fern-leaved beech

Canon EOS-1Ds MkII, 17–40mm lens, f/11. Softened slightly and contrast increased in Photoshop.
I walked carefully through the outer leaves, then set the tripod very low, and laid down on the ground to get the best possible angle, using the widest setting on my 17–40mm lens.

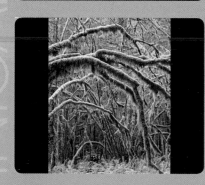

ADAM GIBBS (p.179)
Cattail moss

Toho-Shimo FC-45X, 300mm, f/64, Velvia 50, polariser
I wanted to compress the scene so that the maples would arch one beneath the other. To do this I used a relatively long lens and stopped the lens down considerably.

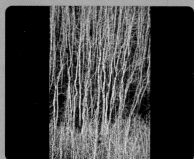

DANIEL KENCKE (p.180)
Winter aspens

Canon EOS 40D, Canon EF 100–400mm IS USM zoom, f/5.6. Sharpened in Photoshop.
There were several tiers of dense aspen groves on an open hillside. I used a telephoto lens to compress the distance between tiers and to pick the composition that best told the story of these wind-shaped trees.

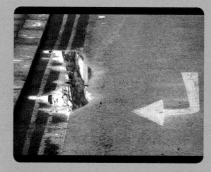

SUNA AKTAS (p.181)
Tree on the road

Olympus C-740
I had to work quickly to capture this image, so didn't have any opportunity to experiment with a variety of angles.

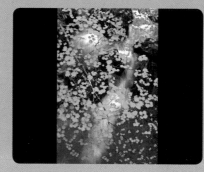

KEVIN SCHAFER (p.182)
Vine maple and stream

Nikon D2X, 17–35mm lens
By photographing in the middle of the afternoon, when the light was directly overhead, I was able to avoid deep shadows. I had attempted the same scene a few days earlier to help me perfect my settings and technique.

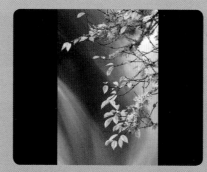

MARSHALL BLACK (p.183)
Autumn falls

Canon EOS-1D MkII, Canon 70–200mm f/4 L lens, f/22, polariser
As this photograph was taken from a walled bridge, my framing options were limited. By using only one extended tripod leg it was possible to support the other two on the top of the wall and shuffle sideways for framing.

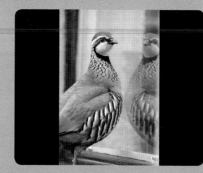

FERGUS GILL (p.186)
Partridge reflection

Nikon D70, 300mm f/2.8 lens, f/5.6
I had to rest my camera on top of a bin as I peered round the corner of the house. I used vertical format to frame the bird by the window.

RICHARD STARK (p.187)
Garden orb

Fuji FinePix S6500fd, f/3.9. Cropped to a square, then used distortion and rotation in Photoshop.
I manipulated the image in Photoshop. The more you look into it the more detail you notice.

TECHNICAL INFORMATION

KAT WATERS (p.188)
Shadow

Sony Cybershot
I took my camera out, hoping to get some good shots. I spotted these amazing shadows in a pool of light on a tree trunk. The shadows really were that vivid green – no Photoshop involved!

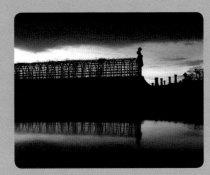

KAT WATERS (pp.192–193)
The Privy Garden at sunset

Olympus C-8080 Wide Zoom, 7.1–35.6mm lens, f/2.5
While photographing close-ups of a sundial's gnomon as the sun was going down, I noticed this reflection of the Privy Garden.

JULIETTE COLACO (p.189)
In the runner beans

Canon PowerShot A630
Summer is my favourite season, and I wanted to take a lot of photographs to show the different aspects of the season.

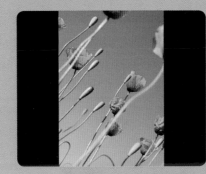

GRAEME SMITH (p.194)
Red poppies

Nikon D40x, Nikon 18–55mm AF-S DXII lens, f/5.6. Colour, contrast, noise reduction and white balance adjusted in DXO Optics Pro.
I first made some standard images using the grass as the background, but then tipped the camera to make a quirky and more abstract image.

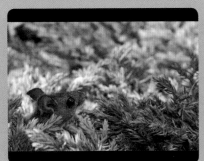

OLIVER TREW (p.190)
My little friend

Canon EOS 400D, 18–55mm lens, f/5.6
I set the camera to ISO 100 to keep noise at a minimum, and the aperture to f/5.6 for a shallow depth of field.

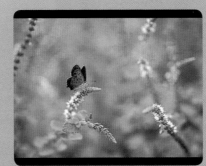

DAZYL YOUNG (p.195)
The wings of life

Canon EOS 350D, 400mm f/5.6 lens, f/5.6
Butterflies frighten easily so I had to be super quiet and hide in the plants to achieve a successful photograph.

RAPHAELLA PHILCOX (p.190)
Come back Ken, I want my sunglasses!

Olympus Camedia C-370
We had a very sunny couple of days so I took the opportunity to create a number of photo-stories. I created stories using plants and insects, which looked very large against the dolls.

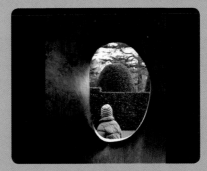

CHRISTIAN MAROT (p.195)
Through the hole

Canon PowerShot Pro90IS, 58mm lens, f/2.8
I considered a different angle and looked through the sculpture to take a picture. As I was preparing, the girl walked into frame and I shot, focusing quickly.

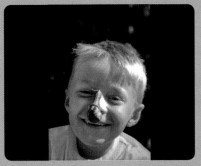

WILL JENKINS (p.191)
My brother Harry loves snails

I had to stand up, as Harry is taller than me. I made sure the sun was not in front of me and I pointed the camera at the snail and cut out the rest of my brother, as it looked better.

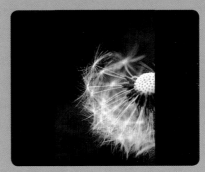

LIAM LESLIE (p.196)
Dandelion

Nikon D50, Nikon 80–200mm f/2.8 lens, f/11, polariser
Setting my tripod to its lowest level allowed me to get very close to the flower. Then, using my longest lens, I manually focused on the seeds, trying to single out an individual, with my Nikon flash overhead.

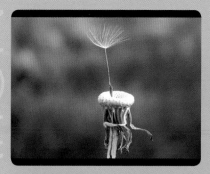

NADIA AZARHOUCHANG (p.197)
Dandelion

Fuji FinePix S602 Zoom
I zoomed in on this dandelion head.

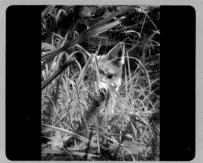

HOWARD BUDZYNSKI (p.198)
Can you spot the second fox?

Fuji FinePix S6500, 28–300mm lens, f/4.9
I would sit quiet and still in the garden near the den, staying at a safe distance so as not to make the foxes nervous. I tried for several days and eventually a fox turned and looked directly at me.

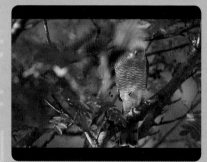

FERGUS GILL (p.199)
Sparrowhawk gaze

I positioned my hide 10 metres from the tree and camped out in it after school, waiting for the bird to arrive. I tried to frame the shot so that the bird was peering through the branches, giving it a natural, wild feel.

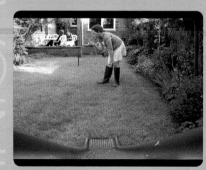

RAPHAELLA PHILCOX (p.200)
Self-portrait in my garden

Olympus Camedia C-370
I don't have a tripod, so I put my camera in a number of safe places around the garden, set the timer, and then posed. I liked the way the slide entered into the picture, giving a sense of movement while I was very still.

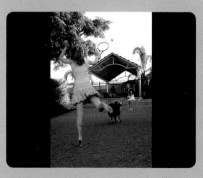

ERIN MCAULEY (p.201)
Tennis anyone?

Canon
I took many photos of my sisters playing but I like this one the best as it isn't posed. It will be a treasured reminder of how we used to spend our time in the garden.

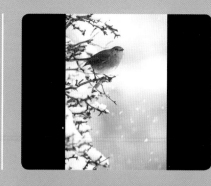

FERGUS GILL (p.202)
Winter robin

Nikon D200, Nikon 200–400mm f/4 lens
This robin kept landing in the same place, so I turned my camera to the point and waited for it to appear. I shot the picture in vertical format as I thought it would frame the bird, the hedge and the snow strongly.

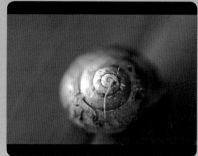

SAM ROWLEY (p.203)
Snail shell

Nikon D200, Nikon 105mm macro lens, f/4.2
I usually take pictures of animals, but on this occasion tried to create a picture that was still and different. This snail shell was the perfect model.

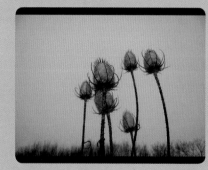

LYDIA GREENAWAY (p.204)
Frozen in time

Nikon D200, 35–70mm f/2.8D lens, f/2.8. Saturation and brightness reduced.
I positioned the teasels stretching away from the camera so that their bold shapes were silhouetted against the paler sky.

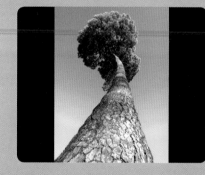

ZOE WITHEY (p.205)
Leaning pine

Olympus Camedia C-5060
To get the most dramatic view I moved right in near to the trunk and took the photograph looking almost straight up.

INDEX

INDEX

INDEX

INDEX

The contact details for all of the photographers featured in this book, with the exception of Young Garden Photographer, can be found at the International Garden Photographer of the Year website, www.igpoty.com